ART/WORK

—————————— Everything You Need to Know
(and Do) As You Pursue Your Art Career

Heather Darcy Bhandari
Jonathan Melber

Free Press
New York London Toronto Sydney

NOTE TO READERS

This publication contains the opinions and ideas of its authors. It is intended to provide helpful and informative material on the subjects addressed in the publication. It is sold with the understanding that neither the authors nor publisher is engaged in rendering legal or any other kind of personal professional services in the book. The reader should consult his or her attorney or other competent professional before adopting any of the suggestions in this book or drawing inferences from it. The strategies outlined in this book may not be suitable for every individual, and are not guaranteed or warranted to produce any particular results.

The authors and publisher specifically disclaim all responsibility for any liability, loss or risk, personal or otherwise, which is incurred as a consequence, directly or indirectly, of the use and application of any of the contents of this book.

Free Press

A Division of Simon & Schuster, Inc.

1230 Avenue of the Americas

New York, NY 10020

Copyright © 2009 by Heather Darcy Bhandari and Jonathan Melber

First Free Press hardcover edition January 2009

FREE PRESS and colophon are trademarks of Simon & Schuster, Inc.

For information about special discounts for bulk purchases, please contact Simon & Schuster Special Sales at 1-800-456-6798 or business@simonandschuster.com.

Designed by GREENBLATT-WEXLER

Illustrations by Kammy Roulner.

Manufactured in the United States of America

10 9 8 7 6 5 4

Library of Congress Cataloging-in-Publication Data
Bhandari, Heather Darcy
 Art/work: everything you need to know (and do) as you pursue your art career / Heather Darcy Bhandari and Jonathan Melber.
 p. cm.
Includes index.
 1. Art—Vocational guidance—United States. I. Melber, Jonathan. II. Title. N6505.B575 2009
 702'.3—dc22

 2008042092

ISBN-13: 978-1-4165-7233-6

ISBN-10: 1-4165-7233-3

CONTENTS

ART/WORK

CHAPTER 1

The Big Picture

The art world is full of people who like saying "there are no rules in the art world," which is only sort of true. There's certainly nothing written in stone (there's barely anything written on paper). And sure, what you do in the studio is entirely up to you; there aren't any rules about what you choose to make or how you make it. But there *are* general customs in the art world, and widespread expectations among arts professionals, which you should know before you head out of the studio and start meeting these people.

The customs have changed, too. It used to be a given, for example, that you would need many years of studio time before a gallery would look at your work. Today, galleries compete over the newest talent to come out of school, even trying to scoop up MFA students before they've graduated. That's not to say everyone is ready for a commercial gallery, by the way. Pressure to sell can stifle development, especially at the beginning of a career. But because there's a real possibility to sell work as an emerging artist, you have to confront issues, and understand how the art world works, in a way that emerging artists never had to before.

Of course, you don't have to follow custom or accept other people's expectations. We're not prescribing a bunch of rules that you need to follow. If you want to buck the system, go right ahead. Do the *wrong* thing. Just do it on purpose, not by accident, and know why you're doing it.

Also, what worked for someone else may not work for you. You have to weigh the information and recommendations in this book according to your personality, your goals, your art. Aiming for a big New York gallery, for example, is very different from establishing a regional practice in a smaller city or trying to survive on direct sales from your studio. No priority is better or worse—it's *your* definition of success that matters and no one else's—and each one calls for a different approach.

Who are we to be telling you all this? One of us is a gallery director, the other an arts lawyer. We've been close friends since the beginning of college. As is true of most arts professionals, we do what we do because we love art and we love artists. We've both been in New York for a decade, and over the years a lot of our artist friends have asked us a lot of the same questions— about career choices, business issues, and legal problems.

————————"When you look at the history of art, you see a history of mavericks—people doing the wrong thing. I wish that I saw more artists doing the wrong thing. That's really more in the spirit of art that I love."

Fred Tomaselli, artist, Brooklyn, N.Y.

—————"I understand there are perceived, and real, power dynamics in the art world, but the artist is the critical center of all we do. In a larger sense, they are the driving force that will matter in history—there is nothing I can do without an artist. At the same time, in the immediate process, I don't feel any more or less important to what feels like a large organic system trying to achieve the same thing (in the best-case scenario). I know it's complicated, but if you treat it that way, you can encourage real exchange that produces good shows and good work." **Shamim Momin, curator, Whitney Museum of American Art, New York**

—————"Being a curator is using pattern recognition. You see one thing happening here and another thing happening there and you start to sense a new swelling wave of something going on. You build an exhibition around it to take a pulse of the current moment. For me, it is something pertinent or relevant that I want to pin down in a show. It could be a single artist or a group of artists. It's like throwing down the gauntlet and saying, 'This is important and we should pay attention to it—we should champion or recognize these artists.'" **Michael Darling, curator, Seattle Art Museum, Seattle**

After a while, something obvious (in hindsight) dawned on us. Unlike other creative professionals, artists don't have agents or managers to deal with these issues for them. They have to do it all themselves, at least until they're very successful. Galleries are supposed to act like agents for their artists, but not all of them live up to that standard. And even the best ones still have to balance the needs of their artists with the desires of their collectors—a conflict of interest that simply doesn't exist for agents in other creative fields.

So we thought it would be useful to write a book that tells artists how to act as their own agents and managers— a book that answers all those questions people keep asking us.

We knew that the only way to do these topics any justice was to find out what other arts professionals had to say about them. We interviewed nearly one hundred people across the country—gallerists, curators, accountants, lawyers, and, of course, artists—and spent the better part of a year synthesizing their opinions, and ours, into the book you're reading now. And because we also wanted you to hear these people in their own words, we have included quotes of theirs throughout the book. The quotes represent the most commonly held—and occasionally diverging—views in the art world.

QUICK TOUR OF THE ART WORLD

There are a lot of people in the art world who play crucial roles in how your art is made, shown, understood, sold, and remembered. First, there are all the people who can help you develop your art, your ideas, and your goals: other *artists,* your former *professors,* the directors and staff at *residencies* and *foundations* that support artists.

There are the *framers, printers, fabricators,* and other *production* people whose skills you may need to tap (or learn) to finish your work.

Curators choose the work for group and solo exhibitions. They usually have an academic background, with a master's or PhD in art history or curatorial studies. The ones on staff at museums or nonprofits are called *institutional curators.*

Independent curators freelance, putting together their own exhibitions or collaborating with museums, galleries, non-profits, and alternative spaces. There are also *private curators* who work for corporations or big *collectors,* maintaining and developing their collections.

Art advisors and *art consultants* help private collectors, corporations, and institutions buy work, for either a fee or a percentage of the work's price. Some of them focus on emerging artists and may want to visit your studio or introduce you to their clients.

Dealers show your work and try to sell it. They tend to specialize in either the *primary art market,* meaning art sold for the first time, or the *secondary art market,* meaning resale. Primary market dealers represent living artists and manage their careers. Secondary market dealers help sell work that's already been bought at least once. They don't usually work with artists; they deal directly with collectors and other dealers.

Many dealers call themselves *gallerists,* to emphasize their roles as curators, managers, and producers. Others stick with "dealer" because they don't want to downplay the commercial aspect of selling art. (We'll use the term *gallerist* throughout this book, although we think the distinction is only as meaningful as you want it to be.)

SMOKE!

—————"The art world is full of invention and reinvention of personas. Invention and reinvention of roles as this beautiful model for the rest of the world. That's where its great beauty is." **Michael Joo, artist, Brooklyn, N.Y.**

—————"I reassure myself by saying there is an always shifting hierarchy comprising the art apparatus. Collectors and dealers are occupying the top of this ladder right now. Curators are slotted underneath and critics and artists are ruefully on the bottom. We are fodder for what is going on above. This is not a lament. It is an economic reality. If we buy into this reality and the wealthy remain wealthy, it will be the predominant form of the art world for the near future. But in the long run these hierarchies will change and change again, history has proven that." **Michelle Grabner, artist, professor, critic, curator, Chicago**

—————"Find something that is really meaningful to you—that's the most important thing at the end of the day. Even if everything goes well, there are still those moments when you see through it all. Once you see through the fame, money, and social life and ask yourself, 'What is this all about? What does it mean to me?' it's great if you can see your work clearly and what you see is important to you.

"That same thing goes on the other side. When you're wondering why you go through all this hell and you're struggling, at least you see that you really enjoy what you do, you are fulfilled by what you make, and you believe in it." **Charles Long, artist, Mount Baldy, Calif.**

——————"None of us exists without the artists. You have a pyramid. There are only so many dealers, critics, etc. Artists are the biggest portion. The base." **Tony Wight, Tony Wight Gallery, Chicago**

——————"Figure out what kind of artist you want to be. If you have objects that need to be in a commercial gallery, you can probably find a gallery that will sell them for you. It's probably not that hard if you open it up to other cities and other states. But you need to know what part of the art community you want to be a part of. If you want to be part of the art community where you are getting commissions to do installations at museums or you want to be a hip painter who sells out in Miami— these are often two different practices." **Shannon Stratton, artist and director of ThreeWalls, Chicago**

——————"There is art and then there is the art market. For me, they are separate." Fred Tomaselli, artist, Brooklyn, N.Y.

Most galleries have some kind of *gallery staff* to help run the space. They may organize their staff by task or by artist. The main tasks include:

Sales: staying in touch with collectors, finding new collectors, previewing your work, describing it to visitors, following up with leads, handling sales transactions.

Curator: selecting artists for the program, selecting work for shows, organizing and installing shows, preparing written materials for shows, applying to art fairs.

Artist support: keeping in touch with you, helping you with whatever you need, advising you on career decisions such as applying to residencies, running your studio, and participating in shows in other cities.

Registrar: tracking the location, condition, price, and status of every work that moves through the gallery; filling out, negotiating, and enforcing consignment agreements; overseeing shipping.

Art handler (or "preparator"): packing, shipping, and storing the work that moves through the gallery; installing shows.

Archivist: cataloging all your images, press, and written materials.

Bookkeeper: accounting, paying the bills.

Gallerina: greeting visitors, answering phones, administrative tasks. (Yes, the guys are called "gallerinas," too.)

Gallery manager: basically the head of operations, managing the space and equipment.

Press person: following up with story leads, distributing press releases.

Director: overseeing everything and every one, reporting to the owner.

—————————"The art world is not the monolithic monster it can seem to be. Sure, it has a lot of monstrous parts, but it's just people with different interests and viewpoints. As an artist, you are one part, and you decide how you interact with the rest. It's not 'your work meets the art world monster.'"

Bill Davenport, artist and critic, Houston

In small galleries, the owner might do everything. Larger galleries have several directors and may employee dozens of people.

Then there are a whole bunch of people whom you may come across but not work with directly:

Art critics write about shows—if you're lucky they'll write about yours. Whereas their job is obviously to assess the art they see, there are also *reporters* and *bloggers* who cover the art world from a news or personal perspective. (And, of course, the *publishers* and their staffs at art magazines and newspapers.)

Art fair directors and their staffs manage the numerous art fairs that take place around the world every year.

The basic function of *auction houses* is to take work from collectors looking to sell and auction it to the highest bidder, for a percentage of the final sale price. They also provide services for collectors such as valuation, placement, and private sales. Some have expanded their role into traditional gallery terrain—not necessarily to the delight of gallerists—showcasing new work and making primary art market sales.

WHERE YOU COME IN

No matter where you are in your career, we think you will find this book helpful. It covers everything from tracking your inventory to installing a show; from designing your website to drafting an invoice; from paying your taxes to protecting your copyright; from landing a gallery to planning a commission. The book includes forms, charts, and sample agreements that you're likely to need during your career. And it has a slash in the title, so it will look cool on your shelf.

We organized the chapters in roughly the order of issues you'll encounter as you begin your career, but with the idea that you will probably skip around a lot. We'll tell you where to look whenever we mention something that's explained in another chapter, so don't feel compelled to read through cover-to-cover the way you would with a novel.

Now just to be clear, we're not telling you how to make art. This book is about what you *didn't* learn in art school, not what you did. We're also not telling you that if you do everything we say, you will be the next Damien Hirst. But whatever your potential, this book will help you realize it.

CHAPTER 2
—————— Groundwork

As an artist, you have more independence than most professionals ever experience. *Everything* you do is up to you, from where you live to what you make to when you work. All that independence demands a good dose of self-reliance and structure, which is why it's useful to think of yourself as an entrepreneur. That doesn't mean treating your work as if it's a "product." It means recognizing that you will have more control over your career when you organize yourself—and your time—as if you were running a business.

In this chapter, we'll go through some of those "business" issues you face right out of the gate, such as finding studio space, selecting the right day job, registering your copyright, setting up inventory and invoice forms, and paying your taxes.

BALANCING YOUR TIME

The best thing you can do for your practice when you're starting out is to get in the studio right away. This is not a revolutionary concept—obviously if you're making work for a living you need to *make the work*—but it can be surprisingly difficult advice to follow. Most people have bosses who crack the whip. You, on the other hand, *are* your boss. No one else is going to force you into the studio.

Small wonder, then, that many successful artists designate regular blocks of studio time and don't change them. That means treating studio time like the job that it is. It means going to the studio when you're not feeling creative. It means going to the studio even when a friend's visiting. If you can't work on your art—let's say you're waiting for some materials to arrive—there are always plenty of administrative items to tend to. (This book is full of them!)

We're not saying the same schedule works for everyone. Maybe you're more creative pulling a few all-nighters every week than sitting in your studio from nine to five every day. Your practice must be rigorous, but it must also fit your personality. Identify your tendencies early on—when are you most productive? how long before you start to lose focus?—and incorporate them into your schedule.

————"Make your work. Make your work constantly. Love it. And hate it. But make it."

Stephanie Diamond, artist, New York

———————"I make sure I show up even if it's just to clean the floor and look at my work. I've made a really definitive schedule. It's a job and I have to go to the studio. It's not a leisure activity." **Sarah Chuldenko, artist, New York**

———————"Oftentimes, five or more graduates will move together and communally rent a space. This is the most viable means of survival. As they make connections to galleries and other artists, they create a beautiful network as they fan out." **Kevin Jankowski, assistant director for career programs, Rhode Island School of Design, Providence, R.I.**

———————"It's really important to have contact with your peers. Your peers are important conduits for information and ideas. For many artists it works best to work together with other artists: they share studios or have studios down the hall; they talk about ideas with each other; they have a really strong core of peer support." **Andrea Rosen, Andrea Rosen Gallery, New York**

———————"Space is the biggest, most important thing. If you are a painter or a sculptor, you need to get a space. Photographs and videos can be made out of a studio apartment, but big paintings, no. I got a big space, divided it and got tenants. I pay less than one-fifth of the rent because I set it up. I didn't know that I knew how to build walls, do plumbing, or build a kitchen until I did it." **Michael Yoder, artist, Philadelphia**

———————"You make work whenever you can. For me, I always have little drawings with me in my backpack. I have this theory—even if you are buying supplies or making a list of drawings to make, it's studio time. My work has gotten better because I've had more time to reflect on the work. I've gotten used to making art, not just in the studio." **Joseph Smolinski, artist, New Haven, Conn.**

Your "practice," by the way, includes *everything* you do for your art. It's not just what happens when you're physically in your studio. Getting supplies, reading, and thinking about your art are all meaningful aspects of your practice.

The sooner you can get into whatever schedule you choose, the better. Some artists give themselves a while to decompress after art school or their last show. But by the time they decide to get back in the studio, they have to squeeze studio time around whatever job and social life they've settled into. Rather than forcing studio time into a set schedule, organize your job and social life around studio time from the beginning.

THE HOME STUDIO: IF YOU LIVED HERE, YOU'D BE IN THE STUDIO BY NOW

The nice thing about a home studio is that it's right there, in your home. Going to work literally takes no time at all. But a home studio will only work for you if you are disciplined and focused. So do a little soul-searching. Can you ignore your TV? Will it distract you if your children are in the next room? Are you disciplined enough to work when your bed is only a few feet away? (Probably good to do a little wallet searching, too. If you can't afford a separate studio, well, at least that's one decision you don't have to spend time figuring out.)

Before deciding whether a home studio is the way to go, think about the kind of space your artwork demands. Would a home studio allow you to work on the scale you need to, or would it limit you? While you need to be realistic about your budget, you also need to be serious about your career—which means not letting your studio dictate the size of your art or the materials you use. For example, should your sculpture be larger than the size of the room allows? Should your drawings be paintings, but you're afraid to get paint on the floor?

If you have a basement or garage or extra room that you can turn into a studio and that's all the space you need, great. But if you live in a cramped apartment and don't have room at home to make the work you really want to, get a separate studio.

Of course, your space *can* influence your work. Sometimes the constraints of your studio will push you in new directions

that actually improve your art. That happens when the space affects the *concept* behind your work, not just its size; or when you're forced to change something that ends up improving how you present your work.

THE SEPARATE STUDIO: SOMETIMES YOU NEED A LITTLE SPACE

This is the way to go if you need a formal separation between work time and downtime, or if you don't have enough space at home to make your art. But remember that even with a big studio you still have to be careful not to let the space dictate the size of your work. Art is not a goldfish. It shouldn't just grow with the size of your studio. Don't make an artwork bigger than it needs to be just because you have the extra space.

One of the best things about separate studios: they typically come with other artists. Sharing space with artists in a studio building usually means sharing ideas, techniques, even critiques. This can be a boon to your inspiration and creativity. And it's a natural way to stay connected to the art community, which is an essential component of developing as an artist. (More on that later in the chapter.)

Working around other artists also increases the chance of fortuitous encounters, since your neighbors will get visits from curators, collectors, and gallerists. The number-one way gallerists and curators find new artists is through recommendations from the artists they already know. So the odds of being in the right place at the right time increase greatly when you start working in an active studio building.

You can find subsidized studios in every major city. And while *artist loft* sometimes means "expensive condo," there are still warehouses full of artist's studios across the country. If you don't have a studio building in your area, take matters into your own hands and create one. There is probably an art school or art club in your area; connect with the artists there, rent a large space, and divide it into smaller studios. We know a lot of artists who have done this—they ended up with great studio space *and* an income stream to boot.

Second Studios

It's becoming more common for artists in smaller cities to get together with other artists and rent studio space in places like New York and Los Angeles. They split the costs so everyone can keep some work in the second space to show gallerists and collectors who aren't likely to visit them in their hometowns.

──────*"I want to have the freedom to live where I please and still be connected to the world's leading art market. From a business standpoint, it made sense to maintain a footprint in the market, and maintain my lifestyle outside the city. I wanted to have my cake and eat it, too." Howard Fonda, artist, Scottsdale, Ariz.*

THE DAY JOB

Unfortunately—and unfairly, in our opinion—a number of gallerists are biased against artists who have day jobs. They say that they're only interested in emerging artists who are "committed" to their practice, as if artists shouldn't also be committed to food and shelter.

Want to know a dirty little secret? *Every* artist has a day job (almost). We're not just talking about MFA grads at the beginning of their careers, but successful artists at big-city galleries. Midcareer artists at well-known blue-chip galleries may not need day jobs—and no, Jeff Koons doesn't need one either—but very few emerging artists, or even midcareer artists, can live off their art alone. So don't buy into the myth that you're not a good artist, or a successful artist, or a "real" artist, if your art doesn't pay the bills.

While we're at it, here's another little secret: The average income of an artist at an emerging gallery, from sales of artwork, is less than *ten thousand dollars a year*. The big-name artists selling work for hundreds of thousands of dollars are a tiny fraction of the art world.

In deciding what kind of day (or night) job you should get, ask yourself how much money you need to *live* (not just survive). Do you need stimulation or inspiration from your day job? Do you want to interact with other artists at work?

We recommend finding a day job that will somehow add to your practice. Maybe working where you'll get discounts on your materials (art supply store, lumberyard, photography lab) or access to your subject matter (botanical garden, science lab, community center). Or where you'll hone your craft: commercial photographer, printer, framer, illustrator, costume builder, stylist, set builder, faux finisher, artist's assistant.

That last one—working as an artist's assistant—can make for excellent training. You see how a successful artist runs his or her studio; you meet other artists in similar places in their careers; you learn new techniques; you get a lot of practice working with the medium. It can also lead to new connections and new opportunities.

Be aware, though, that this kind of work can mess with your head—and your hand. After months of spending eight hours

The Myth of the Struggling Artist

You don't have to be struggling and poor to make good art. While destitution and anxiety can generate creativity, so can comfort and tranquility. You're not going to lose your inspiration because you took a day job and can suddenly afford health insurance.

The point isn't that you should strive to make a lot of money; it's that whether you do or not is unrelated to the quality of the art you make.

IT'S MY HOMAGE TO BRANCUSI'S ENDLESS COLUMN.

PEACHES ¢.99

————"Don't jump into anything too quickly. I have always felt you are better off having a day job and going slowly rather than jumping into a situation that will be detrimental in the future. Not all artists feel that way, but it was certainly something Felix Gonzalez-Torres was adamant about. You never want to compromise the development of your work because you are under pressure." **Andrea Rosen, Andrea Rosen Gallery, New York**

————"I can count maybe five or six artists who live off their art. It's a very small percentage. Basically, how, as an artist, can you figure out ways to generate income that have nothing to do with your work? Obviously a lot of us make money teaching, but it is good to have other sources of income. My husband and I, for example, invested in cheap rental property because we are good at fixing things and fixing things up. That's what's going to keep you in the studio. Either you are independently wealthy—and there are a lot who are in the art world—or you need to find some way of making money that is not art-related." **Francesca Fuchs, artist, Houston**

————"The key question is what makes you really happy? The further you get away from that, the worse it is. Artist to art handler is not a big separation. Artist to Wall Street or plumber is a big separation." **George Adams, George Adams Gallery, New York**

—————"An old-fashioned master-and-student atelier system can work. Mike Kelley, Paul McCarthy, and Charlie Ray's studios are hotbed feeding grounds for young artists. The young artists see the ambition and the work, while the older artists recognize the young artists who are smart. It's like a farm system of sorts." **Michael Darling, curator, Seattle Art Museum, Seattle**

—————"It's really important you like the artist and you believe in the work. That can be a double-edged sword. You can start making work very similar to theirs. On the other side, they can take your ideas as their own. One of the reasons I wanted to work for Peter Halley was our work had nothing in common." **Michael Yoder, artist, Philadelphia**

—————"I mixed color for the first couple of months I worked in Jeff Koons's studio, so I can get to a color pretty immediately. You spend so much time—forty hours a week—mixing color and it has to be perfect. Sometimes you mix colors for two years. Sometimes you mix colors for three months. There were twenty-three painters, the same number of sculptors, and ten to fifteen office people. I think many of the artists have a hard time making their own work, but I know they are all trying." **Sarah Chuldenko, artist, New York**

—————"I have a sketchbook where I constantly draw during the class I teach. I try to draw with the students as a teaching tool, but also as a way to improve my own practice. Now, if I wanted to, I feel that I could draw almost anything because I've already had to in class. Most of all I love the energy. It's so great when they've made a really good drawing or when students write you later and tell you they're going to grad school or invite you to an exhibition they are in. That's what it's all about." **Joseph Smolinski, artist, New Haven, Conn.**

—————"I was an assistant to Terry Winters. That was a really fantastic job for me and I highly recommend artist assistantships. It was great to be around Terry when I was fresh out of school and trying to figure out how to have a career, how to develop my studio practice, and how to sustain my investigation. He's been an inspiring person to have worked for and our friendship continues to this day.

"I've had many assistants and I hope the experience was as beneficial for them as it was for me. Aware of their challenges, I find myself encouraging them, looking at their work and making introductions if I can. I share with them my knowledge of materials and techniques (often reciprocal) and I make them sandwiches. I worked in a deli in art school, so I know how to make a good sandwich." **Charles Long, artist, Mount Baldy, Calif.**

—————"After school, I moved to downtown Los Angeles. Everyone had a day job. There was no market there, so artists were free to do whatever they wanted because they weren't going to sell anything whether they wanted to sell out or not. There was a great feeling of experimentation in the air. Paul McCarthy was doing performances down there and he was a contractor on the side. That was how I expected life as an artist to be.

"We all make compromises every day to get by. I didn't quit my day job until I was thirty-five. But if you are making compromises in your art to get ahead in the art world, you sacrifice the most important aspect of your life." **Fred Tomaselli, artist, Brooklyn, N.Y.**

—————"I think it's essential to have a variety of day jobs. As an artist, you want to focus on your work, but it is also important to have an understanding of different venues and to learn what happens behind the scenes. Knowing the multiple facets of the art world is essential because you acquire an appreciation and an understanding of all the hard work that goes into it." **Hillary Wiedemann, artist and former gallery manager of Artists Space, New York**

——————"Being relatively new to the city, art handling has been a good way to meet other artists and gallerists. In a short time, I've worked at about six spaces. So it has a networking aspect that could probably only be compared to being faculty at a university. It does have a drawback—if you're freelancing there isn't the stability and benefits you might get from a regular position." **Chris Ballantyne, artist, Brooklyn, N.Y.**

——————"I started freelance art handling with David Zwirner Gallery by chance and because it seemed like an interesting place to explore the gallery world. I didn't work for them that much, but it gave me an insight into the way galleries actually function. Naturally, working with the big guys and many artists I really liked was a thrill. Of course it could be a bit stressful—whilst still finding my feet, I remember being casually asked to wrap a one-million-dollar Picabia!

"At the end of the day it's about being engaged enough to be happy to go to work, but not so involved that it affects my art practice. I also need the flexibility to disappear to residencies and have my job waiting for me on my return. I often think that I could make a lot more money using some of my more valuable skills like video editing or photography, but these are so linked with my art practice that they would affect my enjoyment and enthusiasm for it.

"Oddly enough, working at a gallery has very little to do with being an artist, though it has proved very helpful in understanding all aspects of the gallery world. I am a useless schmoozer, so being in Chelsea every week keeps me in touch with some art opportunities and gallery people that I would find myself totally cut off from if I were doing something else." **Rob Carter, artist, Brooklyn, N.Y.**

——————"A good job for an artist is something where you can control your hours and have time in the studio. Many artists have worked here while they were in school, but they don't usually last long. The people who last long give themselves to the project one hundred percent." **Knight Landesman, publisher, Artforum International Magazine**

——————"I am very careful about hiring artists in the gallery. If I do, I give them a very long speech about the business side of art and let them know it's not glamorous. There's a lot of spackle and paint. We have the joy of doing what we do, but it's hard to be the guy/girl in the back who has to schlep around inventory.

"My advice to artists is to seek employment far, far away from art galleries. It can be too disappointing and makes young artists bitter. If you need a part-time job to make ends meet and want to be a coat check person, remove yourself from art people. You don't want people associating you with taking their coat when they see you at your solo exhibition. Be the artist." **Leigh Conner, Conner Contemporary Art, Washington, D.C**

——————"I often think that the world would be a much better place if every artist, before they could show, was required to do gallery work. For one, it develops a real-world skill set that helps you out with installing your own work. Secondly, in doing gallery work, you learn pretty quickly how you should and shouldn't do things. Logging some time handling other people's work will give you a newfound respect for the person on the other end when you ship things out. You'll make sure that things are packed well, clearly labeled, and generally easy to deal with. Finally, having that experience can land you a job working for a museum, not-for-profit, or commercial gallery space. All of which are viable employment options so you can make rent while you're waiting for your MacArthur Grant." **Jason Lahr, artist and curator of exhibitions, South Bend Museum of Art, South Bend, Ind.**

a day painting for someone else, you could feel pretty drained when it comes to your own studio time. And then there's the constant reminder that you're spending most of your time working on someone else's ideas. At some point you may have to face the difficult choice between a steady job and developing your own practice. Know your limits. Some artists can handle this kind of work for many years; others don't last a month.

Teaching is probably the most popular day job because it is an extremely rewarding way to develop your practice. (It also appears to be the only line of work tolerated by gallerists who don't want artists working day jobs.) You share your knowledge and experience with a group of enthusiastic artists; you learn more about your subject matter than you knew before; you revisit the fundamentals of your discipline. That said, teaching isn't for everyone. Just because you can do something doesn't mean you know how to teach it. It requires a completely different set of skills, a significant amount of preparation, and a ton of energy. If you're not going to inspire your students and be inspired by them, you're not going to enjoy the experience.

Art handling at a gallery or museum is a favorite day job for many artists, and not just because you learn how to professionally pack and ship art. You meet a lot of people in the art world and work directly with gallerists and curators. You get to see firsthand how shows are organized. Since many of these positions aren't full-time, you can set your hours. And the access can't be beat: all the curators we spoke with—even the most sought-after, time-pressed museum stars—said they would happily look at the portfolio of an art handler they had worked with. (The training is usually on the job, by the way, so the only way to learn how to do it is to get the job.)

While other art world jobs can fuel your practice, you need to be realistic about what kind of atmosphere you can function in without losing your drive. Working as a museum guard puts you in an inspiring environment and doesn't sap a lot of energy. Sitting behind a gallery desk can do just the opposite. If you really want the gallery experience, make it brief. Learn what you need, meet people, and move on.

There's something to be said for a job that is simple and has nothing to do with the art world, such as a restaurant shift. If you go in this direction, look for work that gives you a mental

break from your practice and doesn't require a lot of transition time between the job and the studio. And aim high: think expensive restaurants and law firm data, not a diner shift or minimum-wage temp job. The more you make an hour, the less time you have to spend away from your studio.

Whatever kind of day job you decide to get, remember that it is just that—your day job. It's not your real job and it doesn't dictate your identity.

WHO DOESN'T LOVE PAPERWORK?

This is why you became an artist, right? To fill out spreadsheets and tally up receipts every three months? For some people, getting organized and keeping up with the paperwork comes naturally (even neurotically). For the rest of us, it's distracting and boring and not how we want to spend our time. But the more disciplined you can be about paperwork from the beginning, the less time you'll ultimately have to spend on it—and the more control you'll have over your career.

Inventory

Somewhere in your studio or home, keep a detailed list of every piece you've finished—along with a backup digital file or two. (You can shell out for an inventory program, such as ArtBase, Artsystems, or FileMaker, or use something more basic like Word or Excel.) Some people keep it old-school with an actual notebook, but that's a real pain to search, sort, and update. Whatever format you choose, include the following, along with any other relevant information, for every artwork you make:

—Title, date, medium, dimensions or duration, edition size
—Location: where the piece is now
—Exhibition history: where and when it was exhibited
—Production cost: what you paid to have the work made
—Framing: whether it is framed and how much that cost
—Price: if it ever had a listed price or insurance value in a show and whether it sold

What does "edition size" mean?

If you are making more than one of something and they are all exactly the same, you're making an edition. The total number you are going to make is the edition size. You would only be concerned with this if you make photographs, prints, videos, or multiple sculptures from the same mold.

Determine edition sizes before you make the work. That way, you can produce all the pieces in the edition at the same time to ensure they are all indeed identical. The same color looks different in "identical" prints and photographs produced at different times or on differently calibrated machines.

Most editions are small: three, five, or six. Artists keep their edition sizes small because very large editions feel more like posters than works of art. That's why there are almost never more than twenty pieces in an edition. Sculptures in particular tend to come in editions of three or fewer. Many artists pick one edition size and stick with it for an entire body of work.

If you want to buck custom and make a huge edition, go right ahead. Just have a good reason— your work is about mass consumption, say, or replication, or identity or bucking custom. Or you just want to make the work available to a large audience.

Anyone who buys or sells your work will want to know your edition size because it affects value: the higher the edition size, the lower the price of each piece. Tell your collector the edition size before you sell a piece.

————"Generally, I want artists to be realistic about what's going to happen and really have control over their careers. Even when an artist has a gallery, it worries me when they say 'yeah, my dealer has that. I don't even know what my résumé has on it anymore.' Have your stuff together. Have control of where your work is, what has gone. Have control over your images. Be in charge. It's your career and your life." Eleanor Williams, art advisor, curator, former gallerist, Houston

—Sale information: who sold it, who bought it, when and for how much
—ID number: to reference the piece

Under "medium," write down all the materials you used, not just "mixed media." You want the most detailed record possible in case you need to fix, re-create, or explain the work later.

Keep a separate record for each piece in an edition and for every artist's proof (AP). For example, if you have an edition of three with two APs, then 1/3, 2/3, 3/3, 1/2AP, and 2/2AP all get their own record in the inventory system or line on your spreadsheet.

Even if you have a gallery that tracks your inventory, keep another record yourself. Be in control.

IMAGE	ID#	YEAR	TITLE	MEDIUM	DIMENSIONS	EDITION	LOCATION
	1	2009	Untitled 3	graphite on paper	30 x 40		Studio
	2	2009	Still-life	wood, plastic, feathers	20 x 15 x 5		Mom's house
	3	2009	Landscape 5	DVD	6:22	1/3	collector
	4	2009	Landscape 5	DVD	6:22	2/3	exhibition
	5	2009	Landscape 5	DVD	6:22	3/3	studio
	6	2008	Landscape 5	DVD	6:22	1/1 AP	studio
	7	2008	Untitled	oil on canvas	11 x 14		donation

————————"I keep track of inventory formally. I tend to do inventory once a year at tax time. I go through all my folders and binders for sales for the year. I look through emails and paperwork for the name and addresses of all the collections so I know where everything went." **Stas Orlovski, artist, Los Angeles**

————————"I keep a master list. All my galleries operate slightly differently. I try to get consignment forms or periodic inventory lists so I make certain that what they have is clear in relation to what I have. It's a lot more work and I would love to give it up, but I am the only one able to look out for my own interests." **Joseph Havel, artist and director of the Core Program, Houston**

TOTAL PRICE	FRAME COST	OTHER COST	SOLD	COLLECTOR CONTACT	SOLD BY	EXHIBITION	NOTES
$1600	$400						
$3200		$600 casting					
$800			Y	Collector Name 100 Orange Street Boston, MA 12345	Gallery Name	"Title" Gallery X, Year	Sold on 4/1/09
$800						"Title" Gallery X, Year	Should be returned by 12/1/09
$800							
NFS							NFS
$1000			Y	Collector Name 100 Orange Street Boston, MA 12345	Non-profit Name	Benefit Name	Sold on 6/1/08

Sign and date all your finished work. If the piece is in an edition, include the edition number. If you don't want to sign the front, sign the back (or the bottom, if it's 3-D). Include the title if you have space. Once you have a gallery, it should use its own label in addition to your signature. Until then, you should label it yourself. Here's a sample:

Artist Name
Landscape 2, 2009
c-print, edition 4/5
20 x 24 inches
ID 35

Artist Name, 20 Pineapple Street, Los Angeles, CA 90001
555-123-4567 info@artistname.net

There are a number of conventions when it comes to signing work:

—Frames, stretchers, and mattes may be separated from the art, so sign the actual work and not an accessory to the work.
—Paintings: Use paint to sign the front or back.
—Photographs: Sign with a soft pencil, acid-free pen, or china marker. (If you permanently mount a photo, sign the back of the mount.) Don't ever use a Sharpie or permanent marker to sign a photograph. The ink will eventually bleed and leak through the image.
—Drawings: Use whatever drawing material you used for the drawing.
—3-D work: Sign or etch your signature on the bottom of a sculpture.
—Slick surfaces: Etch or use an archival sticker.
—Textiles: If you can't sign the textile, attach a signed tag.
—Videos: Sign the actual disk and case with an archival pen or marker.

If there is really no way to sign the piece (because it's an installation, for example, or a performance, or whatever), create a "certificate of authenticity" and give it to whoever buys the piece. To prepare a certificate of authenticity, describe the piece in

detail on a single piece of paper, list your contact information, and sign and date the document. Here's a template:

```
                    LETTERHEAD

              CERTIFICATE OF AUTHENTICITY

                   ┌──────────┐
                   │          │
                   │          │
                   │   IMAGE  │
                   │          │
                   └──────────┘

                    ARTIST NAME
                  Landscape 2, 2009
                 c-print, edition 4/5
         Edition consists of 5 prints and 1 Artist Proof
                    20 x 24 inches
                       ID 35

         _____
                  Signature of Artist

         This document certifies that the piece described above
               is an original artwork by Artist Name.

         Artist Name, 20 Pineapple Street, Los Angeles, CA 90001
                  555-123-4567 www.artistname.net
```

Images

Keep high-quality digital images of all your work. That means an original, unedited image of every piece, as well as detail images of any large, complicated, or textured pieces. Make sure your images look professional. If you're not confident taking your own images, pay someone else to do it for you. Maybe one of your photographer friends will help out for an in-kind trade or a few drinks.

——————*"I think the size of the signature is inversely proportional to the quality of the work. The bigger the signature, the suckier the painting is."* **Kelly Klaasmeyer, critic,** Houston Press, **and editor of glasstire.com, Houston**

——————*"I always hear 'my work is really hard to show in an image.' Of course it is! But you absolutely need to find a way to make it presentable in an image. It's how you first get your work out there. That's true for video and painting and any medium.*

"I did sculpture in glass. It's really hard to photograph, so I had to learn how to do it, and when I could not do it myself, I sought out someone who could. If it's impossible for you to photograph, pay that extra money to have a professional do it." **Hillary Wiedemann, artist and former gallery manager of Artists Space, New York**

Always shoot the greatest resolution possible. Scan small drawings (as long as scanning won't damage the drawing, of course). And match each image to its inventory record. The easiest way to do this is by using the same number for an image as its ID number.

You can resize each image for press, printing, email, and your website. Right now, the ideal resolution and size for press and printing are 300 dpi and 8 x 10 inches. A 72 dpi, 8 x 10 image will do for most other purposes.

The image of your piece should fill the entire frame of the photograph. If it can't—say, for example, you're photographing a narrow painting—then shoot your piece against a neutral background.

Because it is so crucial to make high-quality images of your work, you really need to learn how to retouch and adjust the color of your images with image-editing software such as Photoshop or Illustrator. Don't risk letting poor images sink your chances for a studio visit, grant, or other opportunity. At the same time, doctoring an image so much that you misrepresent your work will only disappoint (or infuriate) the person you're trying to win over.

Document your work at group and solo exhibitions. Usually the venue will do this and give you copies of the images, but don't count on it. Ask ahead of time in case you need to take care of it yourself. And even if the venue will take care of it for you, look at the images before the show is over in case they're not done the way you want them done (that is, while there's still time to reshoot).

Registering Your Copyright

When you make something original, you automatically own the copyright to it, meaning no one else can copy it without your permission. (There are exceptions to this rule, but that's the overall gist.) You don't need to register your copyright, in other words, to be protected by copyright law. But it's pretty cheap to register and you're much better off if you do.

As this book goes to press, it's only thirty-five dollars to register your copyright if you register online. (It's forty-five

dollars if you use snail mail.) And you can register an entire body of work at once; you don't have to pay separately for each image. File the Form VA (that's for "visual arts"). The U.S. Copyright Office's website has user-friendly instructions on how to file and long, helpful lists of frequently asked questions.

So why are you much better off if you file?

Let's say a gallery puts one of your drawings in a group show and a year later you walk into a store and see an exact reproduction of your drawing printed on a stack of T-shirts. Whoever made those shirts violated your copyright (or "infringed" it) and the law entitles you to stop them, or get paid for the shirts if you're okay with them being out there. Of course, there's no problem if you don't mind the shirts and can work something out with the shirt maker, such as getting credit or getting part of the profits. But if you do mind those shirts being sold, or the shirt maker won't give you the time of day, then the only way to protect your copyright is with a lawyer. And lawyers aren't cheap. Even hiring one to write a nasty "cease and desist" letter will run you hundreds of dollars; following up on the threat can cost thousands. (As we explain at the end of this chapter, depending on your financial situation, you *may* be able to find a volunteer lawyer to take your case. But you can't count on that.)

Now, the law requires you to register your copyright before you file a lawsuit, so if you *didn't* do that before you discovered those shirts, you'll have to register to bring a case against the shirt maker. And while you're allowed to register your copyright after someone infringes it, your case will be harder to prove (and therefore more expensive) than it would have been had you registered your copyright before anyone infringed it. Unless you have a lot of money to burn, you can only afford to bring the case if you think you can win at least enough to pay your legal bills. But to do that, you'll have to convince a judge that you suffered "actual damages," meaning the copyright infringement caused you to lose money or diminished the value of your reputation. This is not easy to prove.

If you did register your copyright as soon as you finished your body of work, it'll be easier to prove your case in court; the shirt maker may have to pay your legal bills if you win; and instead of having to prove "actual damages," you'll automatically be entitled to a certain amount of money for each instance of

Do I need to use the © symbol?

Technically, U.S. law protects your copyright in an image whether you slap a copyright notice on the image or not, but it doesn't hurt to use one anyway. Think of it as a bike lock: it won't stop thieves intent on stealing your bike, but it will keep honest people honest. While there's no single format for a copyright notice (if you decide to use a notice at all), a common one looks like this: © 2008 George Boorujy. Also common is the expression "all rights reserved." When people reprint or republish an image of yours, they should include the phrase "courtesy of [your name]" under the image (assuming that they have your permission).

For more background on copyright protection, go to the website of Creative Commons, a nonprofit organization that promotes progressive copyright policy. It has helpful explanations of the different levels of copyright protection that you can choose for your work and instructions on how to use the corresponding copyright notice.

infringement (in other words, for every T-shirt). Not bad for thirty-five dollars.

Press

Save every article written about you—even the ones that only mention you in a list of other artists. Keep an original copy and a scanned copy of every clipping, including the publication name, author, title, date, and page number. You can post scanned articles on your website or include them in submission packages (with proper credit). You should even keep an original copy of bad press because you may want it later; you never know. Check out chapter 3 for more on preparing press clips.

Contacts

Keep the email and contact information of everyone who has:

—bought your work
—expressed interest in your work
—visited your studio
—written about you
—shown your work
—sold your work

Add these people to your postcard and email lists. Make sure all your mailings go to curators, collectors, and press, in addition to friends and family. It never hurts to gather the addresses of your dream dealers, collectors, curators, and press contacts in case you have a reason to reach out to them about something—but don't add people outside the categories above unless your project is about annoying strangers. The idea is to grow your list organically, starting with friends and family and slowly expanding as you meet more people. A random gallery's mailing list wouldn't help you as much as the list you've created of people who already know you and your practice.

Always blind carbon copy (BCC) on mass emails. Collectors and curators tend to guard their email addresses—they do not want you sharing them with a bunch of strangers. And galleries can get pretty competitive with one another, so you don't do yourself any favors by broadcasting the names of all the galleries you're interested in. Besides, no one but you needs to know how big your email list is. Bottom line: be discreet.

Receipts and Expenses

Keep your receipts. You'll be glad you did when it's time to file your tax return. (Just for the record: *file your tax return*.) Your receipts will also help you price your work, since they reflect all of your costs.

Hold on to the receipts for anything directly related to your career, such as:

—Supplies, materials, and equipment
—Framing, printing, and production
—Documentation of your work
—Studio rent and utilities
—Refreshments for open studios
—Meals with art world colleagues
—Travel to shows, fairs, and other art world events
—Food and accommodations at art world events out of town
—Subscriptions to art magazines and periodicals
—Museum memberships
—Books on art or any topic related to your work
—Courses on art or any topic related to your work
—Residencies
—Submission fees
—Website and business cards
—Shipping
—Postage and postcards
—Car expenses
—Work done by assistants or vendors

When in doubt, keep it and consult your accountant about it later. If you don't plan on getting an accountant, read the last section of this chapter, where we tell you to get an accountant.

Because your income as an artist isn't steady, it's better to file your taxes quarterly. This requires you to project your annual income, which you do based on your current, quarterly income. So you'll save yourself major headaches four times a year if you take a little extra time each month and track your income and expenses in a chart. Make one table for your income (whether related to art or not) and one for your art-related expenses. Divide each chart into categories that make sense for

If you have a car and use it for anything art-related, keep track of your art-related mileage. Your accountant will use that mileage to figure out how much of your car expenses you can deduct from your taxes.

If you lose a receipt, write one out by hand as soon as you realize you lost the original. Include the date of purchase, the item, the amount, and what you bought it for.

When you hire people to assist you in the studio, you can deduct from your taxes the amount you pay them for their help. Make sure you get their full names, addresses and Social Security numbers, have them fill out a Form 1099 and file them with the government. (You can find the form on the IRS's website or buy a user-friendly packet of them—with instructions and preaddressed envelopes—from an office supplies store.)

Tell them right from the beginning that you're reporting the amount you pay them so they know it's not under the table.

you, given the kind of work you do and the kind of expenses
you have. If you only make paintings and drawings, for example,
and you have a part-time job as a graphic designer, your income
table should have a column for paintings, a column for
drawings, a column for day job, and a "total" column, like this:

INCOME				
DATE	DRAWINGS	PAINTINGS	DAY JOB	TOTAL
2/28	$250	—	—	$250
3/15	—	—	$2400	$2400
3/22	$200 $1400	$4300	—	$5900
TOTAL	$1850	$4300	$2400	$8550

For your expenses chart, include the major categories of
your expenses that correspond to what you'll tell the government
when you file your taxes. For example, you might want
seperate columns in your chart for studio (rent and utilities),
materials, travel, shipping, and food and entertainment.

ART EXPENSES						
DATE	STUDIO	MATERIALS	TRAVEL	SHIPPING	FOOD AND ENTERTAINMENT	TOTAL
2/9		$95			$30	$125
2/27	$700	$320				$1020
3/5			$105	$50	$45	$200
3/27	$700					$700
4/5			$105	$50		$155
TOTAL	$1400	$415	$210	$100	$75	$2200

Add categories if you have other types of expenses and leave off categories that you don't need. The point is to track your actual expenses in a clean and easy way, not to think up as many hypothetical categories as possible.

When it comes time to file, your accountant will transfer the information on your chart to a "Schedule C" (for self-employment), so you can also just use the categories from a Schedule C if you want. You don't have to, though; think of them as "suggested" categories. If it's easier for you to categorize your expenses in a different way, do that and let your accountant recategorize them for the IRS. Here are the Schedule C categories, with the most relevant ones bolded:

—**Advertising**
—**Car and truck expenses**
—Commissions and fees
—**Contract labor**
—Depletion
—**Depreciation** (that is, of the value of equipment)
—Employee benefit programs
—**Insurance**
—**Mortgage**
—Legal and professional services
—**Office expenses**
—Pension and profit-sharing plans
—**Rent or lease**
—Repairs and maintenance
—**Supplies**
—Taxes and licenses
—**Travel, meals, and entertainment**
—**Utilities**
—Wages
—**Other**

We recommend getting a separate credit card for your art expenses and charging all your art-related purchases with it. That way the credit card company will keep track of your expenses as well. This only works if you're disciplined about charging all your art expenses to the card and *not charging* any unrelated expenses, which should go on a different card.

—————"You should hang an envelope on the closet door and every time you walk in the house, empty all your receipts into it. And when you get receipts, make sure it says something that will ring a bell to you later. What was the $7.32 for? Was it a pack of cigarettes or a book?

"But what you really should get into is a simple kind of bookkeeping. Everybody these days has a computer and if you know any of the number programs like Excel, you don't have to buy a special program." *Joy Harvey, tax preparer, New York*

—————"The government gives you a lot of tax advantages, as it gives all businesses. In exchange, it wants you to be businesslike. You might not think of your studio as a business, but the government does." *Joy Harvey, tax preparer, New York*

(It also only works if you always make your payments. Debt is beyond the scope of this book: we don't want to get into it, and neither do you.)

Invoices

Set up an invoice form that you can quickly fill out and print as needed. Keeping invoices for every piece you sell is the easiest way to track your sales. It also shows your new collector that you're serious (even if it's your mom). Don't forget to keep a copy for yourself.

Once you have a gallery, it will take care of sales for you and you should stop selling your art yourself unless your gallery tells you it's okay. (More on that in chapters 5 and 13.)

We made a couple of sample invoices for you, which you'll find at the end of this section. While you can use our samples as they are, you should think of them as basic templates to tailor to your style. See our explanations of each item we include and decide for yourself what you want to use and what you don't.

Basic Invoice
A bare-bones invoice needs these items:

1. Date
2. Your name, studio address, work phone, and email
3. Your collector's name and address
4. Title, date, medium, dimensions or duration, and edition
5. Price, shipping, sales tax, and total

We recommend adding a thumbnail image of the work. Thirty years later when you're gathering your pieces for a retrospective, you won't be scratching your head trying to remember what "Untitled (vernacular)" was. Some galleries also include interesting provenance details—that is, the piece was in this show or that magazine.

Extras

There are a bunch of other things you can put on an invoice to clarify expectations. Whether to include them is mostly a matter of personal style, since you need to balance protecting yourself, on the one hand, against demanding "too much" from someone you hope will buy more work from you later.

Even if you don't write these items into your invoices, you should understand the issues surrounding them and get comfortable talking about them. It's the only way to avoid unhappy surprises later down the line.

Legal Title

Legal title doesn't refer to the name of an artwork but rather who owns it. Say a collector visits your studio, falls in love with a $700 drawing, and buys it from you on the spot (with cash, no less). The second she gives you the money, the collector becomes the owner and title "passes" from you to her—that is, if she pays you the full $700.

In the real world, of course, few people pay right away. And if you're partially paid—she gives you $350 now and plans to pay you another $350 in a month—you only keep title to the drawing for as long as you actually hold on to it (that is, keep it in your studio or home or wherever). By letting your collector take the piece away, you're giving her title to it—even though she hasn't fully paid you! She still owes you $350, but you don't own the piece anymore.

It is easy (and lawful) to get around this default title rule. All you have to do is state on your invoice:

Title will not pass until full payment is received.

To make it more direct, you can write:

Title will not pass to you until I receive full payment.

Either of these sentences makes clear that you are not letting your collector become the owner of the piece—even if she's already taken it home—until she's paid for it in full.

Another straightforward way to prevent title passing before you're fully paid is to keep the work until you're fully paid. Many galleries choose to do this, stating on their invoices:

The work will not be delivered until full payment is received.

Again, to be more direct you can state:

I will not deliver the work until I receive full payment.

This is more of a symbolic protection than a strictly legal one, in the sense that it's only as effective as you are willing to act on it. When you're first starting out, the excitement of selling work— or the desire to please a new collector—can easily overpower any notion of protecting yourself from hypothetical trouble down the road.

The idea in either case is to avoid a situation where you don't have your piece anymore and your collector is dragging her feet in paying you for it (with nothing but her conscience as motivation to pay).

Insurance
Art gets damaged during shipping all the time, and when it does, guess who doesn't want to pay for it? The collector who bought it from you. We've heard some *nasty* stories about collectors blaming artists and galleries for damage that happened after work was shipped—and by "blaming," we mean hiring a lawyer and threatening a lawsuit.

The way to deal with that is to make it clear up front who has to cover such accidents (in legalese, who "bears the risk of loss") by adding this line to your invoice:

Insurance in transit is the purchaser's responsibility. (Or, "As the buyer, you are responsible for insurance in transit.")

Of course, packing your art well minimizes the risk of damage. See chapter 9 for practical packing and shipping tips.

Payment Terms

Sometimes collectors forget that you actually *need* the money. Don't be afraid to suggest a time frame:

Payment is due within 30 days of receiving this invoice.

Shows

Collectors understand that there may be a time in the future when you want to include sold work in a show. Some artists like to make this explicit in their invoices, with something along these lines:

You agree to allow me to borrow this piece for exhibition in a show at a museum, gallery, or similar space.

Adding this to an invoice is touchy because it places a future burden on the collector. Many gallerists, for example, feel strongly that once a collector buys an artwork, she should be allowed to do (or not to do) whatever she wants with it.

Others think that it is appropriate to raise the topic in a conversation but too aggressive to put anything in writing. As a practical matter, a collector who doesn't want to lend work to a show because she doesn't want to risk damage to the work (or for any other reason) isn't going to lend the work—regardless of what you wrote in your invoice.

According to most gallerists, collectors are typically quite willing to lend work to an exhibition when the institution pays for shipping (this is standard) and they are acknowledged in either a brochure or wall label. The only time collectors pass on such opportunities is when the work is fragile and the risk of damage is high. In those cases, the work probably shouldn't travel anyway.

Copyright

When you sell an artwork to a collector, you're only selling the piece—not the copyright to it. To stick with our example, that means your collector owns the $700 drawing and can hang it wherever she wants, give it to whomever she wants, etc. But she can't use it to make mugs and posters to hock online; she can't sell a copy of the drawing to a clothing company; she can't put the image on her business cards. Only you can do those kinds of things, if you want to, because you have the copyright to the artwork you make—and you keep that copyright after you sell the work.

This is true whether you say anything about it or not in an invoice, but some artists and gallerists add a note just to make sure the collector understands what she's buying (and what she's not buying). Something along these lines:

I retain full copyright in the work.

Resale

Someday down the road, your collector may want to sell your piece. As we explain more fully in chapter 13, depending on where you live, you might be entitled to part of the resale price. Or you may just want the chance to buy your piece back.

—————"It's your art, but there are a couple of areas, like taxes, where your freedom can be taken away and the protection of the art is really important.

All of your effort, even if it's not sticking it to the man or running counter to the culture, is a way of maintaining independence. If you keep all your records and maintain a general knowledge of everything, it's a certain type of independence."

Michael Joo, artist, Brooklyn, NY

Because many new collectors either do not understand the repercussions of resale on an artist's career or do not know the expectations upon resale, some galleries add something like this to their invoices:

I reserve the right of first refusal if the work becomes available. (Or, "I reserve the right of first refusal if you decide to sell the work.")

A friendlier—but more ambiguous—approach:

Please let me know if you are going to resell this piece.

Acknowledgment

Finally, you want your collectors to agree to whatever items you've put in your invoice. You can do this either by including a signature line at the bottom and asking them to sign the invoice (keep a copy of the signed invoice for yourself) or by adding this line to the bottom of the page:

Receipt of payment acts as acknowledgment of these terms. (Or, "By paying the amount listed above, you agree to the terms in this invoice.")

Here are two sample invoices. The first one has the bare minimum and the second is an example of how you can add more terms.

LETTERHEAD
Contact Information

September 23, 2009

Sold to:
Collector Name
4567 Sunshine Blvd
Los Angeles, CA 90210

Invoice # 00100

IMAGE

Artitst Name
Landscape 2, 2009
c-print
20 x 24 inches
edition 4/5
ID 35

$ _____

subtotal _____

shipping _____

tax _____

total $ _____

September 23, 2009

Sold to:
Collector Name
4567 Sunshine Blvd
Los Angeles, CA 90210

Invoice # 00100

IMAGE

Artist Name
Landscape 2, 2009
c-print
20 x 24 inches
edition 4/5
ID 35

$ _____

subtotal _____

shipping _____

tax _____

total $ _____

Payment is due within 30 days of receiving this invoice. The work will not be delivered, and title will not pass, until I receive full payment.

As the buyer, you are responsible for insurance in transit. I retain full copyright in the work. You agree to allow me to borrow this piece for exhibition in a show at a museum, gallery or similar space.

I reserve the right of first refusal if you decide to sell the work. By paying the amount listed above, you agree to the terms in this invoice.

By the way, don't sell everything you have. Keep at least one piece from each body of work; resist pressure from your gallery and your collectors to sell your artist proofs. Being able to look at your old work (and not just an image of it) lets you see how you've developed. It can anchor your perspective and inform your current work. It may also be worth something someday.

HELP!

Some things you really shouldn't do yourself. Open-heart surgery, for example. Even if you understand the principle of stabilizing a broken leg, plaster casts are best left to the experts. So it is with insurance, taxes, and legal problems.

Health Insurance

Get it. We know, we know—no one else bothers. It's way too expensive and you're always really careful, so what could possibly happen? A lot of horrible things that we'd rather not dwell on. The sad fact is that even the less horrible things can be really, really expensive.

 Try to get health insurance through your day job. If it's not the kind of job that offers benefits, look up organizations such as the Freelancers Union or local insurance options for freelance workers and artists. Fractured Atlas also has a national health insurance plan for artists. Depending on what state you live in, you might qualify for state-subsidized health insurance.

Renter's Insurance

This may not seem like an absolute necessity but you should treat it like one. It is not very expensive and if you ever need it you will feel like it saved your life. It basically covers all the stuff in your apartment or studio. If you're a victim of theft, fire, or a few other calamities, the insurance company cuts you a big enough check to replace everything that's gone. This will never

—————"Artists should always hold work back. Always keep examples of your work from different periods." *George Adams, George Adams Gallery, New York*

—————"I see artists selling their last artist proof. To the right institution it may be okay if that's what you want, but you may want to hold on to it for ten to twenty years. I am right now looking at work by artists who have pieces from the '60s and '70s that they held on to. I've had artists tell me they keep one piece out of every show and I think it's a smart thing to do." *Anne Ellegood, curator, Hirshhorn Museum and Sculpture Garden, Washington, D.C.*

—————"They must hold work back! It's very important to keep at least one artwork from every series. It's their pension fund and their history. They need to have work in their studio that is not for sale. Ever. It's good for them and their visitors to see the progression and the transitions. Money may seem more important than keeping artwork in the short term, but holding work back in the long term is very important." *Micaela Giovannotti, critic and curator, New York*

bring back your lost artwork but it will cover your equipment and supplies. If you have a sales record, it could also get back the retail value of the lost work.

Be sure your policy is for "replacement value," which means that if the brushes you bought two years ago for $30 now cost $45, your policy gives you $45 (since that's how much it is to replace the old items).

Also make sure they know you are insuring artwork. Many companies will do it, but you have to purchase a special rider for artwork and get an appraisal from a local gallery or arts professional.

Taxes

A lot of artists cringe at the idea of paying someone to do their taxes. But a good accountant will *save* you money. (And time, and frustration.) The IRS considers you a self-employed freelancer, which makes your taxes more complicated because it requires extra reporting forms and itemized lists. Just figuring out which forms you need to submit can be a time-consuming and con-founding exercise, never mind actually trying to calculate a year's worth of deductible expenses. And if you sell directly from your studio, you need an accountant to help you determine when to charge sales tax, how much to charge, and how often to report it. (The rules and rates vary state to state. While much of the information is available online, it is hard to find and harder to parse.)

There are accountants who work primarily with creative people—artists, actors, writers, entertainers—and who will therefore understand your situation, know the proper deductions you can take, explain how much you need to earn in sales to write off certain expenses, and generally maximize your after-tax income without running afoul of the IRS. Ask your artist friends who they use; look for accountants in your area who specialize in the creative fields. While many national chains advertise low rates for standard tax returns, they can easily end up more expensive for artists because of the number of specialized forms needed.

Legal Problems

If you get entangled in a legal dispute, get a lawyer. Do not try to handle the situation by yourself. (*Do* try to avoid legal disputes altogether, by resolving disagreements before they get out of control. But if someone serves you with legal papers, it's time to get help from a professional.) You should also seek legal advice when it comes to contracts, leases, or any other arrangements that may land you in trouble if you don't do them right in the first place.

One of the silver linings to being a struggling artist is that you will likely qualify for free legal assistance (also called "pro bono" legal assistance because lawyers think Latin makes them sound smart). In bigger cities, you can often find volunteer lawyers for the arts willing to help artists look over a contract or get out of a jam. If there isn't a volunteer-lawyers-for-the-arts organization in your city, you may still be able to find pro bono help through the bar association.

Speaking of legal problems: If I want to use other people's images in my work, how can I be sure I'm not infringing their copyright?

Unfortunately, you can't—until, that is, you've been hauled into court and vindicated by a judge or jury. Short of that, the safest course is to get legal advice about your specific question. Short of *that,* you're rolling the dice.

A major misconception is that you're in the clear as long as you "change more than 20 percent of the image" or "enlarge the image by at least 30 percent" or do anything else with it by *x* percent. Not true.

The law generally requires that you "transform" the image, but courts around the country have interpreted that word differently. One court recently said that "transform" refers to the *purpose* behind the change, rather than its physical nature. It's not whether you tripled the size of someone else's photograph, or even turned it into a painting; it's how the purpose behind your work differs from the purpose behind the original. But that's just one court's opinion, and there may be a new standard by the time you read this book.

If you get permission to use the original image, you're home free. That's what licenses are: formal permission slips from copyright owners that allow others to use images protected by copyright. You usually have to pay for a license, though, and you can't force someone to give you one.

The only other safe route is using images already in the "public domain," meaning no one has the copyright to them anymore. But figuring out whether something is in the public domain is complicated; despite what you may have heard, it isn't as straightforward as "anything before 1930." Once again, you really can't be certain without consulting a lawyer.

————"Artists need to see shows they like and shows they don't like. So many artists won't see something because they don't think they'll like it or they think theirs is better. You need to see everything! You need to know why yours is better. See everything and figure out where you fit in and why you fit in." *Steven Sergiovanni, director, Mixed Greens, New York*

————"Never underestimate the power of the artist network." *Kerry Inman, Inman Gallery, Houston*

————"Your work needs to be strong and come first and be clear, and you need to know exactly what you're doing, or at least have some direction. But clearly, as a young artist, you have to really understand the way the art world social machine works." *Tim Blum, Blum & Poe, Los Angeles*

————"It is very important for artists to become involved in their community. That will help them figure out who they are. Go to shows. Meet people. Make connections to people doing grassroots projects. Be friends with your peers who are just starting galleries, curating independently, getting their PhDs in art history, starting to write for a local magazine, or just starting a blog.

"That should be a really important part of their social life because those people grow up. They have commercial galleries, become curators in major institutions, and become serious academics." *Shannon Stratton, artist and director of ThreeWalls, Chicago*

STAYING CONNECTED

It is vital to stay connected with the art community. You need to know what's out there and to view it in person whenever possible. Visit galleries and museums every month, subscribe to at least one contemporary art magazine, and talk to artists, curators, gallerists, and critics about what they're working on. Just as important is getting regular feedback on your work—and the best feedback comes from your peers.

Professional opportunities in the art world almost always come out of personal connections, and community—almost by definition—is the way to make them. That's not a prescription for superficial networking or obnoxious self-promotion, neither of which will get you anywhere (even if you enjoy that kind of thing). It means realizing that the chance to get a piece into a group show or meet a gallerist will probably come through someone you know and respect, who knows and respects you.

Depending on your temperament, building community can feel daunting, artificial, or fun. There's no need to subject yourself to awkward conversation at stuffy cocktail parties. Just keep in touch with your friends and professors from art school, attend local openings, and be open to meeting new people at events. (If you're shy, bring a friend along. It's easier to break your way into conversation when you have a sidekick.) See chapters 5–7 for more ways to build your own community.

CHECKLIST: GROUNDWORK

—SCHEDULE
—STUDIO
—DAY JOB
—INVENTORY
—IMAGE FILES
—REGISTER COPYRIGHT
—PRESS CLIPS
—CONTACTS LIST
—RECEIPTS
—INVOICE FORM
—HEALTH INSURANCE
—RENTERS INSURANCE

—————————"Stay focused on creating your work. At certain stages in your creative process, it is often helpful to have other artists, curators, and writers in your studio; that dialogue can be part of a generative process. Of course, some of your time will likely be spent at your friends' openings and gatherings, supporting their work as they would yours. That ratio should be respected, not inverted, and with that balance, often things can happen." **Sarah Lewis, curator and critic, Yale School of Art, New Haven, Conn.**

—————————"I encourage college-aged artists to stick together. If you want to form a generation, you have to make it yourselves. The important thing is not to be associated with your college in ten years. You want to be known by what you have done together, after school ended." **David Gibson, curator and critic, New York**

—————————"I think the idea that artists are competing against each other is a fallacy and it actually doesn't help them. I'm sure there are intense competitions between artists, but every artist has a different career. We all have a different trajectory. I share information because I am not competing with them." **Leah Oates, artist, Brooklyn, N.Y.**

—————————"Start with the community you know, who knows you, who's interested in whatever it is that you've put together with your work or your gallery space or your magazine or your band or your performance series. Start with who you know and build from there.

"I think it's about working in a way that's true to yourself and that allows things to happen naturally, with bits of prodding to bring new people into contact with what you do." **Peter Eleey, curator, Walker Art Center, Minneapolis**

CHAPTER 3
——————— Submission Materials

People in the art world *love* seeing art in person. It's why they do what they do. Still, there are many reasons they'd rather see a submission first. Here are a few:

—*Time.* Many submission reviews are consolidated and scheduled. If everyone reviewed work in person every day, there wouldn't be time to do anything else.

—*Logistics.* Rarely is one person the sole decision maker. Usually a few people need to get together to make important evaluations.

—*Sensitivity.* Most arts professionals want to digest the work and give it a few moments to sink in before stating an opinion. Having you there forces a rash judgment.

And now a few reasons why *you* shouldn't want anyone to look at unsolicited, original artwork:

—*Perception.* Walking into a gallery with unique artwork creates the illusion that you don't care if your pieces get damaged. Curators, gallerists, and collectors think of artwork as precious. You should, too.

—*Loss.* If you bring actual artwork and leave it for someone to review, you may never see it again. Accidents do happen.

—*Self-respect.* Do you really want to hear what they think when you arrive unannounced and give them no time to prepare?

Just about every professional opportunity you come across will begin with some sort of submission. Residency programs and foundations require specific application materials; galleries often ask for "standard packages"; a curator may just want to see a few images of your current work. Whatever the request, you'll need to submit at least some of the following items: images, a résumé, press clippings, a statement, and a cover letter. Rarely, if ever, will someone ask to see actual artwork as the introduction to your practice. That's why your submission is supposed to give as accurate an idea of you and your work as anyone could get without doing a studio visit.

Because most of these materials take time to prepare well, you should start working on them now and keep them up to date as your career progresses. Don't wait on this! Your submission will often be the first impression you make, the first exposure someone will have to your work, the first chance to make a sale. Creating solid, professional submission materials will therefore save you a lot of time and stress down the road. Sometimes you'll learn of an opportunity at the last minute and will need to rush an application out the door. Or you might meet a dealer who unexpectedly asks to see your work. This is *not* when you want to compose an artist statement from scratch or confirm the spelling of all the names in your résumé.

Expect to tailor every submission for every application, since each one will be different. Even if you're applying for the same residency for the third year in a row, for example, you'll need to update your images to show how your work has developed.

Because some places ask for digital submissions while others prefer physical ones, you need to have both ready to go. Your digital materials are just that: digital files that you can easily email or upload. Your physical materials are hard copies that you can print from your digital files.

Here are the most common components of a submission for galleries, residencies, and almost anywhere else you'll be sending work. See chapter 6 for additional materials you need to submit when applying for grants and residencies.

——————"Artists always ask me what the curators want to see. I'm always confused by that question. They want to see your work represented well. Just be honest with your work and yourself."

Hillary Wiedemann, artist and former gallery manager, Artists Space, New York

IMAGES AND CLIPS

When a curator visits your studio, your art is what matters
most. So too with a portfolio: when a jury reviews your application,
the images of your work are by far the most important part.

Images of 2-D and 3-D Work

You already have images of all your pieces because you read
chapter 2. Now you need to pick ten to twenty images of your best
work. If the work's surface is important—say you make very
intricate or three-dimensional pieces—we recommend creating a
portfolio with a mix of full shots and detail images. If the
scale and context of the work is important, consider selecting a
few installation shots.

Include current work only (that is, finished pieces from your
most recent body of work). If older work is necessary for
context, include one or two older pieces. But in the vast majority
of cases, your current work will create the strongest
package. People want to see that you are in the studio right now.

The days of slides are over, though a smattering of places
still ask for them. If that happens, look online for places that will
convert your digital files to slides. There are many companies
that will do it at a low cost.

Once you have your images, learn how to resize them on your
computer and adjust the resolution. You should keep at least two
sizes of each image on your computer, ready to go:

1. A 300 dpi, 8 x 10 inch image, which you'll use for printing and
 sending to the press.
2. A 72 dpi, 8 x 10 image that you can email, put on a disk for
 submissions, post to your website (see chapter 4), and show
 people on your computer (see "Studio in a Box" in chapter 5).

Ideal file sizes will change, of course, as email and Internet capa-
bilities grow.

Don't forget to label your digital images when you email
them. Include either the title of the piece, your name, or both in

What is a standard package?
Sometimes galleries ask for a "standard package"
without explaining what that means. If you're
too shy to ask, you can assume they expect ten to
twenty images (printouts *and* burned on a
disk), a résumé, press clips, a cover letter, and a
SASE (self-addressed, stamped envelope).

It's common to refer to original artwork as a
portfolio, but when people ask you to send over your
portfolio they mean your basic submission
materials, not your original work. Same deal if some-
one asks you to send them "your documentation."

Always list dimensions as *height* x *width* x *depth*.

What are not appropriate to send as images?
Snapshots, photocopies, head shots, brochures, and
postcards. Only send what they ask for.

your image titles. Regardless of how you save your files, include all basic labeling information in the body of the email: title, year, medium, dimensions or duration, and edition size (if applicable).

While these are general guidelines, *ask* before you submit anything over email and send the exact size, resolution, and file type that you're told to submit. Test your files with a friend before submitting them. You don't want to send people attachments they can't open or let frustrating technical difficulties distract them from the most important thing—your work.

On a disk, you can include the label information with the image or in a separate image list. If you go with an image list, we recommend providing a printout as well as the digital copy on the disk. This lets the people reviewing your work consult your image list while looking at your images, which is more important than you might guess. Images tend to get overlooked or flat-out ignored when their dimensions or media aren't clearly indicated.

Although it is easier to understand 3-D works and installations through video documentation, your still images will have to suffice for most applications. (We assume this will change as technology improves.)

Moving Images

If you are a performance artist or "new media" artist whose work is kinetic or based in sound, video, or film, include both stills and clips in your documentation. Unfortunately, this makes your job harder than it is for artists making 2-D and 3-D work. The conventions aren't uniform, so it's more difficult to anticipate what, exactly, you'll need for any given submission. Nevertheless, there are a few things you can do in advance.

Since most applications ask for one to three video clips, narrowing down your work to your three best pieces is a good start.

You can also prepare several different versions of those three pieces and bet that you'll eventually end up submitting all of them to one place or another. The still image that represents each piece in the menu is the first impression your viewer will have of your work, so choose striking images.

Suggestions for Burning a Disk of Images

—Separate different bodies of work into different folders. Keep your résumé, artist statement, and press clippings in a folder separate from your images.

—Control the order in which your images are viewed. You can do this by beginning each file name with a number (1-Landscape, 2-Landscape, etc.). Even better—though by no means necessary—is to create a PDF or PowerPoint presentation. This allows you to determine the order of images and combine them with text, while minimizing what the viewer has to do to engage your work.

—Remember to edit. Although your disk may have a lot of space on it, do not feel compelled to fill it up. Show that you know how to edit and you know how to follow directions. The rule of thumb is ten to twenty images.

—Test the disk before you put it in the mail. You wouldn't believe how many submissions arrive with disks that do not work. Never assume the recipient will contact you for a replacement.

——————"I can think of some really wonderful artists who have not been accepted to the program because they take really terrible images of their work. Remember we are judging images, not judging work. If you are going through three hundred people's work and somebody has taken really crappy images, it takes too much sympathy to read the application and it just disappears." **Joseph Havel, artist and director of the Core Program, Houston**

——————"I tell students to submit their best images, which is not always their best work. I've sat on many panels and know that they're looking at hundreds of images in a day. Before they can seriously consider your work, you will need to get them to stop clicking the projector. You need to have great images. Maybe you can sneak in a crucial piece that doesn't reproduce well (maybe it has an amazing story and you can sneak that story in) but it's very important to have strong images." **Charles Long, artist, Mount Baldy, Calif.**

——————"We ask for ten images and people will dump their laptop onto a disk. I didn't ask for two hundred images! I asked for ten and I will only look at the first ten. Unless the first ten are good, you don't have any chance. If you send me ten thirty-minute movies, I am not going to spend five hours watching your movies.

"It's not that I'm not interested in you, I just have four hundred and ninety-nine other people to look at!" **Ben Heywood, director, Soap Factory, Minneapolis**

More typically, an application will ask you to edit your works down to three- or five-minute clips. Having a three-minute and five-minute version ready now will save you a huge headache later. (If your piece is less than three minutes, sit back and relax.)

Some applications ask for a highlight reel, which is the most labor-intensive submission of all. It means compiling works in a single file, usually five minutes long. The length of each highlighted work is up to you, as are the transitions between pieces. Still, keep it simple and clean. Transitions should not detract from the clips.

When you submit a disk, make a title frame before the video starts (or just label the piece in the menu) *and* label the disk on the outside. Let the viewer see the length of the reel before it begins. And let the viewer fast-forward. A lot of artists lock their videos, aggravating a lot of curators and gallerists who have to watch a lot of videos.

Finally, ask what equipment the place uses to play DVDs and make sure your disk is compatible.

Physical Images

For a physical submission, the general rule of thumb is to print the highest-quality images on the paper that makes your work look best. Does your work look better on matte or glossy paper? Textured or smooth? These are simple decisions that could significantly impact how your work is read. But, as with everything else, the size and layout depend on what's asked for. Include your name, title, year, medium, dimensions (or duration), and edition size (if applicable) somewhere on the page with each image, or on an attached image list. We recommend trying to combine the text and image on one page if you can do it well. This eliminates another piece of paper and the risk that it will get separated from the images.

ARTIST NAME
IMAGE LIST

1. Landscape 2, 2009
 c-print, edition of 5
 20 x 24 inches

2. Untitled, 2009
 DVD, edition of 3
 5:20

3. Landscape 5, 2009
 DVD, edition of 3
 6:22

4. Community, 2009
 graphite on paper
 30 x 40 inches
 map of the movement filmed in Landscape

5. Community Response, 2009
 graphite on paper
 30 x 40 inches
 map of the movement filmed in Landscape 5

1.
Artist Name
Landscape 2, 2009
c-print, edition of 5
20 x 24 inches

Think about how you will present your images to someone. Bound together? Separate pages? In a folder? In a binder or sleeves? Don't let your presentation fall apart at the last minute! Take some time deciding what the images go in. It doesn't have to be fancy or expensive. Just allow the work to look its best and relate to the rest of your package.

Include a disk with the same images so that people who like what they see in the printout can look at your digital files for better color and detail.

RÉSUMÉ

Your résumé should list all your relevant *art* work; if it's not related to your art it doesn't belong on your résumé. Keep it clean, succinct, consistent, and easy to read. If you're at the beginning of your career, keep it to one page. No matter how

———————"When you give me a CD, it should be very concise. I get CDs with fifty images that don't look like they are made by the same artist. A nice, tidy little presentation will have a better chance of holding my interest." *Heather Taylor, Taylor de Cordoba, Los Angeles*

———————"Depth is better than breadth' is something people just don't get when applying to things. It's something that people just don't get in general. When you are applying to something, you want them to know you are the woman who paints sparrows. They don't really want to know about the cows or the other things. Yes, you can be too narrow, but they need to know you have focus and you do something well." *Christa Blatchford, artist and program officer for artist learning, New York Foundation for the Arts, New York*

much you want to cram in, don't let the font drop below 10-point. It's just too hard to read.

Before you worry about page limits, though, start by making a master résumé, or CV, which you can then tailor to specific opportunities (and shorten, if necessary). Look at artist résumés on gallery websites and see what style they use; that's the style the gallery is used to. Also look at the résumés of established artists you respect. Feel free to mimic their formatting.

And *no typos*. Seriously. Your résumé has to look professional because you're trying to show that you're a professional. So ask someone to proofread your résumé and fix those typos before you start sending anything out. An extra space between words is a typo. If you separate items with a comma, and then decide halfway down the page to separate them with a slash/that's also a typo. If you use Sentence Case for one heading and ALL CAPS for another heading, guess what? Typo.

Here are the most common sections of an artist résumé:

Contact Information

Think "need-to-know basis" here. You're not being interviewed on TV, you're just making sure the reader knows who you are and how to find you. List your name, address, phone numbers, email, and website (you really, really want the person to find you). A lot of artists list their birthplace, year of birth, and where they're "based." Those are optional.

Do not include a picture of yourself unless it is a part of your work. This is not an acting gig; a picture is just distracting and silly. Even if you're drop-dead gorgeous.

To harp on a theme, consistency matters. Pick the way you want your name to be listed and stick with it every time, down to the nickname or middle initial or whatever you want in there.

Education

Year, degree, school.

Whatever order you choose, match it to the other sections. If you start with the year here, start with the year everywhere. Don't list high school. College and graduate degrees only. Also, no need to list course work or your GPA. This is not a job application. (Except that it is, but you know what we mean.)

Solo Exhibitions

Year, title of show, venue, city, state.

List shows in reverse chronological order, beginning with any confirmed future exhibitions.

It's not just about quantity. A gallery wants to see whether you're a good fit given where you are in your trajectory. Have you shown at galleries with similar programs? Look at the résumés of the gallery's artists. Have you shown at galleries that represent artists of similar caliber? Pay attention to this when you're tailoring your résumé for a specific gallery and edit your exhibitions list accordingly.

If you've had less than four solo shows, call this section "Selected Exhibitions" or simply "Exhibitions" and put all your shows here (instead of separating group shows in a "Group Exhibitions" section) and just indicate which shows (if any) were solo exhibitions.

Group Exhibitions

Year, title of show, venue, city, state, curator or juror.

When you're starting out, people want to see that you're active and involved. It's generally better to have a bunch of shows at lesser-known places than only one show at a higher-profile venue.

As your career progresses, think of this section as a "best of" list rather than a comprehensive encyclopedia of your group shows. Include curators and mention any catalogs that were produced from the shows. Don't be afraid to lop off shows in lesser-known venues as you add new ones. Big-city commercial galleries in particular are not going to be impressed with "open submission" shows or exhibitions at retail stores, cafés, and the like. Those are good for exposure and sales, and they may be all you have at first. If that's the case, omit the word *café* or *restaurant* unless it's part of the space's official name and look around for alternative, noncommercial venues to add some variety to your résumé. (See chapter 7 for more on finding venues.)

Don't write a "goal" or "objective" on your résumé. It's an old convention from corporate America that nobody bothers with anymore because your goal is obvious: to get whatever it is you're submitting your résumé for.

What's the difference between a CV and a résumé?
A CV is a general, all-inclusive recitation of one's career. A résumé is a shorter, tailored version. You'll put your CV on your website (see chapter 4) and use a résumé for submissions.

Residencies

Year, name, location.
 Double-check the spelling!

Awards, Grants, and Fellowships

Year, name, description.
 If something isn't obvious from its title, explain what it is in a few words. Put speaking engagements and visiting artist gigs here (and name the section accordingly).

Press

Author, title, publication name, city, state, date, pages.
 For television or radio appearances, list the host, title of show, segment title, station name and date.
 Be discriminating about what you include here. Online press is also press. A well-respected art blog or online magazine is press. Your cousin's Facebook Wall is not press.
 Not everyone agrees with us that online press counts as press, though, so don't be surprised if other people advise against listing online reviews in your résumé. "Often bloggers have not gone through the rigors of training in art history or studio art, and may also lack professional journalistic experience. They frequently proffer unsubstantiated opinion," says Leigh Conner, of Conner Contemporary Art in Washington, D.C. who is not the only person who said "citing blogs on your résumé is just plain dumb."

Collections

Name, city, state.
 Don't bother unless your work is in serious collections, such as a museum's or a famous collector's. It's perfectly fine to have a résumé without a "Collections" section, especially when you're just starting out.

—————————"I look to see if an artist has exhibited in what I consider galleries of a kindred spirit. This requires the artist doing some research to pick the right ones to highlight. Check to see what art fairs the gallery does, and who also participates in those fairs that you've exhibited with. There's no guarantee you won't include someone the gallery doesn't like, but the odds of that are not so great."

Edward Winkleman, Winkleman Gallery, New York

————"You should leave everything on there as far as where you have shown, your education, and where you are from. Those are the basics that give a curator or gallerist talking points. 'Oh—you are from XYZ and went to school at that time—maybe you know so and so.' Also, at the beginning, it's most important that you are showing regularly. If you were born in 1986, no one expects you to be showing at the best places in the world." **Amy Smith-Stewart, Smith-Stewart; former curator at PS1, New York**

————"I recently did a studio visit with an artist who is midcareer and underrecognized. I looked at her CV and I was shocked to see the number of prominent museums she had exhibited in. And she did it on her own, without gallery representation. I loved her work, but when I saw her CV, I was really impressed." **Lorraine Molina, owner and director, Bank, Los Angeles**

————"I do look at people's CVs. If they've been showing for seven years and they're not smart enough to get that café or restaurant show off there, then there's probably some sort of issue. No filter." **Leigh Conner, Conner Contemporary Art, Washington, D.C.**

Related Experience

"Related" means related to your practice. Is it? Obviously waiting tables isn't related, but neither is art handling. Even teaching ceramics isn't related if you're a video artist. Maybe if your videos are about ceramics, but you get the idea. Have you curated an exhibition? That could work. Again, this is not a job application so only include work experience that is truly *related*.

Like "collections," this section is optional.

While you should stick to the order of the first three sections, since those are what people are most interested in and expect to see at the top, you can rearrange, combine, and rename other sections in whatever way makes sense given where you are in your career. And the one-page rule flies out the window once you have more than one page of good material. Here are a few sample résumé to give you an idea.

LETTERHEAD
contact info and website

Artist Name
Born Year, Location
Lives and works in City, ST

EDUCATION

| Year | Degree, University, City, State |
| Year | Degree, University, City, State |

SELECTED EXHIBITIONS

Year	*Title*, Venue, City, ST (solo)
	Title, curated by Important Curator, Venue, City, ST
	Title, Venue, City, ST
Year	*Title*, Venue, City, ST
	Title, Venue, City, ST
	Title, Venue, City, ST (catalog)
	Title, Venue, City, ST
Year	*Title*, Venue, City, ST (solo)
	Title, Venue, City, ST
Year	*Title*, Venue, City, ST

PUBLICATIONS

Year Last Name, First Name, *Title,* Publication, Date, Page
 Last Name, First Name, *Title,* Publication, Date, Page

Year Catalog Title, Publisher

Year Catalog Title, Self-published

AWARDS AND RESIDENCIES

Year Title or Description, City, ST
Year Title or Description, City, ST

How creative should I get with my materials?
It all comes down to presenting a clear, clean, and honest submission. It must be complete, organized, and easy to read. And there's nothing wrong with making it beautiful. That doesn't mean you have to spend a lot of money on the packaging or spray everything with perfume. (In fact perfume is a particularly bad idea.) It just means making the viewing experience as pleasurable and interesting as possible without distracting gimmicks. If you try too hard, you will look like you are overcompensating for poor-quality work.

——————"I think it is good to have something professionally put together and subtle. If it gets too cheesy or aggressive, it feels like used-car sales. I think it can detract from the work." **Kelly Klaasmeyer, critic, Houston Press, and editor of glasstire.com, Houston**

——————"A crayoned note on lined paper does nothing for us. And we've gotten that! Do your homework and send a nice package." **Sara Jo Romero, Schroeder Romero Gallery, New York**

LETTERHEAD
Name, Contact Information and Website

Arist Name
Lives and works in City, ST

Selected Solo and Two-Person Exhibitions

Year *Title*, Venue, City, ST (solo)

Year *Title*, Venue, City, ST (solo) (catalog)
 Title, Venue, City, ST

Year *Title*, Venue, City, ST

Selected Group Exhibitions

Year *Title*, Venue, City, ST
 Title, Venue, City, ST, curated by Important Curator
 Title, Venue, City, ST

Year *Title*, Venue, City, ST (catalog)
 Title, Venue, City, ST
 Title, Venue, City, ST
 Title, Venue, City, ST

Year *Title*, Venue, City, ST
 Title, Venue, City, ST

Year *Title*, Venue, City, ST
 Title, Venue, City, ST

Bibliography

Year Last Name, First Name, *Title*, Publication, Date, Page
 Last Name, First Name, *Title*, Publication, Date, Page

Year Last Name, First Name, *Title*, Publication, Date, Page
 Last Name, First Name, *Title*, Website, Date
 Last Name, First Name, *Title*, Publication, Date, Page

Awards and Residencies

Year Title or Description, City, ST
Year Title or Description, City, ST
Year Title or Description, City, ST

Catalogs

Year Title, Publisher
Year Title Publisher

Education

Year Degree, University, City, State
Year Degree, University, City, State

Teaching

Year Position, Department, University, City, State
Year Position, Department, University, City, State

MOMMY,... CAN YOU EXPLAIN POST-COLONIAL IDENTITY POLITICS TO ME?

ARTIST NAME
Born City, State

EDUCATION

Year
Degree, University, City, ST

SELECTED SOLO EXHIBITIONS

Year
"Title," Venue, City, State

Year
"Title," Venue, City, State
"Title," Venue, City, State

Year
"Title," Venue, City, Country

Year
"Title," Venue, City, State

SELECTED GROUP EXHIBITIONS

Year
"Title," Venue, City, State

"Title," Venue, City, State
"Title," Venue, City, State

Year
"Title," Venue, City, State
"Title," Venue, City, State (curated by Curator Name)
"Title," Venue, City, State
"Title," Venue, City, State

Year
"Title," Venue, City, State
"Title," Venue, City, State

Year
"Title," Venue, City, State (curated by Curator Name)
"Title," Venue, City, State
"Title," Venue, City, State

SELECTED BIBLIOGRAPHY

Year
Last Name, First Name. "Title," Publication, Exact Date, pp x-x.
Last Name, First Name. "Title," Publication, Exact Date, pp x-x.
Last Name, First Name. "Title," Publication, Exact Date, pp x-x.

Year
"Catalog Title," Publisher.
Last Name, First Name. "Title," Publication, Exact Date, pp x-x.

Year
Last Name, First Name. "Title," Publication, Exact Date, pp x-x.
Website, Web Address, Exact Date.
Last Name, First Name. "Title," Publication, Exact Date, pp x-x.

AWARDS/GRANTS

Year
Award/Grant/Fellowship
Year
Residency, City, State
Year
Award/Grant/Fellowship

COLLECTIONS

Collection Name or Collector Name, Location
Collection Name or Collector Name, Location
Collection Name or Collector Name, Location
Collection Name or Collector Name, Location

CURATORIAL PROJECTS

Year
"Title," Venue, City, State
Year
"Title," co-curated with Curator Name, Venue, City, State
Year
"Title," Venue, City, State

Do not email Word versions of your résumé, because the formatting may reset when someone else opens the file on another computer, undoing your hard work of making everything line up. Convert or scan the file to a PDF (or some other unalterable format) and then send it out.

PRESS CLIPS

Make a press clip for any article that mentions you—even if it's one sentence from a group show review. The best way to present an article is by clipping the title bar from the publication's first page, which has the publication's name and date

of the article. Combine that with the article's full text and paste them together, with the page number. Make it look as clean and professional as possible. Now you can scan it for emailing or printing. Or scan all those elements and put them together in Photoshop.

Don't use the online version of an article unless you can't find a back copy of the original. Until everything goes digital, people still like to see the article the way it really looked. If you're getting the article from the online version of the publication, or the article is online-only, you should still crop and reassemble to make the clip look more professional. Exclude any ads, banners, or unrelated information from the clip.

Keep originals and copies of any catalogs and brochures that include your work. Be selective about whom you send originals to, since you'll have a limited number and it's not really necessary for every submission. High-quality copies should suffice.

By the way, this is a good time to decide whether that blog post really counts as press. If you find that you don't want to show the clip to anyone because it's some obscure blog that doesn't cover the art world, then don't—and keep it off your résumé.

Should you include bad press? People are divided on this one. We pretty much agree with the old adage that says there's no such thing as bad press. Our rule of thumb is to include all press—even negative press—unless the review is a total train wreck, either because it is extremely critical (as in, "that show was an unmitigated disaster" or "this artist has no talent whatsoever") or because it fundamentally misrepresents your work.

In assessing how negative a negative review is, try to be aware of how sensitive you are and be careful not to interpret a mixed review as an extremely negative one. The fact that a critic didn't like your favorite piece in a show, for example, is not a reason to exclude the review from your resume, especially if the rest of the article was complimentary. Remember that it is very difficult to get any press in the first place, so it's a big deal if your work is commanding attention—regardless of the critic's conclusion.

————"Press is press. What a gallerist is looking for here is: One, are people writing about your work and Two, who is writing about your work. Just because a talented writer writes about you online rather than in print doesn't change either of those." **Edward Winkleman, Winkleman Gallery, New York**

————"I don't know if blog press is considered proper press. I mean, it's a point of view, and if the person has an interesting point of view and they are smart and make interesting judgments about art, then that is great. It doesn't bother me to see stuff like that, but it's really easy to get your friend to do a blog post. So, I don't think people view that the same way as a review in the paper." **Kelly Klaasmeyer, critic,** Houston Press, **and editor of glasstire.com, Houston**

————"I'd lie to you if I told you it wasn't upsetting to have someone say your work sucked. I try to be philosophical and say that good art has never been about being popular. You can rationalize why it's not such a bad thing, but it still stings. It's like when someone tells you your work is ugly, they're saying you are ugly. You're still like 'Oh, gee, I'm sorry that I'm ugly.' You take it personally." **Fred Tomaselli, artist, Brooklyn, N.Y.**

————"I think the lack of press is worse than bad press. If you are making work no one cares much about, that's a much bigger problem. For an artist's career to be very well respected and discussed, you need all the signifiers of quality to kick in: curators, critics, galleries, and collectors. That includes coverage in the art magazines." **Knight Landesman, publisher,** Artforum International Magazine

————————"Do I read artist statements? No! I don't know who came up with that idea, either. Why make the work if you're going to write the statement about it?

"Everyone wants things to be packaged and predigested so there is very little effort on the part of the viewer to come to terms with it. For me, much of the work remains ambiguous and I don't expect it to offer up answers immediately."
Shane Campbell, Shane Campbell Gallery, Chicago

————————"Eventually someone is going to request an artist statement, whether it is required for a grant application or someone is writing a press release for an upcoming exhibition. My suggestion is to start with something basic—a few sentences— and then tailor it as needed. It is important to give the party requesting a statement exactly what they are asking for. This most often involves simple and clean language. If the request is for something descriptive, writing something poetic is shooting yourself in the foot. Start with language that articulates the foundation of your beliefs and practice. Then elaborate; cut; redo. If it's unclear what someone is looking for in a statement, ask the person to clarify. And don't be afraid to ask for an example." **Michelle Grabner, artist, professor, critic, curator, Chicago**

I CUT DOWN MY ARTIST STATEMENT TO JUST 175 PAGES.

Keep PDFs (or some other unalterable, small file type) of all your press clips so you can email them easily. You always want the file to be legible when printed, so test that before you send.

ARTIST STATEMENT

When you apply for a residency, a grant, or an academic program, you will almost always need to submit some kind of statement. If there is one universal truth in the art world, it is that everyone dreads writing an artist statement. And plenty of gallerists will tell you they never read them. So why do you have to write one? Especially now, before anyone's asked for one?

You have to write one because there are a lot of people in the art world who *do* read them, such as curators and selection committee jurors. And they take them seriously.

The reason to write one now is that it takes most people a long time to come up with something they like. The process is painful enough, frankly, without a deadline looming. If you start it now, you can put it down and take a break without feeling the pressure to finish; after a few days, you can pick it back up with a fresh start. Even after you've "finished," you may reread it a month later and decide to rewrite some parts. And the cold, hard truth is that you will, eventually, have to submit one. Better to have a solid, general statement that you can tailor to specific opportunities as they arise than to scramble at the last minute to write one from scratch while putting everything else in your application together.

Keeping the function of an artist statement in mind will help you write one. Your eventual reader will look to your statement to get a better understanding of *what* you are trying to do in your work and *why*. That doesn't mean positing a comprehensive theory of your place in art history or psychoanalyzing your motivation—attempting either can be bad for your health (and worse for your statement). You just want to describe, as simply as possible, what it is that you hope to do, or show, or say, with your art, and what it is that makes you interested in doing, showing, or saying that. If there is something unique or important to you about your process, talk about that, too.

Sometimes artists complain that it is impossible to convey the true nature of their work through images. Well, this is one of the only places where you get to explain what's missing. In that way, an effective artist statement is essentially a concise, written version of the conversation that might take place during a studio visit. Your statement is a chance to teach that person about your art. Just remember that your reader is often going to be someone who didn't get a degree in studio art, who has never tried to do what you're doing, whose idea of what's "obvious" is very different from your own.

Also keep in mind the length: one hundred to three hundred words. That's less than one page of this book. Never go over a page.

There are many ways to tackle a writing project, so adjust our advice to your style. But the best way, we think, to end up with a good artist statement is to follow these steps:

1. *Brainstorm.*
 Jot down all your ideas in whatever order you think of them. The point is to get all your ideas on paper until you've thought of every aspect that's important or related—you'll cut down later, so let the ideas flow at this stage. Be yourself and think hard about where the work is coming from.

2. *Outline.*
 Look at all the words and ideas you have on paper and put them into an order, a structure, that makes sense to you. Not everything from your brainstorm needs to end up in your outline.

3. *Draft.*
 Take your outline of ideas and turn each line into a full sentence, tying them together into paragraphs. Don't worry about how things sound at this point; just bang out the sentences quickly and as naturally as you can.

4. *Edit.*
 This is when you worry about how things sound. Get rid of jargon. Trust us here: even the most complicated and profound concepts can be explained clearly, without relying on jargon. And three syllables are not always better than two. You're not

————"You're good at what you are good at. Writers are not asked to be visual artists; no one is asking that visual artists become highfalutin writers for their artist statements. The goal of your artist statement is to clarify and state your intentions. Do not add florid language and overthink it. The jargon isn't necessary or desirable. Most of the time, especially for emerging artists, it can create a stumbling block between your reader and your work." **Sarah Lewis, curator and critic, Yale School of Art, New Haven, Conn.**

————"No amount of poor padding with theory is going to make work look any more convincing or intriguing than it already is. I look at everybody's images first. Then I go to project statements. Then maybe I read the artist statement. I am looking for plain language: 'I am doing this and I am going to do this thing with it.' I have stayed away from reading the more poetic, theory-heavy, philosophizing artist statements because they kill it. Leave the interpretation to us, the audience. If you do it well, you have already interpreted your own content. Someone else will put it into words at some point." **Shannon Stratton, artist and director of ThreeWalls, Chicago**

————"Last year, I applied for a grant and I didn't get it because my artist's statement was 'insufficiently earnest.' I resented having to write the statement at all, so I made it sarcastic and funny and I lost the grant because of that. So, if you want to succeed, don't do something stupid like that and piss people off." **Bill Davenport, artist and critic, Houston**

out to impress people with your vocabulary (or your thesaurus). If you want to impress them, come up with a direct, honest description that leaves your readers feeling like they understand more about your work than they did before reading your statement. One very effective way to start editing is to read your statement out loud to someone who knows you well enough to say whether it sounds like *you*.

5. *Proofread.*

By the time you get to this step, you will have reread your statement so many times that you cannot possibly expect to hunt down every typo. Ask someone to do it for you. Put it down for a week, then proof it again yourself.

6. *Don't skip step 5.*

As your work evolves, you should update your artist statement so it's true to what you're doing now, not five years ago (or even six months ago).

We are not including sample artist statements because your statement needs to reflect what is unique about *your* work and be written in *your* voice. Reading other people's statements won't help you achieve either goal. Following the instructions above, however, will.

You can always get someone else to write your statement for you. A writer friend is the obvious choice, but an artist friend who understands your work may have an easier time writing your statement than his or her own.

Even when you are coming up empty, thinking about your statement makes you think about the work. It makes you think about your influences, your peers, your place in art history, and your process. These are all good things that will improve your practice.

COVER LETTER

You should always write a cover letter when you submit materials. (We'll explain how to write a cover letter when applying for a grant or residency in chapter 6.) This is your chance to demonstrate how much you know about the program and why you, in particular, belong in it. Go through a miniversion of the same process you used for your artist statement—brainstorm, outline, draft, edit—to write your cover letter. Similar guidelines apply: be direct and simple and avoid metaphysical complexity and pseudointellectual jargon.

LETTERHEAD

Date

Contact Name
Venue Name
50 Cranberry Street
Louisville, KY 12345

Dear Contact Name:

Start by saying who you are and what you want. If you share an acquaintance with the person you're writing to, mention the name of the acquaintance.

Explain why you think you're a good fit for the venue. Show the venue that you understand what it is and what it does. Say what makes you interesting. Say "Thank you for the opportunity" or something along those lines.

Sincerely,
Sign your name
Type your name

Artist Name, 20 Pineapple Street, Los Angeles, CA 90001
www.artistname.net

————"I am looking for nouns. Nouns and verbs. Anything that starts off too flowery, I crumple up and throw away." **Leigh Conner, Conner Contemporary Art, Washington, D.C.**

————"I will read artist statements but artists don't have to be great writers. Actually, many of them are terrible writers, which is fine, since that's not the primary "language" of theirs that I'm listening to. If they have taken the time to write a text, I will read it and it can often be quite useful, though artists shouldn't be overly concerned with crafting a perfect, publishable piece.

"While it's great that art schools spend more time teaching practicalities, sometimes it can backfire and all the statements begin to sound the same. I prefer how different the conversations can be. Much like being friends with someone, they don't tell you how to be friends with them. They act a certain way and you know." **Shamim Momin, curator, Whitney Museum of American Art, New York**

————"One of the nice things that we are sometimes fortunate to do is sit on panels for awards and residencies. Those are invaluable opportunities to see things we haven't seen before. I am always curious to see the way an artist articulates what they are doing in the studio visit or as an artist statement that gets briefly read in the half-light of a projected image." **Franklin Sirmans, curator, Menil Collection, Houston**

————"There are many, many contexts where the first introduction people have to your work is the written word. What you write about your work ends up in press releases and reviews. If you can write, it gives you so much more control." **Edward Winkleman, Winkleman Gallery, New York**

For email submissions, the body of your email acts as your cover letter so it should follow the basic format above (without the addresses). *Never* CC a bunch of people with the same submission. Send your email submissions one at a time, using people's full names (not "Sir or Madam"). If you think emailing a form letter to a bunch of galleries at once will save you time, you might as well save even more time and not send anything at all.

SASE

SASE stands for "self-addressed, stamped envelope." It is the easiest part of the application to make and the easiest part to forget. Do not assume anyone will send your materials back without a SASE.

If you are sending out a lot of submissions at once, write the name and address of the organization in the return address space. That way, if they send your materials back without a letter, you'll know where it came from.

TIMING

Be smart about when you send in a submission. Look at the venue's schedule so you don't email the staff the day of an opening (or the day after), when no one will look at your submission and your email will quickly fall to the bottom of everyone's inbox. The same principle applies to art fairs: find out which ones the venue participates in and hold off during the days just before and after. (Obviously, if someone asks you to send in your materials on or by a certain date, that trumps these general guidelines.)

Galleries tend to have more group shows in the summer and are therefore most open to considering new artists in late winter through early spring, when those shows are planned. If you hear through the grapevine about a particular theme for a show that a gallery or curator is working on and it relates to your work, go ahead and send in a submission. But read chapter 7 first.

Should I pay to submit work to a show?
Paying for people to look at your work can become very expensive, very fast. Sometimes it's justified, as with nonprofits that use the money to cover the costs of processing applications and exhibiting work. But do your research and make sure you understand where the money is going. If it looks sketchy, it may very well be.

——————"I would definitely research the venue and the jurors. With the Internet, you can find out pretty fast if this is the right show to apply to. There are higher-profile ones and when you are starting out, applying can be a good idea. It can be expensive though, so you really want to do your homework. Make sure your work is the kind that institution has shown before and that the curators are interesting." *Andrea Pollan, owner, Curator's Office, Washington, D.C.*

CHECKLIST: SUBMISSION MATERIALS

—IMAGES
—RÉSUMÉ
—PRESS CLIPS
—ARTIST STATEMENT
—COVER LETTER
—SASE

Do I have to live in New York, Los Angeles, or Chicago to be successful?

The short answer is *no*.

While those cities have obvious advantages and produce the most famous artists, they represent only one part of the contemporary art world. You can make your work just about anywhere. The key is to be aware of what is going on throughout the country, regardless of where you live, and to appreciate your local audience and early supporters no matter where you end up.

As one gallerist put it, "If you are making art and making a living, be happy about it for crying out loud!"

CHAPTER 4

Websites and Business Cards

WEBSITES

There was a time when people thought it was tacky for an artist to have a website. Now a lot of art world professionals consider it unacceptable *not* to have one. Galleries, curators, collectors, and press rely on artist websites to quickly find accurate, up-to-date information about the artists they're interested in.

A basic artist website is easy to put together and cheap to maintain. It's the best way to make your work accessible to a wide audience. And it's the only place, aside from your studio, where you have total control over how people see your work. Take advantage of this opportunity to add context to your work and present it in the right way. Don't just rely on your gallery's website, which most likely uses the same style for every artist. Make your own.

If you don't know how to set up a website, take a class or get a friend to do it for you. Given the number of companies that provide inexpensive platforms to host simple sites, there's really no excuse not to have one.

What Goes on the Site

You don't know who's going to look at your website and therefore can't tailor it the way you would, say, a gallery submission. So choose content you would be comfortable showing anyone.

Think seriously about your artwork before you design your site. What colors and layouts are best suited to what you do as an artist? Minimal art, for example, lends itself to a minimal site. If your work is heavily informed by a theory or movement or era, maybe your site should be, too. Check out the sites of artists, galleries, and nonprofits you admire and see what works and what doesn't.

Make your site easy to navigate. You want your visitors focusing on whatever it is they're looking for, not on the difficulty they're having finding it.

Keep your site up to date—not just your CV, but *everything:* images, press, shows, bio. Listing an "upcoming show" that ended two years ago looks unprofessional. And it can give someone the impression you aren't working on anything now.

————————"Not having a website is like not having a phone number. You have to have it. At least get a blog and put some images up. Every artist needs a website."

David Gibson, curator and critic, New York

Keep commercial work off your artist website. Many artists—particularly illustrators and photographers—have "day jobs" making commercial artwork. If you fall in this category, keep that work on a separate website that isn't easily mistaken for your artist website. We know a New York painter, for example, who does commercial portraits on the side; she uses her maiden name for her artist website and her married name for her commercial site. Using a company name for your commercial site also does the trick.

Home Page
This is your first impression, so make it count—in whatever way you want it to. The home page should include your name and navigational buttons for the other pages. If you want people to see your art (and nothing else) when they first go to your site, create a splash page that they can skip if they want.

It's also a good idea to use your home page to announce upcoming shows and post recent press, with links to more information such as the venue, press release, or article. Still, keep it clean. If you have a ton of news and upcoming events, it might be better to link to a "news" section rather than clutter up your home page.

Contact
Link to your gallery if you are represented and ask them to do the same. If you are not represented, provide a way for visitors to contact you directly. Avoid spam and viruses with a form that visitors can fill out on your website (so you don't need to display your email address). Or list your email address with "(at)" instead of the @ sign to thwart automated spam programs.

Images and Clips
Your artwork, of course, is the most important part of your website, so use your best images. And don't post everything you've ever done—curate your site the way you'd curate a studio visit. Put some thought into how you want people to experience your work for the first time. Do you want them to see one work at

a time? Multiple works at once? Current work in one section and past work in another?

We recommend allowing viewers to enlarge your images so they can see as much detail and texture as possible. Just use low-resolution JPEGS for the site (72 dpi) so the pages load quickly. Many galleries like to make high-resolution images available on their sites in addition to the low-res ones (as opposed to saying "high-resolution images available on request"). This raises the issue of copying and misuse: What's to stop people from downloading a high-quality image of your work and using it or selling it without your permission? If you're really worried about this—most people aren't—use a watermark on the high-res images (the copies you post on your site, not your originals).

Include the same information for your images that you did for your physical portfolio: title, year, medium, dimensions or duration, and edition (if applicable). This is also where you can add a brief description to any images you think need one.

A lot of artists post installation shots in a separate section, since they give visitors a sense of scale. It doesn't matter whether the photos are from your studio or an exhibition; use the ones that look the best.

What's a watermark?

A watermark is a transparent symbol or word that appears on an image indicating that the image is protected by copyright. It discourages people from using the image since they can only copy it with the compromising watermark. You can find watermarking software online or use Photoshop to create one.

For videos and performances, we recommend posting clips rather than complete works. Invite people to contact you for the full-length version; this gives you some control over where your videos go and how they're viewed. It also boosts your email list. If you have trouble posting video to your site, link to a video-hosting website.

CV

Everything we talked about in chapter 3 concerning your physical résumé applies here, except that for your website you can post a CV—meaning it's fine to include more information on this version than you might when sending to a specific gallery. But you still need to edit. And you still need to keep your non-art jobs outta there! The only exception is if you're applying to teach art, in which case you'll want to list past teaching positions under "Work Experience."

Take advantage of the website format by creating links from the items in your CV to other pages with more information. For past group shows, for example, see if the gallery still has a live page with installation shots and link to it from that line in your CV. If you have press, link from the articles listed in your CV to your press page with the full text. Just remember to keep the links current.

Make sure your CV is visible on the screen. Also create a link so that someone can download the document and print it cleanly—a PDF is usually best.

Text Is the New Press

A lot of artists have started titling their press-clips page "text" because it's a broader term than "press." Under "text," you can list excerpts from a catalog or press release and you avoid silly debates over whether online press counts.

Obviously you'll want to post any positive articles or reviews that focus on you. For pieces that only mention you briefly, such as group-show reviews, you can just post the excerpt that talks about you as long as you link to the full article. Remember to credit the article and the author the same way you do in your résumé and press clippings.

If you have a lot of press, there's no need to post all of it. List your most glowing reviews and most impressive publications. Keep it clean and easy to read.

Again, check that everything prints well.

Biography (Optional)

A short narrative version of your CV, where you elaborate on the important points. Include personal details, such as where you were born, where you grew up, and where you live now. Mention your education, training, and apprenticeships. Describe the highlights of your art career. This is also where you can put up a picture of yourself if you want to.

It's more common for biographies to be written in the third person but you can write it in the first person if you prefer.

Artist Bios

New

(Artist Name) was born in (Year) in (Town, State or Country). In (Year), she received her (degree) in (subject) at (University). (Last Name) has already been included in various important exhibitions including ("Title") at (Venue, City, State) and ("Title") at (Venue, City, State). This year, she will attend (Residency or Special Program). Upcoming shows include ("Title") at (Venue, City, State). (Last Name) currently lives and works in (City, State).

Emerging

(Artist Name) lives and works in (City, State) and was a (Year) recipient of a (Grant/Scholarship/Something Important). He has exhibited in solo exhibitions at (Venue, City, State) and (Venue, City, State). His numerous group exhibitions include ("Title") at (Venue, City, State) and ("Title") at (Venue, City, State). (Last name) was honored with the (Title of Grant/Award) in (Year). Public Collections include (Name) and (Name). He is currently working on (describe work in a few words) for ("Title") at (Venue, City, State) in (Year).

Midcareer

(Artist Name) received her BFA in (Year) from (University) and her MFA in (Year) from (University). She was a member of the (Art/Art History/other) faculty at (University) for the last (#) years. (Last Name)'s work has been written about in (Publication), (Publication), and (Publication). She has been actively involved in guest residencies and lectures (Nationally/Internationally). Her works are included in the public collections of (collection), (collection) and (collection). Solo exhibition venues include (Venue, City, State), (Venue, City, State) and (Venue, City, State). Group exhibition highlights include ("Title") at (Venue, City, State) and ("Title") at (Venue, City, State).

Artist Statement (Optional)

While plenty of artists choose to post their artist statements, we do not recommend doing so unless it is integral to understanding your work (for example, conceptual work or a unique process may require explanation). That's because you will write your strongest artist statement when you have a goal in mind and you know whom you're writing to, such as when you apply for a grant. It is harder to come up with an effective statement when you're addressing the world at large. And most people go to your website to look at your work and CV, anyway. Those who want to read your artist statement are typically people who will ask for it as part of an application or submission.

Links (Optional)

Another way to reveal yourself to your visitors and add context to your work is through a list of links, which creates an impression the same way a "favorite books" list does. Link to artists you love; galleries you admire; venues you've shown in; magazines and blogs you read. Get reciprocal links whenever you can.

The Price Isn't Right

Do not list prices on your website. Better to say something like "contact me [or my gallery] for price information." There are a few reasons for this.

First, galleries expect pricing to be collaborative and it's easier to raise (or lower) your prices if you haven't already announced to the world what you intend to charge for your work. And when you have a gallery, you do not want to create the impression that people can buy directly from you.

Second, as we discuss more in chapter 5, your prices will change over time. You just create more work for yourself if you list prices because you have to keep updating your site as they rise.

Third, the point of your website is to expose people to your work. You want visitors to understand your art, to learn more about you, to come to a show. Prices are distracting. They pull your visitors away from appreciating your art for its own sake and force them to think about whether they want to buy it.

BLOGS

Artist blogs are becoming almost as popular as artist websites. And they're easier to launch because so many companies provide free (or inexpensive) blog templates.

Not all art "needs" a blog, obviously, so you shouldn't feel compelled to start one, especially if you work in a more traditional medium. They are particularly effective for process-oriented, time-based, and community-based art—or anything where images alone cannot convey the full scope of the concept.

Keep these points in mind if you decide to go blogging:

—People are going to look at this. (We know, who woulda thought?) Don't upload anything that could embarrass you later. And don't badmouth anyone. Gossip travels fast enough in the art world without you going on the record that so-and-so is a sleaze. Vent to your friends in private, not to the world on your blog.

—Proofread before you post. Just because a blog is informal doesn't mean people stop caring whether you spell their names right. Some people even care whether you spell regular words right, too.

—You don't have to blog every day, though to keep visitors coming back there should probably be some method to the madness so they know when to expect more.

—You don't have to use words. Pictures are worth . . . well, you know.

BUSINESS CARDS

Gallerists and curators agree that business cards are a necessity. This makes sense: They help people remember your name, your next show, and where to find your work online without having to memorize anything. And you look more professional when you hand out a card than if you have to make someone wait while you scribble down your website on a napkin. Your card can be the size of a traditional business card or a postcard; it can just have your name and website on it; or it can also have an image or two.

If you don't have a business card, use a show announcement. Or, what the hell, use a napkin—just have your info printed on it ahead of time.

A lot of artists think tiny cards are cute. They're not. They're annoying, because they're easy to lose, because they're tiny.

————————"I'm a big fan of business cards. If I go to

open studios and you have a business card with a name

on it and an image on the back, you make everyone's

life easier."

Melissa Levin, program manager, artist residencies,

Lower Manhattan Cultural Council, New York

CHAPTER 5
Opening Your Studio

*————————"It's a brave thing to allow someone into your studio. But if you're going to allow them in, you must be prepared to give a little bit. You can't think that you've allowed them in and that's the extent of it." **Jasper Sharp, curator, art historian, VOLTA art fair selection committee, Vienna, Austria***

————————"When you reach a point where you have something that is reasonably resolved, that you feel good about, you should invite your friends into your studio. Start trying to articulate what the work is about and see how other people react to it. Then, I think it's helpful to invite other people you know casually, or less well, but whom you also trust; who maybe have shown interest in the work before. The value of structuring it that way is that you get more and more comfortable with how to present the work and your relationship to it.

*"Those people will tell their friends. When someone you don't know hears about it, follows up on it, gives you a ring and comes by, you've already settled into the nature of that encounter and that interaction. By then, hopefully, you've become more comfortable with it and you understand more of how you operate in that situation." **Peter Eleey, curator, Walker Art Center, Minneapolis***

*————————"One piece of advice I would give is to continue working with your peers and have studio visits with other artists or other colleagues in the field, so that you don't just get stuck on your own. Ask people to come over to see and talk about your work." **James Harris, James Harris Gallery, Seattle***

Almost every important step in your career will trace back to some kind of studio visit. (In fact, residencies and grants are probably the only professional opportunities that don't depend on in-person studio visits.) It could be a curator considering your work for a show; a collector looking to buy your work; a gallerist interested in taking you on; an artist giving you feedback.

These visitors want to see your work in person and they expect you to explain what you're doing. They want to learn about your process, to understand your inspirations and intentions. Curators want to discern whether their interpretation of the work aligns with yours. Collectors need context. Gallerists will want to see whether they can put you in front of their collectors and, even more important, whether they will be able to explain your work to their collectors themselves.

All of which is to say that the sooner you get comfortable hosting people in your studio, the better. It's nerve-racking to present your work to a stranger when the stakes are high, so start practicing now. Talk about your work with your peers. Bring your non-art friends to your studio and show them around. The more you do it, the more natural it will feel and the less daunting it will become.

STUDIO GROUPS

Honest feedback is hard to find if you're not in school. You don't have regular crits; you don't have professors with office hours; the gallerists and curators visiting your studio want to learn about what you're doing, not critique it. So you have to seek out feedback from your peers.

One of the best ways to cultivate regular feedback is to start a studio group: get a bunch of your artist friends together and take turns visiting each other's studios (you can include other arts professionals, of course, for different perspectives). A studio group can be a real source of inspiration and guidance. And, through your friends in the group, you're likely to meet other artists and curators who understand you and want to work with you in the future.

OPEN STUDIOS

Every year, cities and towns across the country host "open studios" programs. San Francisco's Open Studios, organized by a local nonprofit called ArtSpan, was the first of its kind when it began over thirty years ago. Another nonprofit, Artspace, organizes a similar program in New Haven. There's Art-a-Whirl in Minneapolis; Dumbo Open Studios in Brooklyn; and, chances are, some kind of open studios where you live, too.

Participating in open studios lets you practice your studio-visit skills and build an audience while you're at it. Since anyone can walk through the door, you'll learn how to field unexpected questions and get used to seeing a wider range of reactions to your work than you've probably been getting.

Ask your friends or search online to find out which organizations host open studios near you. Make sure you register ahead of time and get on the map if there's an official one.

And you can always create your own open studios. Some of the most popular open studios were founded by artists who all lived in the same building. Start small with a cocktail party for your friends, or rope in a few neighbors and invite the public into your studios. Or start huge and organize a weekend-long open studios for your whole town. You'll expand your community, meet other artists and arts professionals, and get your work out there.

Setting Up

Getting ready for open studios is straightforward. You're basically turning your studio into a minigallery space that should entice people to step inside and linger over your work. Push all your supplies and everyday clutter into a closet or a corner, clean the walls, and curate your space.

Curating Your Work

Since you don't know exactly who will come to open studios, it's smart to hang pieces from a few different bodies of work. We don't recommend showing more than three bodies of work

————"My first studio visits in New York were with artists I was meeting in the bar, shooting pool with. Same thing happens now and I don't think it's ever been different, since the beginning of any kind of visual arts community, really. Invite someone to your cave to come check out your cave paintings!

"So it's your peers first and anyone who's interested who displays enthusiasm at all. In the end, they may not go into the arts or have the tools to discuss it, but that is always the beginning. You are creating a network that will become the next generation."
Michael Joo, artist, Brooklyn, N.Y.

————"The Crit Group (a communal organization of which I am a member) has been a great way to guarantee that we have intellectual engagement beyond the idiosyncrasies of the art world. We all get to know each other."
David Gibson, curator and critic, New York

————"Two summers ago, every week we went to a different studio. Nine or ten people would go to a studio every Wednesday. I saw work I had never seen before. One visit was at a point when I was not psyched about my work. A body of work came from that visit a product of a conversation that night." **Michael Yoder, artist, Philadelphia**

because you'll have a harder time conveying the depth of your practice. Hide the rest of your work in an easily accessible spot so you can show anyone who wants to see more.

Make it easy and enjoyable for people to see the work and the coherence among the different pieces. Put pieces from the same body of work together. Separate different bodies of work. And don't overhang. Unless your work is about complete saturation of the senses, it will need room to breathe to be appreciated. Overhanging can overwhelm, confuse, and ultimately turn off your audience.

Hide your unfinished work—unless you have a very good reason to show people a work in progress. Your visitors are likely to walk out with the wrong idea if you're too busy to explain an unfinished piece and what direction it's taking.

Once you've selected the pieces you want to show, arrange them on the floor around the room before you actually install or hang anything. Put cardboard or foam under each piece so the bottom edge does not get damaged. Then rearrange, and rearrange again, until you find the configuration you like best. Now you're ready to install.

Remember that the way you light your work can radically alter how your visitors read it. So light it the way you want it seen—even if that means you have to borrow or buy clip lamps to do it.

After installing, have a friend walk through and give you a second opinion. Other people—particularly artists—notice things you don't because you're so close to the work.

Consider placing labels on the walls or putting out checklists (the way galleries do). It's an easy way to convey basic title information and any other background you want people to know about each piece. It gives your visitors something to refer to as they walk around the room and will tend to slow them down and focus their attention on your work.

Finally, have your website up and running in your studio for visitors who want to see more of your work. If they're really interested in something they see, by all means pull the actual pieces out from storage.

Can't decide what to display? These questions
might help.

—Which pieces are your favorites?

—Which pieces can you talk about best?

—Which pieces show a real breakthrough?

—Which pieces make sense together and tell
a coherent story?

—Which pieces have you gotten the best response
to? Why?

—Can you show a range of sizes and materials
and still look organized?

—Can you simply show your current body of work
(and have older pieces handy)?

—Can you explain why you've chosen the pieces
you have?

Hanging Flat Work

The standard height for hanging flat work is 57 inches from the ground to the center of the work. Some curators prefer slightly higher or lower—the range is from 55 to 62 inches—but more than an inch in either direction makes a pretty dramatic difference. Of course, the point of your work may dictate a radically different height.

Once you pick a height, stick with it. Consistency in hanging height unifies a room.

Be careful how closely you hang your pieces. People will assume that two pieces hung right next to each "go together" as parts of a single piece.

Hang paintings from the stretcher bars. Hang framed work from a wire attached to the frame. (When you hang it from the top edge of the frame, the weight of the work may pull the sides down and away from the top edge, damaging the frame.)

You can use a cleat system or D-rings to hang heavy, mounted, or framed pieces. A cleat system is a combination of low-profile, interlocking wood wedges that hold an object in place:

CLEAT SYSTEM:

2 WOODEN WEDGES
WITH 45° ANGLE
EDGES

WALL

SCREW BOTTOM
WEDGE TO WALL

←—BOTTOM WEDGE

TOP WEDGE ATTACHED TO ART

WALL

←ART

WHEN CONFRONTED WITH A PIECE OF
ART THAT IS NOT VERY GOOD, THE
VIEWER SHOULD ALWAYS REFER TO
THE WORK AS "POWERFUL." THIS VAGUE
COMMENT ALLOWS FOR A VARIETY OF
INTERPRETATIONS AND CAN OFTEN
SOUND LIKE A COMPLIMENT.

—Where are you from? How long have you been
 making art?

—Where did you go to school? (This tells them who
 you've studied with and hints at other interests.)

—How did you make this?

—Why did you choose those materials? That size?

—Why are you making it? Is it an ongoing project?

—What artists are you looking at?

—What/Who are your influences? (Not everyone
 is expecting you to name other artists. They know
 any subject could play a role.)

—Ideally, how would it be shown?

—What came right before?

—What's next?

Cut two wedges at 45-degree angles. Screw one wedge into the wall and attach the other to the back of the piece. Slide the work onto the wedge in the wall.

If you're not allowed to make holes in the wall, get some reusable sticky hooks. (3M makes a variety of sizes that hold quite a bit of weight.) Just follow the instructions carefully so the paintings don't drop to the floor one hour later.

Always level the work with a proper level; don't rely on your eye alone.

When hanging work by screws or nails, you can make minor adjustments to level a piece by banging them up or down. If that doesn't work, try sticking Fun-Tak or a wad of paper on top of the screw that is too low. This way you don't have to make new holes.

Sculptures and Installations

Think about how people will walk through the space. Make it easy to navigate. Placing a sculpture or installation too close to the door can end up blocking the entrance and discouraging people from coming in.

If your sculpture is supposed to be viewed on a pedestal, take the time to build one. Putting a sculpture on a dirty table next to your tools looks unprofessional and can even create the impression that you don't care about your work. A proper pedestal, on the other hand, presents the sculpture in the best light.

Sound and Video

If you have more than one piece with sound, hook them up to earphones so people can concentrate on each one. Playing multiple pieces over speakers can cancel out their impact. And it will drive some of your visitors crazy.

Hosting

Your goal during open studios is to get as many people to come inside your studio as you can. Engage people as they come in. Make the space welcoming and comfortable. Above all, make sure

——————————"Knowing how to smartly install your work is becoming one of the most important parts of your art career. It can make a huge difference in how your work is perceived."

Michael Darling, curator, Seattle Art Museum, Seattle

you are comfortable. Keep a chair nearby so you're not standing the whole time.

Some artists like to put out drinks, snacks, and chairs, a failproof way to get people to stay a while. Others don't (for that very reason). Either way, it's nice to at least have water available.

Mailing List

Put out a sign-in book that asks for names and email addresses. This is a fantastic way to kick-start your mailing list with people who have seen your work. And it makes it easier to follow up with anyone who inquires about a specific piece.

One gallery trick you should borrow is to jot down a few words in the sign-in book after people leave (or to write a few notes on the back of their business cards and staple them into the book). Just something to help you remember your visitors—which pieces they liked, what you talked about, what they're interested in.

I HOPE YOU DON'T MIND BUT I'VE WORKED UP A SHORT SCRIPT FOR TODAY'S STUDIO VISIT.

Talking About Your Work

Try to explain what you're doing in less than two minutes. That doesn't seem like much time, but in a crowded studio it may be all the time you have. (Later in this chapter we'll go over talking about your work during a curator's or gallerist's studio visit.) The challenge is to find ways to discuss your work with people of significantly different levels of art appreciation. There's no magic guideline here, other than keeping your audience in mind as you talk. Over time you'll naturally develop a feel for what works with different people.

Takeaways

Now that you have people coming in, you want them to stay interested long after they're gone. Have something for them to take when they leave, such as a business card or show card—anything that has your website, contact info, and maybe an image or two. Make it obvious that they're there for the taking so that your visitors can find them without asking.

You might even burn some disks with your images and résumé in case someone is really interested in your work.

PRICING AND SELLING YOUR WORK YOURSELF

If a gallery represents you, it will set your prices and handle your sales. All you have to do is get the contact information of anyone interested in buying your work and pass it on to your gallery. It's also a good idea to give your gallery's contact information to the collector, since not all galleries move as quickly as their artists would like them to.

You know what *isn't* a good idea? Selling your work directly to a collector without your gallery's permission. You may feel like you did all the work setting up your space for open studios and landing a collector your gallerist didn't know, but that's not how representation works. There are many, many things your gallery does to earn its half of your sales (see chapter 13 for the

―――――*"I price my work by talking to people and going to find out how much things are in galleries. If I'm making the same number of prints and the artist's résumé is similar to my résumé, I'll charge about the same. My work should be less than an artist's work who's shown more than me. So it's based on what we're making—if it's the same—and what our cachet is."* **Stephanie Diamond, artist, New York**

―――――*"The late '80s and early '90s boom and then recession ruined artists' careers. The price of work was escalating too high from one show to the next. You can't go down."* **Steven Sergiovanni, director, Mixed Greens, New York**

―――――*"Keep your prices fairly close to what you've sold at in the past—whether or not you had a gallery—with maybe a 10 percent discount. If someone buys a lot, then maybe a 20 percent discount. No more, because you will tick people off if you lower your prices. It will be an issue for anyone who has bought your work in the past."* **Andrea Pollan, owner, Curator's Office, Washington, D.C.**

laundry list) and those things don't disappear just because you got a lead during open studios. This is not an issue to take lightly. Gallerists have dropped artists who were selling behind their backs.

If you are not represented, you get to set your own prices. This isn't an easy thing to do, which is why you really need to do it *before* you open your studio to the public. You don't want to be forced to price your work off the cuff when someone surprises you and actually decides to buy it. Nor do you want to put your potential collector in the awkward position of having to suggest a fair price.

Newer artists frequently undervalue their prices out of humility or overvalue them in light of the tremendous amount of work and emotion that went into them. To minimize these tendencies, you have to separate the value *you* place on the work from its ultimate price. What you think a piece is worth should factor into the price you set for it, but there are other factors, too:

—your price and sales history
—what the piece is made of
—fixed costs—fabrication, printing, framing, expensive materials
—how long the piece took to make
—how big the piece is—larger typically means more expensive
—how big the edition is—larger always means less expensive
—whether the piece was part of a notable exhibition
—how many pieces you make in a year
—what your résumé looks like—the more solo exhibitions and museum shows you have, the higher your prices should be

Go to young galleries and emerging art fairs to get a sense of the range of prices out there for work that is roughly comparable to yours. Look at the artists' résumés to see where they are in their careers. But remember that work is more expensive when an artist is represented by a gallery because of the gallery's efforts to promote the artist and develop his or her career. You should not price your work as high if you do not have representation, even if it's "just as good."

Once you've sold a number of pieces, pricing becomes easier because you'll always price relative to your past sales. But this is

Playing the Dealer

A few tips for talking with a collector when you don't have a gallery:

—It's good to allow for different interpretations of your work—but without letting the collector walk all over you. To that end, tell the collector what you were thinking when you made the piece, but try not to limit other readings.

—Asking which pieces the collector likes and why can help you learn more about the collector's perspective, find interesting points of discussion, and even discover a new way to look at your work.

—Don't be afraid to say no. If your work is meant to hang a certain way, for example, don't be shy about saying so.

—Never say that you don't like one of your pieces or that one is worse than another. You could be talking about the one piece the collector likes. If you dislike a piece that much, don't show it in the first place.

—If you don't want to sell one of your pieces, mark it "not for sale." Don't price it in the stratosphere as a way to dissuade buyers. Occasionally we see artists do this; the only effect it has is to undermine the pricing of their other work.

———————"Value is an interesting part of art.

Pricing is a long-term goal and that's the thing to talk

about. It depends on what kind of artist you want

to be. In this market, you can be a short-term artist and

know how to play a certain role. But there are many

ways to be important, with modest prices, and have a

great influence on other artists, affect society,

be an interesting person, use your position for social

consciousness, and lead a really interesting life."

Andrea Rosen, Andrea Rosen Gallery, New York

————"We price based on how much it cost to make the work, what the demand is, and where the pricing is at the moment. It depends—if you are an unrepresented artist in your studio, how many pieces do you make? Should you sell them and move on to make the next pieces? Once you get a gallery, you can work on the integrity of the sale."
Mary Leigh Cherry, Cherry and Martin, Los Angeles

————"The first time I felt like a professional artist was when a dealer came through for a studio visit on the Venice Art Walk. She said, 'First I want to buy this one, this one, this one, and this one for myself.' Then she asked how much they were and I had no idea. I couldn't tell her too much because I wanted her to buy them. I couldn't tell her too little because I didn't want to seem green. I ended up asking her what she thought was fair. In retrospect, I was lucky she gave me a fair price." **Stas Orlovski, artist, Los Angeles**

————"I take exorbitant production costs into account. However, we had an installation a while back and the artist paid incredible production costs. He spent over $20,000 but he was willing to sell it for not much more just to have it in the world. You have to be realistic. It's a gut feeling. Weigh those factors and be aware of what everyone else in the market is doing." **Monique Meloche, monique-meloche gallery, Chicago**

still tricky. When you let your prices rise too fast, you risk pricing out your collectors, which in turn can force you to lower your prices. But you never want to be in a position where you have to lower your prices, because the art world is extremely unkind to artists whose prices have fallen. Speculation spreads that their careers are over, making it harder to sell work, fueling more speculation—a vicious cycle that can take years to reverse. That's why slow price increases are always better than big jumps (we promise!).

Discounts on Direct Sales

It is standard to give museums a 20 percent discount on any sale (sometimes it's even higher than that). Galleries do this all the time because museums are (a) nonprofits and (b) the best long-term home for most artwork. Art advisors typically get discounts between 10 and 20 percent. (Usually, they'll charge their clients the full retail price, pay the gallery the discounted price, and keep the difference as a fee.) Beyond that, there aren't any standards—despite what you might be told by a collector who "always" gets a 10 percent discount.

Many artists, mimicking galleries, give discounts to collectors who buy more than one piece. Some artists give everyone a 10 percent discount because it sounds fair and makes all their collectors feel special. (The artists we know who do this tend to factor that discount into their original pricing, but don't tell anyone.) Some artists only give discounts to family and friends. So it's up to you—but unless you're selling to a museum, a nonprofit institution, or an art consultant, you shouldn't be talked into more than a 10 percent discount on an ordinary sale.

Don't Forget the Paperwork

When you make a sale out of your studio, either because you don't have a gallery or your gallery gave you permission, print out two copies of your invoice form. Give one to your collector and keep one for your files. If you don't have a form ready to print out from your computer, go back to chapter 2 and make one.

INDIVIDUAL STUDIO VISITS

There are three basic reasons curators or gallerists would want to visit your studio: they are doing general research and want to see what you (and other artists) have been up to lately; they are searching for artists to include in a specific show or to add to their gallery program; or they are doing someone who knows you a favor.

These reasons can overlap and you won't necessarily know which one led to a particular studio visit. Some curators and gallerists will tell you point-blank so as not to mislead you. Others won't, so as not to raise your expectations. Ultimately, the reason for a specific visit isn't that important from your perspective, because your goal is the same regardless: to give your visitor the best impression of your work that you can in the time you have.

Preparing for the Visit

Getting ready for an individual studio visit is easier than it is for open studios, since you know who's coming and can prepare specifically for that person. You also don't need to turn your studio into a gallery space the way you do for open studios because curators and gallerists want to see what your studio looks like on a normal day.

But you still need to curate your work and present it thoughtfully. Show your best work and your most recent work (ideally the same thing). Apply the same curatorial principles from the open studios section above, keeping in mind that you have more control during an individual studio visit. Plan on directing your visitors' attention to the work you want to show, in the order you want it seen.

Research your visitor before the studio visit. (Your visitor will likely have spent time researching you, too.) Even if you already know the person, you should look up what he or she has been doing lately. You'll feel more confident during the visit and you may get a better idea of why the person is interested in your work at that particular time. You'll also see the kinds of shows and institutions your visitor has been involved with, which is an important factor in deciding whether you want to work together in the future.

—————"I prefer to see a good amount of work before I meet an artist. Not to decide whether I want to see them, but out of respect for them. I want to have something to say and often things take time to shape in your mind." **Jasper Sharp, curator, art historian, VOLTA art fair selection committee, Vienna, Austria**

—————"Whether you are going to get something out of it or not is irrelevant. When they come in and see your work and they get excited, you get excited." **Bill Davenport, artist and critic, Houston**

—————"You have colleagues and you do favors for colleagues. A submission with a curator or critic's name on it definitely gets a fuller review. Those visits can be awkward because they are a favor. The worst is when I've discovered I am one in a long line of studio visits. Ten other people are doing the same favor." **Mary Leigh Cherry, Cherry and Martin, Los Angeles**

—————"I want the artist to be prepared and I want them to have things ready for me to see. I don't want them saying 'Oh wait, let me dig that out of the back storage room.'

"I'm going to follow their lead in terms of earlier work. Sometimes I will ask to see earlier work because I am looking at a current work and I want to have context for it. So I want them to be prepared and have a sense of what they want to show me. It shouldn't be too much. No one can process twenty-five years of a career in an hour or so." **Anne Ellegood, curator, Hirshhorn Museum and Sculpture Garden, Washington, D.C.**

——————"There are two reasons why curators often hesitate and don't want to explain what their motivations are. First, we might not have any specific motivations, save curiosity. Second, when I am working on something specific, I try to be cautious. I don't want to set up an expectation with an artist which may not ultimately work out. I'm not interested in leading someone down a path of thinking about the way a work can be exhibited in our space, for example, until I have thought through the basics of that myself." **Peter Eleey, curator, Walker Art Center, Minneapolis**

——————"In the best studio visits, the artist has thought through a narrative and presents the work in a way that gives me faster access. One example that has stayed with me was an artist with eight paintings and only one was turned around at a time. At the end, when all eight were turned around, all the threads we were talking about came together." **Edward Winkleman, Winkleman Gallery, New York**

——————"Be ahead of that curve. Be proactive. Have your five-minute elevator speech about your work. Even if you hate talking about your work, stand in front of the mirror in your bathroom and come up with five things to say so that when someone asks to discuss your work, you have five articulate sentences you can utter." **Kim Ward, director, Washington Project for the Arts, Washington, D.C.**

——————"Art can be difficult to explain and discuss, especially for the artist. But it is important and I always tell artists that they should be able to explain it. There will be a press person or a curator who will eventually ask you about it and if you can't explain it, you may miss an opportunity." **Heather Taylor, Taylor de Cordoba, Los Angeles**

Hosting

During a studio visit, you want your visitor to focus on your work and little else. Put yourself in your visitor's shoes and think about how to minimize any distractions. If your studio is a sixth-floor walk-up, offer some water. If it's the middle of winter, have some tea ready and maybe a place for your visitor to hang his or her coat. If it's during lunch or dinner time, offer a snack. Simple hospitality works best. Going over the top with an elaborate buffet just creates another distraction.

And while you want to treat your visitor as you would a guest in your home, common courtesy runs both ways. Expect your guest to treat you with respect, too.

Talking About Your Work

There's no real debate on this one: you have to be able to talk about your work during a studio visit. That doesn't mean you need sound like a professional orator but you *do* have to figure out how to articulate what you're doing and why.

Gallerists and curators understand artwork more deeply when they know the influences and motivations that led to it. They want to know where you get your ideas; how you conceive of your projects; what your processes are. So be prepared to tell them.

At the same time, be flexible with how "hands-on" you are during a studio visit, because people have very different styles. One curator we talked to lamented the fact that he always has to listen to a rehearsed presentation when he walks in the door. Another said he expects the artist to dive right in and doesn't like it if he has to ask about the work before his host starts talking. Some curators prefer to assess what they see in silence; others ask a ton of questions. Stay loose and adapt your presentation to your visitor's style.

And just to echo a sentiment from the last section, don't say you don't like something you made. If you really don't like it, don't show it. Studio visits can last as little as twenty minutes, so focus your presentation on what you think you're doing well.

It's Not a Crit

While a good studio visit usually involves an interesting conversation, it is not an art school critique. Curators and gallerists visit your studio to learn about your work, not critique it for you. And you shouldn't want them to, anyway, because they may have agendas that don't align with your artistic intentions. That's why the ones who do give crit-style feedback during studio visits develop (bad) reputations for directing artists' work to fulfill their own goals.

To get the kind of feedback you used to get in crits, go to your peers, mentors, and former professors.

Takeaways

Prepare something along the lines of a minisubmission for your visitor to take away: your résumé, press, and a few images in a personalized envelope or folder. This is a tangible reminder of you and your work, one more way you've made it easy to contact you and, most important, one more demonstration that you are treating the studio visit like the professional meeting that it is.

After the Visit

The first thing to do after a studio visit is to get out of the studio. See a movie, take a walk, meet up with friends, whatever you like to do to relax. Don't rush back to work. Let the conversation you just had percolate a while. Maybe you shouldn't be influenced by the way the person reacted to your work, or maybe you should. Give yourself time to figure that out.

We recommend sending a short thank-you note to your visitor, along with some images, a link to your website, and any materials the person asked for. While not everyone expects this, it's another way to show that you're interested, serious, and easy to work with.

Don't be surprised if you don't hear back from the person for a long time. People in the art world tend not to rush. Even when

—————"It can be like going on a date. Sometimes you leave a visit and you think, God! That was so fun! Didn't we have a great time? I think he likes me. Then, you never hear from him again and you're like—was I the only one sitting at the dinner table?

"In general, maybe I am less formal than others, but I don't expect a formal acknowledgment after a studio visit. If there were good ideas generated or there was a nice rapport and a tête-à-tête, then that's probably a conversation you will want to continue with that artist." **Anne Ellegood, curator, Hirshhorn Museum and Sculpture Garden, Washington, D.C.**

—————"I really like it when an artist promptly responds to requests. I did a studio visit in London that ended with 'please send me JPEGS and a CV.' It would have been proper for that artist to send those materials fairly quickly. I didn't get a response until three months later! By then, I had already let it go. I assumed they weren't interested." **Lorraine Molina, owner and director, Bank, Los Angeles**

—————"During the follow-up process, I think you really have to gauge the personality of the person who came and whether they would be open to it. A lot of times I will tell artists to update me and they tell me where their work is going with new images and new work. In other cases, if the gallerist or curator doesn't say anything, don't push it." **Amy Smith-Stewart, Smith-Stewart, former curator at PS1, New York**

—————"I have been on visits when the artist is trying to tell me what to think about the work and that gets kind of irritating, when they are not willing to entertain questions or feedback and they are trying to impose on me one way to think about the work." **John Rasmussen, director, Midway Contemporary Art, Minneapolis**

—————"I ask lots of questions during studio visits; some of my colleagues apparently do not: I find this surprising. They are so aware of their grand role, of their responsibility to the art world, as if brain surgery were at stake. I think it is much more interesting to have a dialogue on a studio visit. There are things you just cannot get unless you ask questions." **Joachim Pissaro, curator, professor, art historian, former Museum of Modern Art curator, New York**

—————"Know how to talk about your work. If you can't, we can't. It has to be concise. If there is a heavy-duty concept involved, there has to be an easy way to explain it in a couple of sentences. If we've got someone important in here, we have to be able to explain it in five minutes because they are going to get bored and walk away. If we have longer, we can go into details, but we need to be able to summarize the important aspects of the work quickly." **Lisa Schroeder and Sara Jo Romero, Schroeder Romero Gallery, New York**

—————"You have to have an intention, you always do. When I get my students to talk about intention, I'm asking them to try to get clear about what they are doing. It takes courage to do that—to reveal your intentions fully. When you see any work of art, you are often trying to find an answer to this question: 'Why am I being asked to look at this?' If an artist is investing their life to do it, whether or not they've found the exact words, they have a reason. Have the courage to let it be known." **Sarah Lewis, curator and critic, Yale School of Art, New Haven, Conn.**

—————"I don't want to just see the work. I want to talk with the artists to get a more complete idea of what they are thinking and what the work is about. And I expect to have a proper business relationship with them. I want to know they are mature and responsible." **Rosamund Felsen, Rosamund Felsen Gallery, Santa Monica, Calif.**

—————"Studio visits with people in graduate school are tough. They expect a full critique and I am just there to look at work. We can talk about how things are working or not working, but I am not there to give a critique. I am there to see if the work will fit into a show." **Andrea Pollan, owner, Curator's Office, Washington, D.C.**

—————"I do visits like a conversation. The most important thing is hearing how they talk about their work. They need to educate me and, although I may have a certain response and understanding, I need to understand where they are coming from. That is the most important." **Lorraine Molina, owner and director, Bank, Los Angeles**

————————"I think a curator has a huge responsibility walking into your incredibly intimate space where you make the most important thing in the world to you. It's our job to navigate that sensitively and professionally so that you feel comfortable. To me it is less about making it perfect; treat it the way you would when you want someone to be comfortable in your house with your friends. I don't like it when it is too formal and polished, frankly, and I really do love the fact that everyone is such a freak.

"Having access to your weird, private space—essentially walking into your bedroom—is a privilege to be treated as such. You are showing me things that matter to you and I am a stranger you have never met. I have thirty seconds to figure out who I need to be to make you comfortable enough to tell me the things you care most about." **Shamim Momin, curator, Whitney Museum of American Art, New York**

————————"Lead the studio visit: you have control. Know what you want them to take away. It is one message if it is a dealer. Another if it is a collector. Another if it is a curator. Know what you want out of the studio visit. Craft your narrative around it." **Edward Winkleman, Winkleman Gallery, New York**

————————"Articulating what they're doing is important. They don't have to be great public speakers, but they do need to be able to explain themselves. And that can be in so many different ways. But it has to come across clear because if you're having a dialogue about whatever they're making and they can't respond with any kind of social, historical, or psychological reasoning that's clear, then forget it." **Tim Blum, Blum & Poe, Los Angeles**

————————"It turns me off the most when artists are clueless about other work that might look like theirs or laid the groundwork for what their work is doing. I get excited when an artist knows the tradition in which they are working. I get excited when I hear an artist talking about another artist's work. It shows a passion for art that isn't about being an art star. They do not have to be eloquent, but something must be communicated. It shows there is an active intelligence." **Michael Darling, curator, Seattle Art Museum, Seattle**

————————"The hardest thing to do is balance humility and grandiosity. Artists need to believe they are the greatest artists ever. The flip side is that countless artists say 'I'm doing something that no one has ever done before.' Show me your work and I'll give you three names in thirty seconds of people whose work looks just like yours. I don't want to hear that you're completely new and original. Explain to me where your work fits into the art historical continuum." **Cornell DeWitt, private dealer and consultant, former gallery owner and director, New York**

a curator comes away from a visit thinking the work is perfect for a show, he or she will usually need to collaborate with colleagues and directors before making any final decisions. This can literally take years. And, as we discuss more fully in chapter 8, there are lots of reasons a curator or gallerist may not end up including an artist's work in a show, regardless of whether the person loves the work.

The healthiest way to deal with this is to continue making your work and occasionally send updates to the person who visited your studio.

STUDIO IN A BOX

Sometimes you need to bring your work to your "visitor" with a virtual tour on your laptop. This is a good option if you live off the grid and can't expect a lot of traffic through your studio, or if there is nothing in your studio because, for example, you make large-scale installations or sculpture. (By the way, if the reason there is nothing in your studio is that your work is in an exhibition, take your visitor to the show, not your empty studio.)

Your presentation can be a simple slide show of your work that you narrate in person. Maybe you include some detail shots, installation photos from past exhibitions, or studio views. Keep it to a digestible length—around ten minutes—and practice your presentation before you actually sit down with a gallerist or curator and deliver it. Curate your presentation the same way you would for an actual visit. It should be smooth and organized, with an emphasis on the work.

Be ready for technical problems. Bring your charger and have a couple of backup disks (for Mac and PC format) that you can use on the gallery's computer if all else fails. You can leave one of those extra disks behind when your tour ends.

PORTFOLIO REVIEWS

Another crucial form of feedback is the portfolio review, where you meet with a curator, gallerist, or other arts professional to discuss an aspect of your practice. Many arts organizations (and even the occasional gallery) will hold them throughout the year. The review could focus on the quality of your work, your ability to present it, or the effectiveness of your submission materials. A few tips for going to a portfolio review:

—The host organization will announce the focus and format of its upcoming review so you can prepare accordingly. These parameters are typically strict: fifteen minutes really do end after fifteen minutes. Think about what you want from the review and why. The more specific your questions are, the more helpful your feedback will be. Prioritize your goals in case you don't have time to get to every one. Look up the reviewers' backgrounds to get the most out of your time with them.

—Don't forget to listen. If you talk the whole time, you won't get any feedback—which is presumably what you're there for.

—Never bring original art to a portfolio review. You'll waste precious time unwrapping and displaying it, not to mention the risk of damage. Bring images—your best images. You want to spend your time talking about the work, not explaining what's wrong with the images. And make sure you indicate the actual scale and materials of each work.

—One body of work is usually all you'll have time for, so pick what you want the most feedback on and stick to that.

—Bring your statement and résumé, since reviewers are usually willing to give feedback on those, too, if there's time.

—Bring a takeaway, such as a postcard, for the reviewer in case you're asked for one.

More Advice for Portfolio Reviews
Clint Willour, curator, Galveston Arts Center, Galveston, Texas:

1. Do your homework and know who I am and why I'm doing this.
2. Don't show me fifteen images in fifteen minutes and then tell me you have three more bodies of work when they announce that we have five minutes left in the review session.
3. If you talk for the entire session, it doesn't leave much time for my comments, does it? And listen to what I say. Just because I don't respond to one picture doesn't mean I hate your work.
4. Don't hand me a pair of white gloves and tell me how to handle your prints. There's a reason they asked me to review portfolios.
5. Always have some materials with at least one image to leave with me if I ask for it.
6. Always ask if I would like to have the packet of materials that you are about to give me. Sometimes I won't. And please don't add me to your email blast list without asking me.
7. Don't apologize for being disorganized. Get your shit together and you won't have to.
8. Don't show me work that I've seen before. I have an image memory that would scare the pants off of you.
9. And speaking of that, don't show me a photo of your naked crotch and ask me what I think of it. (Believe me, this happens way more often than you would think.)
10. At the end of our session, don't ask me what I can do for you. I just did it.
11. And just so you'll know, I've only made three people cry and torn up one photograph in the twenty-two years I've been doing this and I've made hundreds of life-long friends in the process.

Courtesy of glasstire.com.

CHAPTER 6
Residencies and Grants

Want some free money? How about a free studio?

There are literally thousands of programs across the country whose sole mission is to support artists. These programs typically give awards to a number of artists each year after an application-based competition. The awards fall into two main categories, which we like to call by their technical names: "cash" and "stuff."

Cash includes grants and other monetary awards. Most cash programs award grants for specific projects only. These grants are "restricted," in that you can only use them for expenses related directly to the project you propose. Some cash programs award fellowships and other "unrestricted" grants (also called "general operating support"). They give you money just because they believe in you. These awards range from a few hundred dollars to the $500,000 MacArthur "genius grant." With an unrestricted grant, you can spend the money on literally anything.

A few organizations also offer "emergency grants" to artists facing unexpected catastrophe such as fire, flood, eviction, or serious medical emergency.

Stuff is everything other than cash: residency programs, studio programs, equipment programs, etc. Basically anything that involves more than just money, even if some of these programs include cash stipends.

Residency programs are the most popular. They're a great way to build community, develop your practice, or learn new techniques. Typically, you live and work with a group of other artists in a supportive setting from one week to more than a year. Some residencies are very hands-on and social: you'll attend lectures, show your work to visiting curators, and get career mentoring from the staff. Other residencies are designed to let you focus on your work without distraction. You might get keys to a live-in studio and a show at the end of the month. You can find residencies in bustling city centers, on rural farm-land, and in the mountains. They even have them in the Caribbean.

Studio programs (or "space programs") are similar to residencies, except that you don't usually live there during the program. They're mostly found in urban areas where real estate is expensive. If you're having trouble finding affordable studio space, these programs are a godsend. Some space

————————"I apply for grants because they keep

me less dependent on the commercial system. That has

been important for me all along: finding ways where

I won't have to sacrifice the quality of my work by making

repeats or more saleable pieces. In the early days

it was my day job—now grants and teaching keep me a

better artist."

Charles Long, artist, Mount Baldy, Calif.

————"Artists focus too much on opportunities that are prestigious. There are so many opportunities for traveling around the world. My best experience was in Taiwan in 2004 at the Taipei Artist Village. It changed my work. Up until then, I had only photographed rural settings. This was entirely urban." **Leah Oates, artist, Brooklyn, N.Y.**

————"At our residency, you are allowed to fail. It is a testing ground for dynamic conversation." **Shannon Stratton, artist and director of ThreeWalls, Chicago**

————"Residencies are a window on what's happening and they provide networks and contacts to the artist so he/she can grow. Hopefully the artists learn how to discuss their work—because they are going to be doing that a lot with colleagues and visitors—and learn practical issues around their work. For instance, they will not produce something bigger than what fits in their limited studio or use materials they cannot buy in the area. They have to present something that is representative of what they do within the constraints of the residency. There are a lot of things to sort out." **Micaela Giovannotti, curator and critic, Art Omi Critic 2008, New York**

————"Most applications are very basic. You fill out your name and send twelve images. If you are not even doing that, are you considering yourself as a serious artist?" **Alessandra Exposito, artist, Queens, N.Y.**

programs offer regular workshops, open studios, mentoring, and other guidance. (A lot of people call these programs "residencies," by the way, even though technically that's not what they are.)

A handful of other programs offer artists the use of expensive equipment such as printing presses, sound-recording studios, or photography labs. And there are a smattering of programs that award apprenticeships, commissions, or relatively small stipends for "inexpensive" supplies such as paint.

Not all stuff is 100 percent free, by the way. It might be subsidized or heavily discounted, requiring you to cough up the rest.

A COUPLE OF IMPORTANT CONSIDERATIONS BEFORE YOU APPLY

Important Consideration #1: You

There are over three thousand arts-related funding sources in the United States, which run more than six thousand different programs. *Maybe* fifteen of these programs will fit you at any given time in your career, because each program has its own mission; each one aims to support particular types of artists, or types of art, or regions of the country, or other demographic categories. It is a waste of your time and energy—and will prove extremely discouraging—to apply to every funding source you come across. To figure out which ones make sense to apply to, think hard about:

What You're Doing
—What kind of artist are you?
—What subjects does your art relate to?
—What are you trying to accomplish through your art?
—Who is your audience?
—What effect do you want your art to have on your audience?
—Where do you think you fit into recent art history?
—What and who are your artistic influences?

—Are you affiliated with any organizations that support the arts?
—What is your demographic?

What You Want to Do
—What do you want to make?
—How do you want to develop your practice?
—In what directions do you want to go?
—Is there a medium you haven't worked in yet but want to?
—What kind of environment do you want to work in?
—Do you want to interact with people outside the art community?
—What specific project or body of work do you want to tackle next?

What You Need
—Does anything stand between you and the art you want to make?
—How much time do you need to complete the project?
—Do you need studio space?
. . . access to expensive equipment?
. . . materials or fabrication?
. . . training or practice in a particular technique?
. . . mentoring?
. . . a place to live?
. . . other artists to collaborate with?
. . . total solitude?

Important Consideration #2: Them

You will be a happier, more effective applicant when you understand how programs work, what they offer, to whom, and why.

Foundations and other entities that run award programs are usually set up as nonprofit organizations (or "501(c)(3)s") because of the tax benefits that come with nonprofit status. Families and companies that create foundations can use them to lower their overall taxes, as can individuals who donate to them. The people who start these foundations generally care a great deal about art. They understand that without support, many artists couldn't make their art at all, either because they're

—————"I've sat on juries with serious curators and very specific metrics, juries that meet several times a year. I've also sat on juries that meet over coffee once a year and don't appear to have any specific metric at all. Just last week I was on a committee where people seemed to just be picking things they liked, saying 'I don't know, how about this?' or 'I kind of like that one.' I tried to bring some focus, saying 'Wait a minute, do we want to talk about any criteria here? What are we going for?'" *Melissa Potter, artist, faculty, Columbia College, lecturer, New York Foundation for the Arts, New York*

—————"I think it's a matter of understanding what they are asking for. It's something I talk about a lot in terms of reading and asking 'Who am I? What are they asking for? Who do I match with?' I end up using the example of the arts organization Creative Capital because for years I have told myself that I have to apply. This year, I was just dragging my feet and finally realized I don't do project-based work that is community-based. That's not what my work is about and I'm just not going to work with their funding type. I will apply to them someday when I have that kind of project and it feels right." *Christa Blatchford, artist and program officer for artist learning, New York Foundation for the Arts, New York*

not established enough to get a gallery to cover their production costs or because their work is too experimental for the art market.

These organizations run the gamut from small endowments with very specific missions to enormous umbrella organizations dispensing millions of dollars a year. Some are extremely efficient and well run; others are less formal in their structure or, frankly, less consistent in their decision making. Knowing the size and reputation of the foundation you're applying to will help you calibrate your expectations.

The law requires nonprofit organizations to disclose a good deal of information about themselves to the public, so you should be able to find out everything you need to know about a program before deciding to apply to it. Bigger programs have websites with frequently asked questions or other user-friendly guidelines that tell you what they're looking for. Smaller programs don't post as much information on their websites (some don't even have websites), but if you search online for a particular program you might find it mentioned in local news articles, described in institution brochures and annual reports, or listed in the résumés of past recipients.

Every nonprofit has to file a "Form 990" with the IRS, disclosing relevant financial data, the awards it has granted, its officers, its trustees, and other details that give you a sense of how the foundation operates. A Form 990 is not the most user-friendly document in the world (surprise!) but it may be the only source of information about the program you're looking into.

The Foundation Center (foundationcenter.org) is a phenomenal resource for researching granting bodies. It provides detailed financial information about funders, including an exhaustive database of Form 990s, as well as trend reports, educational materials, and training courses. Another comprehensive resource is the New York Foundation for the Arts (NYFA). One of its goals is to identify and describe every arts-related award program in the country, and it appears to be succeeding: there are already thousands of programs in the "NYFA Source" database and it's still growing. You can access it for free at nyfa.org and use the Advanced Search function to zero in on the cluster of places most likely to offer the kind of support you're looking for.

Nonprofit organizations have to go through a similar application process to secure their funding.

——————*"When approaching foundations, it is important to find the right fit instead of trying to mold your programming around the foundation's mission. Early in our history, we received support from St. Paul's Jerome Foundation midway through an exhibition season. Unfortunately, since we had submitted our proposal, our list of exhibiting artists had changed to the point that our season no longer fit within Jerome's guidelines. Rather than readjust our season, we had to make a difficult decision to return the grant and stick to our lineup of exhibitions. It was a $5,000 grant and at that point our budget was only $30,000 for the year, so it was substantial, but we decided it was not worth changing around the program. That was a major decision because it really changed the way we thought about our commitment to our mission and programming."* **John Rasmussen, director, Midway Contemporary Art Center, Minneapolis**

——————————"When we talk about granting and grant prospecting in workshops, we talk about the fact that, as a visual artist, you need to think about what you need. Most people think they need cash, but cash doesn't happen all that easily. What happens more easily are things like time in a residency or connecting with other people. A lot of programs give you access to people or equipment you may not have otherwise.

"So we encourage people to think about it in the broadest sense. Who am I? What do I really need?"

Christa Blatchford, artist and program officer for artist learning, New York Foundation for the Arts, New York

The federal government lists its grants on grants.gov. You can find state and city government grants online by looking up your local council on the arts and department of cultural affairs. Check the websites of public spaces, such as airports, government buildings, and libraries, to find commissions and other funding opportunities.

You can also find funding *outside* the art world. A foundation may hand out grants related to the subject matter of your art, for example, even if they're not specifically geared toward artists. Foundations in the sciences are a particularly good place to look, as some of them are interested in new ways to visualize scientific principles. The National Science Foundation, for example, has an artist residency in Antarctica.

Take your time researching programs. Set aside a few afternoons and dig in. It's worth it. Instead of hearing about everything last-minute from your friends, you'll know which deadlines are coming up long in advance. And you will have already figured out which programs are the right ones for you and which ones you don't need to worry about this time around.

Here is what to look for when doing your research:

—*Type of award.*
 This is the fastest way to narrow your search. Is it cash or stuff? An apartment in Texas or studio space in New York? Is it only for making new work, or can you use it to show old work (or to continue working on unfinished work)?

—*Eligibility.*
 This is the second-fastest way to trim the search. Is the award only for artists in a specific region, state, or city? Is it for a certain age group, gender, or ethnicity? Is it for artists at a particular place in their careers? Some awards are only for students, others are specifically *not* for students. Some awards rotate disciplines: last year for theater, this year for dance, next year for visual arts.

—*Size.*
 How much money is the grant? How long is the residency?

—*Frequency.*
How many times a year do they give out awards? Some programs dole out awards a few times a year; others are once a year or even once every few years.

—*Deadlines.*
Do you have enough time to apply this round? Or will your application be much stronger if you put more time into it and apply for the next deadline?

—*Turnaround.*
How much time between the deadline and the award? How often does the selection committee meet?

—*Alumni.*
Who were last year's recipients? (Also called "grantees.") You can usually find a list of grantees on an organization's website. Go to these artists' websites to see their work and their résumés. Is your career in the same place, give or take a few years? Be realistic about what the program is looking for.

HOW TO APPLY

Two words: *follow directions.*

That's basically it. Yes, we have more to say in this section, but none of it is as important as those two words. Award programs actually do mean what they say in their instructions. If a residency announces on its website that "we are not accepting any applications until next March," don't send your application in before March! When a form states, "include six work samples," *include six work samples.* Not seven, not five, not forty-five. Six.

No one is trying to cramp your style or compromise your individuality here. They're just trying to be fair to the other artists by comparing the same set of materials from everyone. They also want to see that you take the program seriously.

————"Just be simple and clear and who you are. And know enough about the thing you are writing for so you address it in some way. We get letters of application from people also applying to teaching positions and it is the same letter. You can hear it. It's been tweaked a little, but it's basically the exact same letter they wrote for the teaching program. It makes us think we are not necessarily the right program for them because they haven't researched us carefully enough."
Joseph Havel, artist and director of the Core Program, Houston

Show them you understand that this is a professional endeavor, not some casual roll of the dice.

Many programs will tell you what they focus on when evaluating applications. Of all the directions to follow, these are the most important. They're not as easy to spot because they're not necessarily written in the form of direct directions but rather as "criteria." You might see something like this: "Artists' Fellowships are chosen based on the single criterion of work that demonstrates a compelling vision as defined by the assembled panel's collective opinion." Note the words *single criterion*. They're telling you up front that there's only one thing that matters: "work that demonstrates a compelling vision." This program will make a qualitative assessment of your work, period. You therefore need to spend the most time on that part of the application and submit the best-quality images you can.

Compare that to a foundation looking for projects with "socially relevant outcomes" or a "community response." These words mean you need to show a *result,* such as raising social awareness, enriching a political discussion, or triggering community activity. There's an organization, for example, that funds "works and projects that advance gender equity in our cultural, artistic, intellectual and political spheres, and that provide a forum for broader discussions of the urgent social justice issues of our day." *How* your project would attempt to accomplish this result is just as important to the committee as the quality of your work.

Chart Work

We strongly recommend creating a chart that tracks the progress of your applications. Include basic information about the program, the type of application, important dates, contact information, and anything else you find helpful to have in one place:

If You Don't Answer ALL the Questions, You're Not Following the Directions

A surprising number of artists think it's okay to leave some questions on their application blank—as if answering were optional—or to write "see answer to Number 3, above" when they think two questions are asking the same thing.

Don't be one of these artists. There are selection committees out there that will *disqualify* you for it.

Whether two questions overlap is simply not a debate you want to have with the selection committee. The people who wrote those questions are not trying to waste your time any more than they are their own. So you can safely assume that they don't think the questions are redundant, even if you do. And since they're the ones who will decide whether you are accepted or rejected, it's best to just roll with it and answer their questions. All of 'em.

APPLICATION PROGRESS							
ORGANIZATION	AWARD	APPLICATION	**DEADLINE**	SUBMITTED	RESPONSE	FOLLOW-UP	CONTACT
NYFA	$7000	online	1/15/09 post-marked	1/6/09	pending	left vm 3/16/09	jason (212) 555-1234
FarmArt	residency	paper 8 copies	2/15/09 delivery	2/5/09	accepted 3/15/09	thank you sent 3/21/09	beverly (555) 234-5678
Little Boxes	residency	online	11/30/08 post-marked	11/2/08	rejected	—	sarah sbh@cf.org
Airport Council of the Arts	$2500	online	rolling				cliff cliff@ap3.gov

—*Organization.*

The name is enough, though it can't hurt to list a mailing address and website, too.

—*Award.*

What it is (stuff or cash).

—*Application.*

Note whether it's a physical application, online application, project proposal, or something else. This is where you can also list the specific materials you need to submit (for example, résumé, three work samples, two letters of recommendation) and check them off as you complete them. If that clutters up your worksheet too much, make a checklist for each application on a separate page.

—*Deadline.*

Programs that accept applications at any time of year have "rolling" or "ongoing" deadlines. For programs with exact deadlines, be careful to note whether the deadline is a "postmark" date (that is, the post office must stamp your

application by that date) or a "delivery" date (the program has to receive your application by then).

—*Submitted.*
The date you submitted everything.

—*Response.*
The date they got back to you (and what they said). You might also note when you *expect* a response. You can usually find the date programs send out notification letters on their websites. For programs with rolling deadlines, you can estimate the turnaround time by looking up when the selection committee meets to review applications; if it's not clear, ask the program officer.

—*Follow-up.*
It's nice to write a thank-you note, whether you received the award or not. And, as we discuss later in the chapter, you should take advantage of any feedback a program offers for rejected applications.

—*Contact.*
The name, phone number, and email address of the program officer. A program officer manages the award process from beginning to end: solicitation, review, selection, and notification. This is your point person for questions and feedback—but take a minute and check that you're not asking about something that's already addressed in the application itself or, say, on the website's frequently asked questions (FAQ) page. Not all program officers have a background in art. They may come from some academic field, law, finance, or something related to the foundation's specific mission.

APPLICATION MATERIALS

You already know from chapter 3 how to put together your work samples (images), résumé, artist statement, and SASE.

You may also have to submit an artist biography, which we went over in chapter 4. There are a few more items you might need in order to apply for cash and stuff, which we'll go through now.

Cover Letter

We mention this first because it is the first part of your application, but it's the last part that you should prepare. Your cover letter will serve as the most succinct introduction to your application and your work, so it will be easier to write *after* you've updated your artist statement and finished your detailed project narrative and budget. Keep it to one page.

Cover letters follow a standard format and tone:

—First, tell them what you want: "I respectfully request your consideration for a grant of $5,000" or "I respectfully request your consideration for the XYZ residency program." Or something equally clear and courteous.

—Second, explain what you will do with the money or how you will spend your time at the residency: "With this grant, I will spend three months in Ecuador to complete a new body of photographs" or "During the XYZ residency, I will have the time and facilities I need to edit a new video exploring the effects of urban sprawl."

—Third, briefly describe your experience, qualifications, and other biographical information that tells the program why it should accept your application. Emphasize the foundation's priorities. We'll discuss this topic more in the Project Narrative section below.

—Fourth, if the award is based on social change or activism, state who will benefit from your proposal.

—End with "Thank you for your consideration."

Date

Program Officer
Granting Organization
50 Gold Street
Bellemont, NY 10456

Dear Program Officer:

I respectfully request your consideration for _____. Briefly explain what you will do if you receive the award. This is essentially a one-sentence summary of your project narrative's Project Description section.

Describe your experience, qualifications and biographical information, as they relate to the organization's priorities. This should summarize the most important points of your project narrative's Background section.

Thank you for your consideration.

Sincerely,

Sign your name
Type your name

Artist Name, 20 Pineapple Street, Los Angeles, CA 90001
www.artistname.net

WHEN I GROW UP I WANNA' BECOME A PERFORMANCE ARTIST AND PUT EVERYDAY OBJECTS INTO MY ANUS.

Project Narrative

Your project narrative is a detailed explanation of your project. As with cover letters, there is a standard structure—though some applications may ask for a particular order or emphasis, in which case you obviously need to follow those instructions. Typically, you'll organize your project narrative like this:

—Executive summary.
A concise, one-paragraph summary of the rest of the narrative. It should include your request and briefly describe the project.

Do this *after* you've finished the other sections of your narrative. (You can then use your executive summary as a starting point for your cover letter.)

—*Background (or qualifications).*
Explain your interest and experience related to the work you are proposing. The key is to tie your background and experience to the foundation's priorities. This should be straightforward if you went through the Important Considerations exercise at the beginning of this chapter. The reasons that led you to apply to the program in the first place probably have something to do with your background and qualifications.

—*Project description.*
Explain what your project is. Use the same process you used for your artist statement in chapter 3—brainstorm, outline, draft, edit—to transform your thoughts and motivations into a coherent narrative. Yes, it is easier to describe a specific project than to come up with an artist statement, but it's not *so* easy that you should skip the writing process altogether. And similar guidelines apply: be direct and simple; avoid metaphysical complexity and pseudointellectual jargon. State what you want to accomplish in as few words as possible. Don't forget the basics: who, what, where, when, why.

—*Timeline (or schedule).*
Give as much detail as space allows.

—*Audience.*
When relevant, state whom your project serves, including numbers and demographics if possible.

—*Expected outcome.*
Discuss your goals and predictions for the project.

—*Thanks.*
End by thanking the committee for its consideration.

Terms vary from program to program, so pay attention to the vocabulary each program uses and mirror it. If they ask for a "schedule," give them a "schedule," not a "timeline." Using their terms eliminates any potential ambiguity. It makes it easier for a jury to quickly find what it is looking for in your application and focus on the substance of your proposal.

Always separate the executive summary from the rest of the project narrative with a section header. For long narratives, it's helpful to use headers for the other sections, too.

Speaking of length, *mind the page limit.* Don't even think about going over. It's fine if your first draft is too long, because you can cut it down. But leave yourself plenty of time to do that and have someone proofread the final draft before you submit it.

Project Budget

Some applications give you a budget form to fill out, which is great because you don't have to guess what they're looking for. Other applications just ask you to attach a budget and expect you to know what that means. When they do, err on the side of too much information. List all project expenses *and* project income to demonstrate that you've thought through how you're going to fund the project. When you're done, your budget should complement your project narrative.

There are several ways to put together a budget; you don't have to do it our way. If you find one that's more intuitive for you, by all means run with it. Here's a basic budget template:

PROJECT BUDGET		
EXPENSES	AMOUNT	EXPLANATION
personnel		
travel		
equipment		
supplies		
TOTAL EXPENSES		
INCOME	AMOUNT	EXPLANATION
earned income		
contributed income		
in-kind contributions		
TOTAL INCOME		
TOTAL REQUEST		

Project Expenses

—Personnel.

Include any wages you'll pay assistants, website designers, production people, contractors, lawyers, or other consultants. Make sure you're paying them at going professional rates.

Freelancers have to take a fee based on the value of their work. (You can't pay them a percentage of the award because the size of the award is not related to what they do for you.) You can't include yourself under "personnel" and carve out a part of the award as your salary, but you can and should use the award to cover your direct project expenses (see "Travel, equipment, supplies" below). Because most funders will not cover your personal expenses—daily costs unrelated to your project—you'll need to find other ways to pay for those, such as a part-time job. And if you do find a program that covers personal expenses, be excited. Creative Capital, for instance, encourages artists to allocate a percentage of their project budgets to an "artist fee."

—*Amount and explanation.*
Put the total expense of an item under "Amount." Show your math in the "Explanation" column by writing out, for example, a consultant's hourly rate, multiplied by the number of hours per day, multiplied by the number of days: "$27/hour x 4 hours/day x 2 days."

—*Travel, equipment, supplies.*
Most funders cover these kinds of direct project expenses, as long as they're reasonable (you can't start flying first-class, but you can take a taxi to the airport). Do your research here. Call stores; look up ticket prices; confirm rental rates for space and equipment.

—*Amount and explanation.*
Same as above, only here you'll break down the amount into price per item: "($1.75 per lightbulb) x (450 lightbulbs)" or "($150 per roundtrip train ticket) x (2 trips)."

—*Total project expenses.*
Add up the Amount column. This is the total cost of your project.

Project Income

—*Earned income.*
This refers primarily to the income your project will generate
(if any). A project that culminates in an exhibition might
lead to sales of work, for example. For other ways your project
might generate revenue, think like a museum: a public art
installation could generate ticket sales, tours, education work-
shops, merchandise, and concessions. Estimate the revenue
from each of these potential sources. This is also where
you would put any money you intend to raise for the project
with an event or, say, from selling items conceptually related
to the project (the bake-sale model). Don't put grants and
other awards here; that goes in the next section.

In-kind contributions should relate to expenses.
You'd list donated space as an in-kind contribution,
for example, *and* the rent for that space in the
expenses section.

—*Contributed (or unearned) income.*
List money you received (or will receive) from awards,
donations, and corporate sponsorships—*including the award
you're applying to with this budget.* Since most grants won't
cover the full cost of a project, you'll need to cobble together
several sources of funding. Put them here to show the
program how its grant will fit into the picture. Don't leave out
programs you've applied to but haven't heard back from yet—
just indicate that the award is "requested" or "pending."
(There is nothing wrong with having outstanding award appli-
cations in your budget. Programs *want* to see that you're
not relying solely on them to get your project off the ground.)

—*In-kind contributions.*
List the cash value of space or equipment people will donate to
your project. (Cash value is what you would have to pay for
the item, not what it "costs" the donor to donate it.) As always,
show your math in the Explanation column.

—*Total project income.*
Tally up all the numbers in the Amount column (from the
Project Income section only). This is the total income
from your project. Ideally, the total income from your project
will equal its total cost. A small deficit or surplus is fine,
but too big a discrepancy means you have a problem with your

budget: either you don't have enough funding to cover the project or you're asking for more than you really need. (That is, more than you "need" to fund the project, as opposed to funding your groceries.)

—*Total request*.
This is what you're asking for in your application. It's the same number you already entered under Contributed Income, along with the other grants you have applied for or received. Separating it out at the bottom makes it easier for the selection committee to quickly see the requested amount.

Be careful with any expenses a program says it won't cover. Include them in your budget—but create specific lines in your income section to show that you plan to cover them with another funding source, so it's clear you're not asking the program to pay for something it's already said it wouldn't pay for.

If your project income doesn't completely pay for your project expenses, it's all right to say in a footnote at the bottom of the budget that you intend to cover the difference personally—but this is a bit tricky if you're talking about a significant amount of money or a big percentage of the total expenses, which is why you may want to deal with it separately from what you list in the Contributed Income section. A lot of selection committees take your financial situation into consideration, whether it's an explicit criterion for that grant or just a subconscious sense of who needs help most. You don't want to seem so needy that the committee feels you won't be able to finish the project, or appear so wealthy that they feel you don't need the money. Ask the program officer whether what you're proposing is appropriate for the grant you're seeking.

Some artists find it more intuitive to leave out the amount of the award they're applying for so that the difference between a project's total income and total expenses equals the amount they're requesting. Say your total expenses are $7,000 and your income is $5,000 before counting the $2,000 grant you're applying for. Instead of listing the $2,000 under Contributed Income, as we suggest above (in which case total income and total expenses both equal $7,000), you would exclude the $2,000 and list total

expenses as $7,000, total income as $5,000, and the requested amount as $2,000.

Make your budget with Excel or another spreadsheet program. Word-processing programs are *not* the way to go. If you're uncomfortable with spreadsheets, get comfortable. It takes a lot less time to teach yourself how to set up automatic calculations and other shortcuts than it does to recalculate your budget by hand every time you add some new expense or adjust a particular price estimate.

And make it easy to read. Use a large font, bold the totals, put a box around the Total Request—whatever you think makes it clear and user-friendly. Also, "serif" fonts—the ones with the little hooks and bumps around the edges—are apparently easier on the eyes than "sans serif" fonts (according to NYFA). Whichever font you choose, use it throughout the entire application.

Financial Information

Applications often require a "Statement of Need" or other personal financial information beyond what you include in your project budget, such as income tax returns and bank-account statements. You may also have to estimate your total monthly income and expenses and list how much you make from selling your artwork.

Fee

You might have to pay a fee to help cover the program's administration costs.

Reply Postcard

Include a self-addressed, stamped postcard for the program staff to send you to confirm that your application was received. This is in addition to a SASE they can use to return your materials.

Letters of Recommendation

The most effective letters of recommendation come from people who know you and your work well, *and* whose perspective matters to the selection committee. Look through your CV for everyone who has mentored you, or seen, curated, or written about your work. Who is relevant to the award you're applying for? If your project has an academic bent, for example, ask one of your former professors. Or say you're applying for a residency program that emphasizes community participation: an artist or curator who can talk about how active you are in the community would make sense.

Keep your references current. While professors are an obvious place to go for recommendations, the longer you've been out of school, the less relevant their recommendations will be (unless, of course, they stay in touch and continue to follow your work).

When you ask people to write a recommendation, send them a link to the award you're applying for. Show them your project narrative and images of your latest work. And ask whether they'd like you to give them a list of qualities you want them to emphasize in their letter.

Some applications ask for "additional support materials." These can include brochures, catalogs, or letters of recommendation. If you're proposing a project that's more ambitious than anything you've done in the past, letters of recommendation— or a letter from the venue or community in your proposal—can have a huge impact on the jury.

FINALLY!! A GRANT FOR 43-YEAR-OLD UZBEKI LESBIANS.

FISCAL SPONSORS

Many government bodies give awards to nonprofit organizations, not individuals. To access these grants you need a "fiscal sponsor": a nonprofit organization that technically applies for the grant on your behalf. In essence, the organization lets you use their nonprofit status to apply for the award. You're still the one who prepares the application, but some fiscal sponsors offer technical assistance and financial services during the application process.

Many nonprofits advertise themselves as fiscal sponsors on their websites. And even the ones that don't can become sponsors if you ask them to. Keep in mind that to get a fiscal sponsor you may need to go through a separate application process, which can add a good deal of lead time to your project. Some organizations have a formal process that is similar to applying directly for a grant, while others are willing to lend their name and nonprofit status without a lot of paperwork.

Just about any nonprofit organization can act as a fiscal sponsor (it does not have to be an arts organization). To start your search, check the websites of large donor and government organizations, such as the National Endowment for the Arts, and see who their beneficiaries are. Those are the places that have received grants—voilà your potential fiscal sponsors. The New York Foundation for the Arts is one of the largest fiscal sponsors in the country; its website is another good place to search. You can also look to your local nonprofits.

Once you've found the right fiscal sponsor, you'll need to sign a contract with it before applying for the grant. Make sure you retain creative license and ownership of the project. The contract should also state whether your fiscal sponsor takes a flat fee or a percentage to cover administrative costs (this could be up to 15 percent of the money you raise). It may also say something about the organization ensuring that you use the money according to the grant's protocol. Many fiscal sponsors have their own forms. As with all contracts and legal documents, you should take it to a volunteer lawyer for the arts or some other pro bono legal advisor to look over and make sure you're getting what you deserve out of the arrangement.

Remember to include in your project budget any fees you'll have to pay your fiscal sponsor.

————"Getting a fiscal sponsor allowed me to apply for more grants (since many granting organizations can only give to nonprofits) and to solicit tax-deductible donations from individuals. Having NYFA, or another big organization, as your sponsor has the added benefit of providing a sort of 'mark of approval' since their process for determining whether to sponsor a project is fairly rigorous. The process sets you up well to write more grants and their name has recognition with a number of grantors." *Eve Mosher, artist, Brooklyn, N.Y.*

————"No one grant is perfect for everyone. It's definitely not a quality assessment. People have to remember that grant bodies are panels of professionals who all have their own set of prerogatives and preferences and it's really quite unusual that you might fit in.

"I got a couple of residencies in the past, which have all been great, as well as some really helpful grant support, but the first major grants I got after applying to many others, and getting rejected, was a Guggenheim Memorial fellowship in 1998, followed by a Joan Mitchell grant the next year. They really helped me out at a critical moment. It was at a point when I was going to have to change the way I worked or otherwise reassess things. There was a lesson in that for me— the other grants would have been great, but there were some that really helped when I needed it most." *Michael Joo, artist, Brooklyn, N.Y.*

One of the biggest benefits to having a fiscal sponsor is that private individuals can receive tax credits for donating to your project, regardless of whether you receive other grants.

Pssssssst—You Have to Pay Taxes on Grants

Hard to believe, right? After scraping together a bunch of grants just to make a project happen—a project that may not even recoup its own costs—you have to turn around and pay income tax on the funds you raised. Well don't blame us; we're just the messengers.

The federal government considers a grant to be taxable income, meaning you owe a percentage of the grant in taxes the next time you file. You'll probably be able to deduct a lot of that amount thanks to your project expenses—but not all expenses are 100 percent deductible, so you'll still have to pay something. And if you thought putting together your project budget was complicated, just wait till you try to figure out your line-item deductions! This is why we highly, highly recommend paying for professional tax help. Once your project gets into thousands of dollars, it really is worth the two hundred dollars or so to hire an accountant who can figure it all out for you.

Unfortunately, artists almost never include estimated taxes (or related accountant fees) in their project expenses. That doesn't mean those costs aren't legitimate project expenses—we think they are—but it is decidedly *not* industry custom. In most cases, foundations seem to expect artists to use other funds (that is, not grant money) to pay the taxes owed on grants. With very large grants, however, you may be able to include the taxes and accountant fees in the project expenses. Once again, ask the program officer for guidance.

NOW WHAT?

Congratulations, you got your application in. Plan on waiting a long time before you'll know whether you were accepted. It can take up to a year for some programs to distribute their awards.

After the application deadline passes, the program officers begin reviewing all the applications. This can take months. First, they return applications that are incomplete or clearly unqualified. Then they compile the rest and eventually present them to the selection committee at a meeting (or series of meetings, depending on how many applications there are). The committee members review the application materials and choose which applicants receive awards. Then they send out letters notifying recipients. Some time after that, the actual awards go out.

Many programs post these dates on their websites so it's a less mysterious process.

FOLLOW-UP

Once you hear whether or not you've received the award, consider sending a thank-you note to the program officer to acknowledge his or her time, even if you didn't get in. It's another way to show your continued interest in the program.

A few programs offer feedback on applications. Whether you were accepted or rejected, take them up on this offer. (Most people don't). It's the best way to learn what you did right, what you did wrong, and whether it makes sense to reapply. Even if they don't advertise feedback, you can always call the program officer and see whether he or she will discuss your application with you.

And keep in mind that many grant recipients and artists-in-residence had to apply several years in a row before their applications were accepted. We even know of an artist who got into a popular program at a New York museum *on her seventeenth try*. That's obviously the extreme end of the spectrum—if you've been rejected six times you're probably better off directing your energy elsewhere—but so is getting in on your first attempt, given the daunting number of applicants. (To see just how daunting, check out chapter 8, where we talk about rejection.) The point here is that selection committees expect to see repeat applications and will look at them as a sign of commitment and determination, not some sort of failure. And with a lot of programs, committee membership changes year to year, so what didn't make the cut one year could very well make it the next.

So if you get rejected on your first try, reevaluate your application as objectively and honestly as you can, confirm that your goals still match the program's the next time you can apply, update your application, and send it in again. If you get rejected on your sixth try, you might not be as good a fit for the program as you thought.

CHAPTER 7

—————— Showing Your Work

—————"The idea of what an artist is has really shifted, especially in New York City, to become really, really gallery-centric. Sometimes I think about NYFA and how we have an obligation to guide artists toward a fuller idea of what being an artist means. It means participating in your community. It means showing at nonprofits as well as commercial galleries." *Christa Blatchford, artist and program officer for artist learning, New York Foundation for the Arts, New York*

—————"Think about the long term. What is going to be the best long-term goal for your work? What's it going to be like in twenty years from now when you've reached mid-career?" *Andrea Rosen, Andrea Rosen Gallery, New York*

—————"There is nothing like doing something on your own to make people want you. That's something people don't realize. When commercial galleries are the only thing artists are looking to, there's this impression that gallerists are going to make their lives better and they have all the power, instead of 'Okay, I'm going to do this project and it's going to be exciting and engaging to me and I'm going to meet people and maybe I'll sell some work and maybe I won't.' You have to decide how you want to exist as an artist and what is reasonable. Goal-setting is a crucial part of it." *Christa Blatchford, artist and program officer for artist learning, New York Foundation for the Arts, New York*

Commercial galleries aren't the only places that show art. Even if your ultimate goal is to find a gallery, there are many other ways to get your work out there in the meantime: registries, online "galleries," collaboratives, nonprofits, artist-only fairs, retail stores, and restaurants. We'll go through each of them and then talk about how to approach commercial galleries.

RESEARCH

You can have exquisite images, an impressive résumé, and a flawless statement, but if you send them to the wrong venue you might as well be throwing them out. That's why you need to think seriously about what you want and look realistically at what is possible given where you are in your career. Even if you're a hotshot and there's a lot of interest in your work, you need to take control and educate yourself so you're not just pressured into taking the first gallery offer to come your way.

The kinds of questions you asked yourself in chapter 6, when you were searching for residencies and grants, apply equally to finding venues to show your work. A few more things to consider:

—What's the best context for your work?
—How much control do you want over the way your work is shown?
—Do you want to sell your work?
—How much space do you need to show your work?
—Do you need a venue that can assist you financially?
—Who is your current audience?
—Who is your ideal audience?

Answering these questions (and the ones in chapter 6) should help you narrow down a list of venues. Once you've done that, make a list of all the artists you respect—no matter how far along their careers are—and read their résumés (they're all online). You'll probably discover a few venues you haven't heard of. Research them to see whether you should add them to your list.

Now look through your mailing list to see whether you have any personal connections to the venues you're focusing on. The people you've met—through open studios or your studio group

or whatever art event—can be a huge help when it comes to getting an introduction.

That's why it's so important to focus on your current audience. Those are the people who want to help you. If your goal is a gallery audience, for example, but you're currently most appreciated by your professors, then that kind of support translates more easily into a show at a university gallery or a nonprofit first. You can still aim for that gallery, but you'll have to take a few steps to get there. When you're just starting out, your friends may be your only audience. In that case, you'll likely have to build your audience before you can get in the door somewhere else.

REGISTRIES AND FLAT FILES

One way curators and gallerists find new artists is by combing through registries and flat files. Registries are collections of digital images that artists submit. Before they went digital, they were called "slide registries." Flat files are just that: thin, flat drawers that a venue uses to keep works on paper (as opposed to slides or digital images) submitted by artists.

Nonprofits with registries or flat files often use them to curate group shows. Or they invite independent curators to put together exhibitions with at least a certain number of artists from their registry. And now that most registries are online, curators and gallerists from literally anywhere can easily search them for new artists.

Every venue with a registry or flat file should have submission instructions on its website. Note that some are open to everyone and some are curated, meaning your submission could be rejected. Flat files are the most selective because there's only so much room in those drawers.

So there are many good reasons to submit your best images (and your résumé and contact information) to registries. And because online registries allow visitors to search by key words, you should pick search terms that will capture the widest audience.

Both flat files and registries might ask you to resubmit your work every year or two to stay current (and to weed out artists who aren't making work anymore). In any case, you should

————"I often find artists through registries online. You have to be willing to scroll through. One of my early shows was curated by going through all the slide files at NURTUREart in Brooklyn. I took three hours and looked through all of them, making quick judgments and tagging the ones I felt applied to my concept." **David Gibson, curator and critic, New York**

————"We accept submissions on a regular basis for a number of local artist opportunities. For our Flat Files program, we select portfolios semiannually, to put on view as a resource of local—and now Midwestern—artists' work which visitors can peruse themselves. It offers a real opportunity for local artists to show their work in an institution. And, it gives the visitors an opportunity to view the work directly and linger over the pieces they find most interesting. In the past, we have also invited each artist exhibiting at the Contemporary Museum to curate a selection from the Flat Files. I hope we continue to do this—the rotating display of work from the files reinvigorates the program in a certain way, and it allows visiting artists, and of course the public, to see what kind of work is being made in the region." **Laura Fried, curator, Contemporary Art Museum St. Louis, St. Louis**

————"Going digital has made slide registries more expansive and more accessible to artists and people who want to view them. Our registry is on our website now. Before we had physical slide files, but it was only open two days a week. Now you can look at them from home at whatever hour you like." **Hillary Wiedemann, artist and former gallery manager of Artists Space, New York**

always update your file whenever your contact information changes or your work develops.

ONLINE GALLERIES AND ARTIST COMMUNITIES

A number of websites, such as galleryartist.com, neoimages.net, and myartspace.com, function like online registries except that they're not necessarily affiliated with a particular venue. One of the most popular is Saatchi Online, hosted by the Saatchi Gallery in London and open to anyone. They're all worth perusing to decide whether you want your work to be up there, too.

The most helpful sites are searchable and allow you to upload your résumé and other written materials along with your images. Treat these the way you treat your own website: only put up your best work and don't post anything you wouldn't want the entire art world to know about you.

Be careful with any site that offers to sell your work. Read the fine print carefully. Reach out to artists already on the site to see how their experiences have been before agreeing to anything.

MY PAINTING IS OBVIOUSLY THE BEST ONE.

————"A lot of artists don't do their research as carefully as they should. Look at the list of exhibitions on artist résumés posted online. They are what we call the best-kept secret. On each gallery's site, for example, you are looking at twenty blueprints of what each artist showing in the gallery did. Where have they shown? What residencies have they done?"

Kevin Jankowski, assistant director for career programs,
Rhode Island School of Design, Providence, R.I.

COLLABORATIVES AND ARTIST-RUN SPACES

One way to get your work out there is to form a collaborative (or a "cooperative") and curate your own shows. Some collaboratives only produce group work, while in others, members make their own work but curate their shows together. By pooling resources and creativity, it's easier to rent space and get the word out.

With those advantages come the complications of group decisions and creative differences, so it's good to think through a few issues before opening a collaborative space:

—Who will the members be?
—Will you accept new members over time?
—How will you divvy up responsibilities?
—Will the group need to make decisions unanimously, or by a majority?
—Will this be a one-time thing or a long-term project?
—Will every member get a show? How often?
—How do you decide what to show, whether to sell, and at what price?
—What will the collaborative do with money from sales?

These questions can suck the fun out of the room in no time, but they're much more difficult to figure out later on, when you discover that your friends had very different expectations than you did.

Some artists start their own galleries. Opening a more traditional gallery space raises fewer "group" issues than starting a collaborative, but it is no cakewalk. If you want to go this route, we recommend Edward Winkleman's book *How to Start and Run a Commercial Art Gallery* (Allworth Press).

Even if you're not up for starting your own space, you should research artist-run spaces in your area to see whether they make sense as places to show your work. While you need to approach them in the same professional way you would any other commercial gallery, they're typically more approachable and understanding, since they know exactly what you're going through.

You're So Alternative

People throw around the term *alternative space* to mean just about anything that isn't a commercial gallery. (Although you can probably find commercial galleries that consider themselves "alternative," too.)

We focus in this chapter on the most common alternative spaces in the art world, but if you're enterprising you can create an alternative space just about anywhere. Artists find ways to show their work in libraries, botanical gardens, science centers, natural history museums, and hospitals. If you think the context fits, by all means put your work there.

The "space" doesn't have to be three-dimensional, either. A big trend right now is self-publishing: books, catalogs, zines, podcasts, and project-specific websites.

—————"The downside of running an art gallery is having to turn away people when you really like their work. At best, you can only show ten artists a year and that's not many. So we do projects some of which are traditional and some less traditional—like a gallery without walls. We wanted to create art with these people so we started a performance radio in the gallery. We wanted to break out a little. Now we're on public radio." **David Salmela, artist and cofounder, Creative Electric Studios, Minneapolis**

NONPROFITS

Because nonprofits, by definition, do not have a commercial focus, they provide a crucial space for more experimental, cutting-edge work, often by lesser-known artists. This is how installation, performance, and new media artists often get their start.

Nonprofits do not work with the same stable of artists over many years, the way commercial galleries do. Every show will include new artists, meaning your chances of fitting into a show at a nonprofit are much higher than at a commercial gallery. In fact, nonprofits often solicit proposals for exhibitions, so you're actually *expected* to approach them with ideas about showing your work. And while they don't usually sell work, their shows can lead to direct sales.

It's easy to research nonprofits because they have clear mission statements posted on their websites. Use these statements to narrow your list the way you did in chapter 6 with foundations.

Academic nonprofits, such as university galleries and university museums, are also potential venues for your work. Given their educational mission, they are particularly well suited to art that is theory-based, art-historical, conceptual, experimental, or that demonstrates an advanced technique. Showing at a university has a few perks: you're allowed to draft a team of student "volunteers" to help make and install your work; there's usually a budget for some sort of brochure, which makes for an impressive addition to your submission materials; and, most important, your work will be recognized as withstanding academic scrutiny. In return for the exhibition, the university may ask you to teach a class, give a lecture, or do studio visits with the students.

Donate to Nonprofit Auctions

Many nonprofits hold auctions of donated work to raise money for their programs. This is a fantastic way to get your work and your name out there.

Three things to keep in mind:

1. Donating work is like donating money. Give to organizations you feel strongly about. Once you do it, every place in town will start asking you for more. Pace yourself. Learn to say no.

2. Don't donate crappy work. If you wouldn't put it in a show, don't give it to a benefit.

3. When collectors donate your work, they get to deduct its market price from their taxes. When you donate your work, you can only deduct the cost of materials.

MUSEUMS

You usually have to gain considerable attention before a museum will look at you. But that doesn't mean you can't participate in museum programs and get to know the curators. The museums in your area might offer programs for local artists. They may have education departments that hire artists. Some museums

————"We are looking everywhere for artists. We look at the submissions when they come in, for sure, though it sometimes takes us some time to get through them. These are artists who are taking the time to introduce us to their work and, in most cases, have made a thoughtful effort to give it to us in the best light." **Peter Eleey, curator, Walker Art Center, Menneapolis**

————"It is a bad idea for artists to sit around waiting for a gallery to come to them or a museum to discover them. They should take matters into their own hands. Artist-run spaces continually provide the new fuel for new art scenes. This is what happened in Los Angeles. Even ACME gallery started off as FOOD HOUSE. Blum & Poe started as a tiny little place and now it is a juggernaut. Guild & Greyshkul in New York. Crawl Space here in Seattle. It is artists getting together and doing their thing. People like me like it because there is an edge and pure intention. I can't say enough for those initiatives." **Michael Darling, curator, Seattle Art Museum, Seattle**

————"For the most part, artists have already worked through the early stages of their art carreers by the time they get here.

"However, our version of Modernism is tailored to a Bay Area focus, and my job, and the jobs of the other assistant curators, is to have a relationship with the art world around here. We do the SECA [Society for the Encouragement of Contemporary Art] art awards every other year. We solicit nominations from two hundred to four hundred people in the art world in San Francisco. Then we invite the nominated artists to submit. We get about two hundred submissions, narrow it down to thirty finalists, and then we do thirty studio visits and choose four winners. They get a stipend and an exhibition at SFMOMA [San Francisco Museum of Modern Art]. We have a Bay Area exhibition and produce a little catalog." **Alison Gass, San Francisco Museum of Meodern Art**

even take submissions and curate project spaces dedicated to local talent. It doesn't hurt to get involved in one way or another. Even if it doesn't lead to a show, you'll expand your circle of artists and curators. Younger curators outside of major art centers are especially open to community artists and they will often go to open studios and other events.

ARTIST-ONLY FAIRS

There are several art fairs for artists only (as opposed to the fairs for galleries, which we'll talk about more in a bit). You apply to them as you would anything else and, if you're accepted, you get—that is, you pay for—a booth or a hotel room and three or four days to sell your work.

Participating in an artist-only fair will make you sympathize with galleries in a way you never thought possible. You will stand for hours on end. You will have to talk to lots of people, and then you will have to talk to more people, and then more people. It will start to hurt when you smile. You'll explain your work over and over and over. You'll answer the same questions over and over and over. And then you'll do it all again the next day, and the day after that.

But that's what experience is, and there's no better way to practice all the skills we talked about in chapter 5 than running your own booth at an art fair. You'll need to know your prices, prepare your invoices, and be ready to pack and ship your work anywhere in the world (see chapter 9 on packing work). And all that explaining will help you learn how to talk about your work clearly and effectively.

It's also a chance to meet curators and galleries interested in unrepresented artists, as well as expand your circle of artist friends.

A few issues to think about:

1. Don't expect to make back what you spend on the booth. Success is breaking even, and not everyone "succeeds." Decide whether the exposure justifies the expense. (Hotel fairs end up costing less, by the way, because you can sleep in the room.)

2. Find out what the walls are made of and whether you are allowed to drill into them. See chapters 5 and 9 for more on installation issues.

3. Most fairs provide the same, neutral sign for every booth and won't let you use your own. Ask before you spend a long time making a pretty sign.

4. Fairs do not provide wall labels so you'll have to make your own labels. A price list is also a good idea.

5. Ask whether the fair provides storage for packing materials. If it doesn't, disguise them as tables or pedestals.

6. Find out what the floors are made of. Carpet is a godsend. Concrete is an enhanced interrogation technique. Dress accordingly.

7. Don't forget your business cards, show cards, and a sign-in book.

8. Bring some office supplies.

OH YEAH!!... WELL I'VE GOT A COLLAGE IN A 22 PERSON GROUP SHOW AT JAVA JOE'S.

————"When I did Geisai, it was amazing. I met more people in one weekend than I would have in a year. I didn't know what anyone looked like, so other artists pointed out collectors and curators coming through. I got to know who they were and when they came in, I was thrilled. I developed a great respect for the gallerists doing the fairs—it was absolutely exhausting." *Blane De St. Croix, artist, Brooklyn, N.Y.*

————"I participated in the POOL fair to get feedback on my work. I think others thought they were going to get their big break. I got lots of great feedback and had conversations about my work, which made it worthwhile." *Leah Oates, artist, Brooklyn, N.Y.*

————"I participated in an artist-run fair coinciding with Miami Basel. This was a so-called "satellite" fair, meant to capitalize on the crowds in Miami that weekend. It was a mixed bag. Artists paid for their own rooms, but kept any income earned from sales. I sold a few things—enough to break even—but many people didn't sell anything and for me it was close. Still, it felt worth it, because I made contact with a small gallery in Chicago and ended up in a show there, so that part was great. The bad parts were having to do everything myself—it was a ton of work—and feeling sort of out of the loop of things. There wasn't a ton of press so we didn't get as much traffic as everyone would have liked, and because it was an artist-run fair there wasn't anyone to rely on for publicity, which was frustrating." *Ann Tarantino, artist, State College, Pa.*

——————"I returned to Minneapolis from graduate school and shopped my work around. Unfortunately, there were no venues for the conceptual type of work that I was making at the time. Even though I had never worked at a gallery, I decided to start one that would provide a platform for this type of work. Midway was an artist-run space from the beginning. We established it as a nonprofit in part because of what we perceived as a lack of a collector base here in Minneapolis, but also because of the non-commercial type of work we wanted to show. And we wanted to work with different artists every single year as opposed to working with a stable of artists like a commercial gallery." **John Rasmussen, director, Midway Contemporary Art Center, Minneapolis**

——————"What Artists Space has always provided, ever since it was founded, is a platform for experimentation. And a place where artists can come and safely experiment to carry out projects. As much as the market has become a very important part of what the art world is about, I think it's really important that there are pockets where the pressure of the market is not as strong. Our goal, as much as possible, is to support those artists in making things happen in a professional context so they can carry out ambitious projects without pressure to sell." **Benjamin Weil, director, Artists Space, New York**

——————"Nonprofits played an important role for me. In a way, it was an extension of graduate school because there was such a youthful atmosphere. Many of the curators that ran those spaces were about the same age and I was showing in a very mixed group. Sometimes with old friends and often making new ones. It was a wonderful, mutual support system and very exciting." **Charles Long, artist, Mount Baldy, Calif.**

——————"The people we prioritize are emerging artists and we give them an expansive space that they wouldn't normally be given at that level. Because it is a place of experimentation, if shows don't turn out the way that was expected, that's seen as part of the learning and figuring out what you are doing as an artist." **Ben Heywood, director, Soap Factory, Minneapolis**

——————"I am interested in working with artists to realize projects that might be absurd or difficult. I am also interested in showing art in places that are not necessarily devoted to it and therefore create new, unexpected connections between an artwork and its surroundings, providing new possible readings. I am interested in providing tools, knowledge, assistance, and resources for an artist to produce artworks that make a difference in his or her understanding of his or her work, and I am interested in providing tools, knowledge, resources, and assistance in producing works that will make a difference in the way the public perceives a certain artwork and even—to be very ambitious—the very definition of art. I am interested in doing what is not there, what has not been done. I am interested in witnessing the moment in which a new artwork comes to exist and creates that strange space around itself that demands our attention."
Massimiliano Gioni, director of special exhibitions, New Museum, New York

——————"Usually cities have artist cooperatives. I think sometimes those artist-run spaces do really innovative programming and the artists that they choose to show are artists who are really committed to their craft. So I tend to look at those spaces to see new, upcoming artists. I think once you get out of school, being involved in some sort of organization like that is crucial. It gets your work out there and starts that network going, and that is such a big thing." **James Harris, James Harris Gallery, Seattle**

——————"I lived with my friend, Tim Brower, in an old sporting goods storefront called Bodybuilder and Sportsman Inc. Part of the space was a makeshift motorcycle repair shop where Tim and another roommate fixed Nortons and BSAs. We lived in the back of the space and decided to turn the front fifteen feet facing the street into a gallery. Our intent was to give exposure to our friends who weren't getting much attention in town. At first we were open only on Saturdays. We split the time in the gallery and divided the cost of the announcement cards with the artists. At the time, you could get five hundred cards from Modern Postcard for $99. We served Old Style beer for a donation of $1 per can." **Tony Wight, Tony Wight Gallery, Chicago**

——————"I would not say a restaurant, out of hand, is a good or bad place to exhibit. It depends on many things, especially what the respect level will be for the work. In general, exhibition opportunities conform to that adage that no press is bad press. I feel that with exhibitions: no exhibition is a bad exhibition. However, if there's a lack of respect, something could go wrong. Your work could get damaged or stolen. Is it worth it to exhibit somewhere at any cost?" **Catharine Clark, Catharine Clark Gallery, San Francisco**

——————"A simple demographic fact: You have tens of thousands more artists than the art world can absorb." **Joachim Pissarro, curator, professor, art historian, former Museum of Modern Art curator, New York**

——————"I think that in the beginning, the artist should try to show anywhere they can only because it shows them what goes into doing an exhibition. For better or for worse, whether it be at a café or not. They know how to mount a show—what goes into it—and they learn how to work with people. One should not keep it on their résumé when they approach a higher caliber of gallery, but we wouldn't discourage them from taking those shows early on." **Heather Marx and Steve Zavattero, Marx & Zavattero, San Francisco**

——————"Show at university museums and colleges, and other academic spaces. They all have art galleries. Try to show in a group show and get friendly with a curator. Show where it is not commercial and it is more about ideas and you will be put in context with other artists of your time. The more commercial aspect will come later." **Shoshana Blank, Shoshana Wayne Gallery, Santa Monica, Calif.**

Should You Ever Say No?

——————*"Early in my career, I never said no. I eventually came to the idea that it was better to wait for the right situation—something I was comfortable with and I could grow with. My modus operandi of just saying yes to every person probably wasn't the best. I could have hung out, making work, waiting for something more solid. At the time, I did the best I could with the information I had. But then I learned the hard way that it was better to just be patient and not go all out in a context where people won't see it. It comes and goes and nobody knows."* **Fred Tomaselli, artist, Brooklyn, N.Y.**

——————*"I don't think you should say no. I just don't. You never know what an opportunity is going to be."* **Eleanor Williams, art advisor, curator, former gallerist, Houston**

——————*"If something is offered to me, I will research the space and scratch around a bit. Often things are gained by taking a chance on an offer that looks dicey or risky. You learn about your own work and how to deal with people. Sometimes it's a huge drag and a disappointment, but other times it's wow. Remarkable."* **Michelle Grabner, artist, professor, critic, curator, Chicago**

——————*"I feel strongly that artists need to realize their art can survive all the different curatorial contexts it is put into. To control it and limit it denies the work that robust quality of being able to mean something to this person or that person. It needs to transcend the curatorial concept. If it can only fit into one box, it's not going to last that long. One artist I know did not want to be in a group show because she only wanted her art to be seen on her own terms. Another artist was intent on writing the catalog on her own show because she wanted to control the interpretation. It revealed a lack of confidence in the work and its ability to speak on its own in the world.*

"However, there is something an artist once told me—if you lay down with dogs, you're going to get fleas. Artists need to be hyperaware of the galleries they choose to show in and, if they find out a group show they are going to be in is filled with artists who are not very good, or the place has a bad reputation, they should stay away from it. It is better to develop a cult following as an unknown than slumming it with not-so-rigorous artists." **Michael Darling, curator, Seattle Art Museum, Seattle**

—————"Saying no is great! If you've already had some exposure, say no to the things that aren't quite right—even if it's pretty right, but it's not quite right. Saying no in those cases leaves you time to prepare yourself for when the right thing comes along. I've had some nice opportunities that could have been great, but they were not what I really wanted. There's only so much time you can put into making great work. What artist isn't scraping for that time?

"A friend of mine has an interesting formula. She asks herself three questions. If the answer is yes to at least two, she will say yes to the opportunity:

"1. Is the money good?

"2. Is it an opportunity that brings something to my career or body of work?

"3. Is it personally fulfilling?"

Charles Long, artist, Mount Baldy, Calif.

—————"Part of me wants to say 'Who cares?!' We have become so structured in our approach to viewing contemporary art that there is not enough happening where you can just throw art up on the wall and let the cards fall as they may. And for many artists, there is a moment early in their careers when they feel enormous pressure to exhibit and get feedback, so any opportunity could look good. But, ultimately, when your work is up in a restaurant, it may not be the venue where you will get the feedback and attention you are seeking. I would err on the side of being pickier.

"When artists ask my opinion about participating in a group show when they don't know the curator or any of the other artists included, I am always skeptical. It could be great and you don't want to come across as a prima donna, but you need more information. If you are asking advice, you have misgivings. If it doesn't feel right, you shouldn't do it. It's not like there won't be another opportunity. In fact, the opportunities that come from participating in a show you don't feel good about may not be the right opportunities. I think people should be discerning. I am not going to work with an artist I don't feel strongly about. Why would an artist exhibit with a curator or in a context they don't feel strongly about? If your work is much stronger than everyone else's, it's not necessarily going to read that way. That is not a discrepancy that is fruitful."

Anne Ellegood, curator, Hirshhorn Museum and Sculpture Garden, Washington, D.C.

—————"I've had a weird career that some have called slow and steady. I never made a big splash. I was showing in more low-key galleries and grew into my life as an artist in dribs and drabs. It wasn't like one day no one knew my work and then, the next day everyone was talking about it. Maybe it's a little more solid for me because of that."

Fred Tomaselli, artist, Brooklyn, N.Y.

CAFÉS, RESTAURANTS, AND RETAIL SPACES

The bottom line with showing in commercial spaces outside the art world: if you don't need to do it, don't. *Selling* to commercial spaces, is fine, of course. We're talking here about consigning your work for an exhibition.

The risk of damage is high—especially in bustling restaurants and bars—while the benefits are usually low. People go to these places to eat, drink, or buy clothes. Sure, it's nice to see some art on the walls, but they're not likely to appreciate your work in the way you'd like them to. A lot of them won't even notice it.

As always, there are exceptions to this rule. Some stores set aside separate rooms for rotating exhibits. Some restaurants are known for the quality of their art program. Since these spaces look and act more like traditional galleries, visitors naturally treat the work more like art and less like décor.

Sometimes you don't have a choice. Maybe you live in a small town and the café down the street is one of the only places around where local artists can show their work. Or you haven't been able to get into any group shows for a while. Or the content of your work relates to food, fashion, or consumer society. If you do decide to hang your work at a restaurant or retail space, be extra careful with installation and any special instructions. Make sure the work is labeled and you are properly credited. And always make sure the place has insurance.

COMMERCIAL GALLERIES

Most artists want to get into a commercial gallery. Having a gallery represent you and show your work validates what you're doing and can give you the psychological (and economic) boost to keep going. But it's not easy to get a gallery to notice you, let alone consider showing your work. And the cold, hard truth is that the vast majority of artists out there never land gallery represen-tation. This does *not* mean you should give up on the idea of getting a gallery or, worse, give up on your art altogether. It means you should approach the gallery system realistically; try not to take rejection personally; and recognize that there are many ways to pursue a fulfilling art career without a commercial gallery.

Approaching Galleries

The worst thing you can do for your prospects is mass-mail a bunch of galleries with a form letter saying "I'd be great for your program." Just as bad—though much more demoralizing—is to trek in person from gallery to gallery with your portfolio asking each one to look at your work. Do not do this!

Seriously, don't do it.

It is more than a waste of your time (and everyone else's). What if you "luck out" and a random gallery tells you it wants to show your work? Do you really want to trust your first show to a place when you don't know its program or reputation? A gallery that wants to use your installation work to diversify its all-photography program may not be the right first step for you.

So what *can* you do?

Take Your Time

Over the last few years, young artists have felt increasing pressure to produce show-worthy work right out of school and get a gallery as soon as possible. This might seem like a good thing from the outside, especially when the latest MFA hotshot is picked up by a blue-chip gallery, sells out a major solo show, gets a fantastic review, and sees his or her prices skyrocket. Success, right? Maybe in the short term, but how do you sustain it? You have to be extremely strong to withstand that kind of jump in the first few years of your career. And there's no tolerance in the art world for declining prices, so you immediately face the wrenching choice between continuing with work you know will sell and taking the (now higher-stakes) risk of developing in a different direction.

Truly successful art careers last a long time. It is not "now or never," and you only do yourself a disservice by rushing your career. Having a lot of energy is great, but so is having a lot of patience. It can take years for your work to develop to a point where it's ready for a program you want to be in. That's why one of the first things we said in this book was to make your work constantly. Countless artists didn't "make it" until they'd been making art for decades. So, take your time.

—————"When my gallery was on 27th Street, I was one of the galleries furthest north. Every Saturday morning, I would get a gaggle of artists bringing their portfolios to every gallery, convinced that by the end of the day they would have representation. Being a new, small gallery by myself, they would think 'this guy needs me.' When I said I did not review portfolios, they would get angry. At the end of the day, I would get another group that had started south and worked their way up." **Cornell DeWitt, private dealer and consultant, former gallery owner and director, New York**

—————"Sometimes I look at blind submissions, but it's like 'it's never going to happen.' There was even an artist who sent a book he published and a CD and it actually looked kind of interesting. It was the first one in ten years that I thought, 'Huh!' but then I was like 'Ahhh, whatever.' I just put it away because I have so much else going on. It wasn't enough to get me out to look at the work. It's brutal. Really brutal." **Tim Blum, Blum & Poe, Los Angeles**

—————"You're not going to get anywhere by throwing packets around the art world. You have to make the situation between yourself and the gallerist an intimate one. Throwing your packet around is not sincere and not intimate. Artists who make frequent submissions are not operating at a realistic level. Making a connection in the art world is not about luck, nor is it as random as it seems. Galleries have protocols for everything that they do." **David Gibson, curator and critic, New York**

Okay, it's not really a rule, but pretend it is. You should follow a gallery's program for about a year before you even *think* about asking the gallery to look at your work. That means going to see the shows; looking at everything on the website; understanding the program and what the owner is trying to do. **(And taking advantage of other exhibition opportunities in the meantime.)**

"Name Five Artists in My Program"

That's Mary Leigh Cherry, a Los Angeles gallery owner, expressing a very common sentiment among dealers. "We were joking that if an artist came in our art fair booth to give us a submission, we would say 'Name five artists in our program.' If they couldn't, they are done. Then we thought about it. Could we name five artists in the programs of galleries we approach for work? Yes! Because we've done the research on their program."

Asking a gallery to look at your work is akin to announcing your belief that you fit into its program. So you'd better be ready to explain why you fit in—something you can't do, of course, unless you are familiar with the other artists. This is a good thing. The more you know about a gallery's artists, the better equipped you'll be in deciding for yourself whether it really is the right place for you.

Study Artist Résumés

Just as important as understanding a gallery's program is becoming familiar with the résumés of all of its artists. Those résumés tell you where the artists were in their careers when they started showing at the gallery, and in that sense they reveal the kinds of things that you need to do before that gallery would probably consider you. Doing the same residency as one of the gallery's artists won't guarantee a thing, obviously. But getting a sense of how many residencies or shows the artists have had; whether they've had several solo shows already; how many years into their careers they are—these are all ways of gauging realistically whether you're ready for a particular gallery.

Top Ten Ways Curators and Gallerists Find Artists

1. Artist recommendation
2. Curator recommendation
3. Solo or group show
4. Art fair
5. Slide registry or flat file
6. Submission or open call
7. Other recommendation
8. Social event
9. Open studios
10. Jurying a show

Talk to Other Artists

The best way to hear about how a gallery operates is from artists who have shown there. They can tell you how they were treated, how the place is organized, and whom to approach about submissions (when the time is right). They can give you a sense of the gallery culture so you can decide whether it's a good match.

Go to Openings

If you've got your eye on a few galleries, you should go to as many of their shows as you can. You should make it a point to see what

—————"If an art community doesn't exist in your area (not likely) or you don't identify with the one that does, change it or make your own. Develop a co-op space with some friends, start a blog, or curate shows in your apartment. Art is made to be looked at, talked about, and argued over. What better place to start than your own backyard?"

Jason Lahr, artist and curator of exhibitions, South Bend Museum of Art, South Bend, Ind.

——————"The most important thing you can do is become familiar with the gallery program. If you're interested in having anybody see your work, you should go to their openings; you should look at their website; you should watch their program and go see all their shows, for a year—at least—so that you can make a really good case for your artwork being part of a certain program." *Melissa Levin, program manager, artist residencies, Lower Manhattan Cultural Council, New York*

——————"As an emerging artist, you have to be realistic when you look at galleries. You can't all be represented by Sikkema Jenkins—look at the size of the space. We all love Sikkema Jenkins, but you have to be a good, solid midcareer artist before you can fill that room with good work, which is why we have two spaces. We recognized that we moved into a realm where some of our artists can't fill the big room. I don't mean they can't literally fill it—they're not ready for it." *Kerry Inman, Inman Gallery, Houston*

——————"I really want to emphasize that an artist should do their homework. You should never want to show in a gallery just because it's a gallery. You want to show in a gallery that is the right gallery for you." *Ed Winkleman, Ed Winkleman Gallery, New York*

——————"The best example I have of someone doing their research was an artist who came to almost every show for a year. Subtle introductions. I started to recognize him and knew his name. One day he came in and asked if I would come to his studio. I said definitely. He had put in the work. Over the years he has kept in touch via email. I haven't done anything with his work yet, but I am following his career. He did it the right way and it was clearly obvious that he got to know the program." *Mary Leigh Cherry, Cherry and Martin, Los Angeles*

——————"To be honest, I don't know many curators who end up working with folks from blind submissions—it nearly always comes from seeing the work out in the world and following whatever piques my interest, or from conversations with colleagues and artists I respect. It's my responsibility to see as much as I possibly can, of course, but curators build up a set of critical ideas and interests that hopefully become a part of how their curatorial vision is perceived, so recommendations from folks who understand their thinking can be invaluable as well." *Shamim Momin, curator, Whitney Museum of American Art, New York*

——————"I've found most of my artists through other artists. I don't think it's a big secret that curators and galleries trust the opinions of the artists whose work they respect more than anyone else. More than other gallerists and other curators. Artists are the most discriminating because they want to impress you as much as you want to impress them." *Amy Smith-Stewart, Smith-Stewart, former curator at PS1, New York*

——————"Most of the best dealers running good galleries are the ones who are constantly listening to their artists. Because the artist is the most important client of the gallery—and somebody you can trust in terms of their eye." **Tim Blum, Blum & Poe, Los Angeles**

——————"There's so much proactive work artists can do themselves. I actually think you can work with a gallery too early in your career. You want to be untethered for a while. Not to say a gallery is a ball and chain, but you're seen as more conventional the moment you exhibit with a gallery, whether it's true or not. There's something raw and exciting about an artist project that exists without a construct around it. That's not to say that there isn't a time when it's appropriate to make that shift, but I do feel like, with young artists, you want to see them doing things outside of the system rather than in an annual exhibit with a gallery.

"I've heard people say 'If you don't look at my slides, how will you ever know what I do?' Well, if we're meant to know it, we will. (That sounds awfully New Agey for me, but there's a point.) If you are out there, creating opportunities for yourself, there are people who are going to respond to that. There is ultimately a career path for everyone. It's sometimes hard to know what it's going to be." **Catharine Clark, Catharine Clark Gallery, San Francisco**

——————"I want to think about an artist's work and be part of it for a long period of time. Institutions have to react so quickly and process so much that, as a curator, you can't keep up with each artist and what they did before and after your show. As a gallerist, I can work long-term. When I show their work or talk about their work, I know their work from the beginning to the point at which they're at now. And I also know what they are going to do. I can't imagine working any other way.

"For me, I am not representing their work properly if I don't understand the development. That's why it takes a long time to decide what I want to show and what artists I want to show. Of course there are many artists I want to work with, but if it takes a long time to get into their work, it might take years for me to decide to work with them." **Amy Smith-Stewart, Smith-Stewart, former curator of PS1, New York**

——————"Sometimes I know I want to represent an artist. Sometimes I just want to watch. There is an artist I saw in London recently whom I've known for twelve years. Just now I offered him a show." **Shoshana Blank, Shoshana Wayne Gallery, Santa Monica, Calif.**

—————"These days, unfortunately, there is an expectation of artists that they will show themselves around a little bit. There are of course many who don't, some of whom are successful nonetheless, but they seem today to be in a minority. Clearly many feel that there is a need, certainly when there's no gallery to do it, for them to play the game and get out there. They can do it in a smart manner, seeking out and engaging the right people in dialog. But if the strategy is limited to turning up at every opening only to spend the evening with a beer in your hand, it can become tiresome." *Jasper Sharp, curator, art historian, VOLTA art fair selection committee, Vienna, Austria*

—————"I had one artist who I threw out of the gallery and told him never to come back again because he was hanging out while I was working with a client, trying to sell something, and it was just not good business behavior. There's a difference between a familiar face and someone who's annoying. Know that boundary. When you see things happening, you should really step aside or come back at another time." *James Harris, James Harris Gallery, Seattle*

their openings are like. It's a great way to get to know their artists and to see who works there. Just remember that an opening is a social event; it is not the best time to see the art. It's probably the worst time. You're there to see what the place is like and how it's run. You can always go back on a normal day to get a better look at the show itself.

Speaking of going back: there's a fine line between becoming a familiar face and becoming a nuisance. Use your judgment. You don't need to go to *every* opening. You don't need to strike up a conversation with the staff *every* time you walk in the door. They know what's going on; they'll understand why you keep checking out their shows.

If you don't live in the same city, keep track of the shows online and then make a trip at some point to visit the gallery in person. Coming from out of town is a good excuse to interrupt the staff for a quick hello. Tell them how much you like the program and ask what their submission policy is (if it's not already posted online).

THE ARTIST IS DEDICATED TO THE INTERPLAY BETWEEN THE CIRCLE AND THE SQUARE.

FASCINATING.

Go to Art Fairs (Unless You Don't Want To)

They may not be the best way to see art, but art fairs are the only way to see galleries from all over the world in one place at one time.

An art fair is essentially a trade show. A bunch of galleries—anywhere from fifteen to five hundred—set up booths in a convention center, hotel, or outdoor space, and spend several days selling as much as they can. The biggest art fair is Art Basel, in Switzerland every June and Miami every December. There's Frieze in London, FIAC in Paris, and the Armory Show in New York. There's Art Dubai and ShContemporary in Shanghai. And then there are the fifty-some satellite fairs, for smaller galleries, like PULSE, NADA, VOLTA, Aqua, Scope, Bridge, Red Dot, and the Dark Fair.

It is *really* expensive for a gallery to participate in an art fair. Booths run from around $6,000 for smaller fairs to over $40,000 for a prominent space at the biggest ones. And that's just for the empty space. Add shipping, insurance, airfare and lodging, and a five-day fair can easily run $100,000. On his blog, Edward Winkleman estimated this budget for an "average" New York gallery to attend a London art fair in 2007:

—Booth: $31,000
—Booth extras (electrical outlet, extra wall, etc.): $2,300
—Crating: $5,000
—Shipping both ways: $25,000
—Empty crate storage: $1,000
—Art handlers to install and deinstall booth: $3,000
—Air travel for gallery staff of four: $2,000
—Hotel for staff: $5,600
—Lunch for staff: $720
—Dinners with clients: $2,500
—Cell phone roaming charges: $1,500
—Car service: $400
—Party for clients: $20,000
 Total: $100,020

The biggest "blue-chip" galleries spend even more. The costs are apparently worth it, though, since a gallery can make more than half its *annual* revenues at an art fair. That's why the last

————"There is no better way for an artist who may be doing well in a local or regional market to become humble than by going to an art fair. It can also be affirmative seeing exactly how many artists are doing the same thing they are. Artists either crumble or come back stronger. When you start to really look, there are some incredible visions out there. If you can't travel to London or New York or L.A. trimonthly, then going to an art fair is a good way to see everything." **Leigh Conner, Conner Contemporary Art, Washington, D.C.**

————"Because I was a curator, I have a hard time with work being seen two, three, or four days and then never seen again. Of course you have to do fairs—I learned that very quickly—to expand your circle. It does a lot for the visibility of the gallery and there is a certain development that has to happen as you grow from one art fair to the next." **Amy Smith-Stewart, Smith-Stewart, former curator at PS1, New York**

————"Some artists enjoy working with their dealers on the stands and discussing their work with collectors while other artists feel intimidated or otherwise uncomfortable at fairs. I know a handful of curators who think art fairs are the worst things in the world and vow never to set foot in one (and others who do most of their buying at art fairs!). Detractors might argue it's commercialism at its worst, a horrible way to view work. I would argue that, on the flip side, fairs enable one to see a survey of a gallery's program and expose visitors to many different artists from many diverse regions across the globe in a short period of time. Done well, art fairs can fulfill a role once reserved only for museums and other cultural institutions." **Helen Allen, executive director, PULSE Contemporary Art Fair**

—————"We do an enormous amount of our annual business at art fairs. I think everybody does. It is such an intense week for us and we are trying to stay focused, and I just want artists trying to introduce themselves or show us their work to stay out of our booth. Please! It's the busiest week ever!" *Sabrina Buell, director, Matthew Marks Gallery, New York*

—————"I understand a lot of people will only see work at art fairs, so occasionally I give a piece to a dealer for a fair with the proviso that they have to get it back for my show. It takes me so long to make a piece, if a collector really wants it that badly, they have to loan it back for the show. Otherwise, I wouldn't have enough work for my exhibition. I've only been to one art fair. It made me feel like the screaming Edvard Munch head." *Fred Tomaselli, artist, Brooklyn, N.Y.*

—————"The main tip is to go, to be there. It's being social in the art world—just like openings. You're present, you're there, and you meet people. If I have an ongoing relationship with a gallery, it's a good way to see them, check in and be present, have them know I'm around.

"It's something that I struggle with because it gets overwhelming at times. But every time I go I'll see something I love, or make a great connection, and ultimately it's always a really good thing. That said, usually I'll leave freaking out a little bit. Overwhelmed, exhausted." *Stephanie Diamond, artist, New York*

several years have seen so many more galleries applying to fairs than there have been spots.

The economy is tanking as we write this book, prompting a lot of speculation about the future of art fairs. It's certainly hard to imagine the art world sustaining so many satellite fairs over the long term. But even if a number of individual fairs shut down, or a swath of galleries stop applying to a specific fair, the art fair system as a whole is clearly here to stay.

Should You Go?

While there are a few fairs that try to import noncommercial values into the selection and presentation of work, by "curating" the fair or requiring solo exhibitions, most art fairs treat art like a pure commodity. Galleries are condensed and lined up in rows and rows of claustrophobic booths, where they typically show as much of their program as possible to the hordes of collectors, curators, and spectators marching by.

This commercialized context can be a difficult thing to be exposed to, which is why some artists never go to art fairs and a few even refuse to let their work be sold at them. Plenty of artists do attend, though, either out of grudging curiosity or because they know it's the best way to get a snapshot of what's out there and to keep up with people in the art world.

Bottom line: don't feel obligated to go, but know that there's a lot to get out of it if you go.

Then What?

So you've gotten to a point where you *know* you fit into a gallery's program, you know who the other artists are, you know who works there. Find out from the artists (or the gallery staff) whom you should approach about looking at your work (maybe it's the director, not the owner) and how (it might be in person, it might be email). And don't be shy about asking artists you know to put in a good word with their gallery.

Chances are you'll be asked to send an email with a link to your website. Keep it short and simple. Mention any personal connection you have to the gallery (assuming it's okay with that

Art Fair Survival Guide

Here are few ways to take the edge off your art fair experience:

—*Do your research.* There can be dozens of fairs going on the same weekend. It's overwhelming to try and see everything. Find the type of fair you want to see first—some emphasize emerging art, some look like they came straight from a museum—and then focus on which galleries you need to visit.

—*Check the schedules.* You don't have to do it all in one day. Look up performances and other events and time your visits accordingly.

—*Eat before you go.* The food at these fairs is almost as expensive as the art.

—*Wear walking shoes.* You'll be on your feet for hours.

—*Don't go alone.* It's much easier to take everything in when you're with a friend. And more fun.

—*The maps are free—take one.* "Browsing" will only give you a headache. Get a map at the entrance and visit the galleries you want to see first. Then wander around until your vision blurs.

—*Take notes.* Bring a pen and paper to jot down galleries and artists you like. Note who shows work that relates to yours.

—*Look for prices.* This is the time to get a sense of the price ranges for different kinds of work. They won't always be on the wall; you may need to look in the books and binders that galleries usually set out on a table in the middle of their booth.

—*Leave the staff alone unless you're going to buy something.* This is absolutely the worst time to introduce yourself to a gallerist. Obviously you can say hi to anyone you already know, but even then you should make a point of making it short.

————————*"Art fairs are strange because they are such an overwhelming experience. A few years ago I would have said that going to an art fair was a fruitful way to find new artists. But I think art fairs generally have shifted to presenting more of a known quantity and there is less experimentation going on there."* **Anne Ellegood, curator, Hirshhorn Museum and Sculpture Garden, Washington, D.C.**

————————*"No one has time. When did you last see a sixty-minute film at a fair? Anything that requires more than a few minutes to reveal itself is, for the most part, excluded. The system of fairs that exists today has allowed collectors to become lazy. In return, they receive a distorted and limited understanding of the types of art that are being produced.*

"I know several artists whose production schedules focus for months on end on one fair after the other. The demands made on them have completely changed the way in which they work. When an artist has two or three galleries, and each of those galleries is doing four or more fairs a year, they are expected more often than not to produce work for those fairs. Two years of work, which traditionally would have become a show, is now only briefly shown in the context of an art fair." **Jasper Sharp, curator, art historian, VOLTA art fair selection committee, Vienna, Austria**

————————*"When you approach a dealer at an art fair, that blank look on their face is them trying to calculate whether they can fit your corpse into their crate and ship it back."* **Edward Winkleman, Winkleman Gallery, New York**

person), convey your interest in the program, and ask whether the gallery would like to see your work in person. Make the link to your website easy to see. Don't include an image in the body of the email (unless you were specifically asked to). Let the gallerist go to your site and see all of your work in context.

What Not to Do

So those are all the things to do in your quest for a gallery. Here are some ways to shoot yourself in the foot. They're not hypothetical. Artists make these mistakes all the time.

1. **Don't send blind submissions.** It's okay if you eventually contact a gallery that is "blind" about you, assuming you've taken the time to learn about its program, you really believe you belong there, and you can explain why when they ask you. But it's never a good idea to submit your work to a gallery that *you're* blind about. Do your research first.

2. **Don't walk into a gallery with your portfolio asking for "just five minutes."**

3. **Don't bring your portfolio to someone else's opening.**

4. **Don't "CC" a group of galleries on the same email submission.** If you don't take the time to contact them individually, they're not going to take the time to read your email, let alone look at your images.

5. **Don't start emails with "To whom it may concern" or "Dear Sir/Madam."** You should know the gallery well enough to have a name.

6. **Don't ever, ever approach a gallerist you don't know at an art fair and ask about submissions.**

7. **Don't interrupt a gallerist when he or she is talking to people you don't know.** You could be interfering with a sale or simply interrupting a story. It's not the way to make yourself known. Wait till they're in between conversations to say your hello.

Never Pay to Show Your Work

There are some "galleries" out there that make you pay a fee to show your work. Don't do it. The reputations of these places tend to be bad, and they have little incentive to promote your show or sell your work. So you won't get anything out of showing with them (other than a bill). You're better off applying for a project grant that covers the expense of putting on a show—that is, finding a space that you turn into a temporary gallery or getting a nonprofit to sponsor you, rather than paying a place that calls itself a gallery.

Note that we're only talking about the United States here. In Japan, for example, it is common for galleries to charge artists for exhibitions. That may be the case in other countries, too. But here, it's not the way to go.

8. **Don't harass people.** It's not easy to read every signal and everyone does things a little differently, but "no" usually means "no." Silence is a little trickier, but if someone doesn't get back to you after a few messages, it's a no.

You May Not Need a Gallery (Really)

Some work doesn't fit in a commercial context. Maybe your work is "too" experimental, or conceptual, or ephemeral. Maybe you work on such a large scale that a gallery couldn't show you. If that's the kind of work you do, you might be happiest working with alternative spaces.

——————*"An artist doesn't need a gallery. It depends on what part of the art world you want to be in or what kind of artist you want to be. We tend to think of the art world as one singular thing and it's not. The magazines, the fairs, Chelsea— that's just one version. That is only one way to live and it can be a lot bigger than that. How do you define success for you? It's your life, not just some- thing you do. Having a gallery is certainly not the only way."* ***Howard Fonda, artist, Phoenix***

CHAPTER 8

—————————Rejection: It's Not You, It's Them

———————"I apply every year to certain programs I really want. I always expect rejection. If it's the same jury every year and they see progress, then it makes sense to do that." *Alessandra Exposito, artist, Queens, N.Y.*

———————"We narrow the pool from three hundred to twenty-five. Then we take the twenty-five and pick four. Probably any of those twenty-five people, if they got into the program, would be okay. Some of the people who are our star alums were wait-listed. And, there have been very well-known artists who have not gotten into our program and probably would have been great in our program. After the twenty-five, it's a little bit of a crapshoot." *Joseph Havel, artist and director of the Core Program, Houston*

———————"Sending in an application or work samples in response to an open call for a show, residency, or other program is a great way to get your work seen by arts professionals. Programs will often have rotating juries selecting work, so it's important to apply more than once and not be discouraged if you're not awarded the first time you apply for something. But if you do reapply, it's important to show progress because there might be someone on the panel who's seen your work before." *Melissa Levin, program manager, artist residencies, Lower Manhattan Cultural Council, New York*

———————"While artists may suspect dealers get a secret, vile pleasure out of saying no, the real pleasure comes from saying yes. To give artists their first show is hugely interesting and fun. Talking artists through their anxieties and working collaboratively is hugely gratifying." *George Adams, George Adams Gallery, New York*

To become a professional artist is to court rejection. We don't know a single artist who hasn't been rejected from *something*. The odds pretty much guarantee it.

According to a recent report of the National Endowment for the Arts, there are more than 200,000 fine artists in the United States. Meanwhile, around 300 art programs across the country produce some 8,000 BFA and MFA graduates a year. Most of them—not all, but most—want to land New York representation. So how many galleries are there in New York? About 1,000. We'll do the math for you: each gallery in New York would have to take on eight new artists *every year* to absorb this many art school grads. And that's pretending that all 1,000 galleries represent emerging artists, which of course isn't true. The actual number of galleries that look at newly minted graduates is probably closer to 200. At most, these galleries bring in a new artist every year.

Residency programs with national reputations are just as competitive. The Lower Manhattan Cultural Council, for example, receives about a thousand applications every year for fifteen residency spots. Houston's Core Program takes four artists a year out of over three hundred applicants and Skowhegan chooses sixty-five people from more than 1,600 applicants.

THIS SUIT IS SPECIALLY DESIGNED TO SHIELD ME FROM THE STING OF REJECTION.

————————"Artists are courageous and vulnerable. They are putting themselves out there and you don't want to make them feel defeated. Their work may not be right for us, and usually it isn't, quite honestly, but you still want to encourage them to continue their quest."

Steve Henry, director, Paula Cooper Gallery, New York

Causes of Rejection That You Can't Control

—gallerist/curator/juror/panelist taste
—your work is too similar to other applicants'
—your work is too different from other applicants'
—your work doesn't balance well with other applicants'
—the program shifts focus to other mediums or styles
—the program budget
—luck

Causes of Rejection That You *Can* Control

—failing to follow directions
—poor-quality images
—sloppy written materials
—not tailoring your submission to the program
—your proposal has unrealistic goals
—not sufficiently describing your experience and background
—failing to make your need apparent

Causes of Rejection That You Can Minimize by Doing Your Homework

—institutional taste: the program never shows that style or medium
—your work isn't ambitious enough
—your work is too ambitious given the program's facilities
—your work does not address the program's mission
—your background and experience don't fit the program
—you don't actually need the program or support

The upshot here is that you have to develop some pretty thick skin and take rejection in stride. You simply *cannot* afford to take it personally. Yes, it's easy for us to say and hard as hell to do, but we're saying it anyway. Consider it one more part of your job.

And just so we're clear: you don't have to pretend you're happy to get rejected from a good program or passed over by your dream gallery. Of course that's disappointing and there's no point faking how you feel when it happens. But a rejection doesn't automatically mean there's something wrong with you or your work.

Take residencies: By the time a committee makes its final selections, the decisions aren't just about quality, as there are obviously many more talented applicants than there are spaces. You might get rejected because your work is too similar to that of someone else already admitted that year. You might get rejected because your work is too different from what the program is emphasizing—a criterion that can change from year to year, meaning that you could fit the program perfectly one year but not another.

You also don't know how "close" you were to getting in. For all you know, four out of nine committee members were ecstatic about your work. Don't assume that a rejection was unanimous or that the committee is telling you to quit. That's why we said in chapter 6 that you should expect to apply to a residency several times before getting in or giving up.

Panelists and jurors go on to judge other competitions, curate shows, and work with collectors. The more often jurors see your name, the more likely they are to remember you, and maybe think of you for a personal project or a client—regardless of whether they championed your application to a particular program.

As for galleries, very few take on new artists each year. When they do, the quality of the work is the most important consideration—but it's not the only one. A gallerist might love your work but not have the collector base to support it. Or you might work on a scale that is too big for that particular space. Or the gallery may already have a couple of artists who do similar work. Or the gallerist may think you wouldn't actually be happy there (believe it or not, gallerists do think about how their artists feel). Or the gallerist might believe that your personality wouldn't mesh well with the gallery's culture.

There's always *this* way to deal with rejection. It didn't get the artist a show at the gallery, but the gallerist will never forget him:

<div style="border:1px solid black;">

12/26/71

Dear gallery director:

 I am sorry to inform you that I cannot consider your gallery an appropriate space for the exhibition of my work at this time, due to any number of the following reasons:

- Bad location
- Poor lighting
- Style of work exhibited incongruous with style of my work
- Lack of reviewed exhibits in art journals
- Lack of advertising in art journals
- Poor quality of work exhibited
- Reputation as 2nd or 3rd rate gallery

- Incompetent or rude staff
- I didn't like the sound of the gallery name
- I was in a bad mood when I visited your space
- I hadn't heard of your gallery before, so I didn't bother to visit
- I hadn't heard of any of the artists represented by your gallery, so I didn't bother to visit.

 Perhaps there are other artists who might be interested in working with your gallery. Best of luck.

</div>

Like panelists and jurors, gallery staff frequently change jobs. Someone who loved your art but couldn't show it where she used to work may think it fits her new program.

And curators? They may love your work but not be working on a show that relates to what you do. They may initially want to include you in a show but the theme or concept evolves in a different direction—a natural consequence of the fact that shows can take years to develop. And they often don't have final say on who ends up in the show, either because they have to collaborate with a gallery owner or get approval from an institution's senior curators or directors.

These reasons for rejection are all common—and very few of them have to do with your artistic ability. So really, *don't take it personally*.

WHEN DOES "NO" MEAN NO?

It's not always easy to translate what you're told. Applications are straightforward: you're either in or you're out. But with galleries, nonprofit spaces, and other venues, there's a lot more gray than black and white. Let's say you meet a gallerist or curator who asks you to send over a standard package. (If you're not sure what that is, check out chapter 3.) You send them everything and you wait to hear back.

We'll go in order from Definitely No to Yes.

—"We've decided to go in a different direction."
—"Your work is developing in a different direction than our own."
—"Your work is not a good fit for the program."
These all amount to a diplomatic no. Getting a letter or email saying something along those lines—and nothing else—means don't hold your breath. You can think about resubmitting later if your work changes and you believe you fit the program better. Asking for more explanation will only exasperate the person who sent you the letter in the first place. If he or she had the time to give you more personalized feedback, you would have gotten it. The reason you didn't is that the person had to send similar letters to a dozen other artists at the same time.

—Radio silence.

This is not a no! It's not a yes, either, but it means there's still a chance. Since most shows are scheduled at least a year in advance, no one's going to feel any particular urgency to get back to you right away. It's entirely possible that the person you sent your work to really liked it but has been wrapped up in other things. Gallerists are busy people. They have to tend to their artists, cultivate their collectors, and juggle multiple art fairs every year. Curators are just as busy working on multiple shows.

So what do you do? You don't want the person to forget about you, but you don't want to be annoying. First, read the submission policy. It may state, for example, that submissions are reviewed every three months. You won't endear yourself to anyone by calling every week. Second, continue going to the openings and following its program. Third, the next time you have a show or event that makes sense to invite the person to, it's probably all right to include him or her on your list. This is a better way to keep in touch than asking for an "answer" to your submission. We're talking about one or two invites over the following year. Enough to remind the person that you're around and still doing interesting work but *not* so much that he or she feels spammed.

—"Send us cards/invites to your shows."

This is not a yes, but it's encouraging. The person likely doesn't think he or she can show you, but is curious about what you'll do and wants to be kept in the loop. Add them to your show mailing list. Including a personal note is a nice touch, even if it's a simple "Hope to see you there." Don't expect a response or take offense if they don't come. The goal is to stay on their radar.

—"Keep us informed."

—"Show us your next body of work."

Again not a yes, but a sign of real interest. You should be happy if you get this kind of response. It means you have real potential at that venue *and* you could end up being a good fit for the program or a group show in the future. The key here is to follow up. "Keep us informed" means just that: you can add the person to your mailing list and let them know when you have work up anywhere else. "Show us your next body of work" is a request to send them another package when you finish your next body of work. Do it and remind them of their request when

How do I know they got my submission? What if it got lost in the mail?

While the chances your materials were lost in the mail are slim, there are a few ways to remove all doubt. Drop the submission off in person, send it by a carrier that can track it, or include a self-addressed, stamped postcard with a note asking them to drop the postcard in the mail when they get your submission. You can also follow up your mailing with a brief, polite confirmation email if you know the person you sent the submission to.

——————"You may get rejected not because *the work stinks, but because the gallery's agenda was not being met." **Andrea Pollan, owner, Curator's Office, Washington, D.C.***

——————"Each artist's work needs to support the *others. Conceptually, they have to meld. One person's work informs another. It's a big circle. Each artist supports the one next to him or her, but the two on either side may not relate as much. It's like a complementary color wheel." **Sara Jo Romero, Schroeder Romero Gallery, New York***

——————"Life is too short to have a shmuck in the *program." **Heather Taylor, Taylor de Cordoba, Los Angeles***

——————"A curator's job is to create a balanced *program throughout an entire year or multiple years. There are tons of artists who would be great to work with, and there are artists who may have a lot of support at a given museum but, for a wide array of reasons, may not actually find their way into the program at a particular moment. Those are realities that can't be very well articulated beyond the framework of an institution." **Peter Eleey, curator, Walker Art Center, Minneapolis***

——————"You need to apply when you have the *right project and it just feels right. I really want to encourage artists to think about that. Who am I right now? What are they asking for? Is it the right fit? Don't just do the applications so you can check off you've applied to something else. Then you just end up getting rejections, rejections, rejections, and it's frustrating." **Christa Blatchford, program officer for artist learning, New York Foundation for the Arts, New York***

you do.

—"We're keeping your materials on file."
This is the best thing short of an all-out yes. Galleries and other institutions that keep artists "on file" will go to the file to spark group show ideas, add artists to a group show list, or schedule studio visits. And no one stores hundreds of submissions on file, so this response means you are now in a small, select group of artists. Definitely add the person to your mailing list and make sure you submit new packages whenever you finish a new body of work. Don't send in something every month—let them know when you have important news or a truly new body of work.

—"Yes."
You won't get a "yes" letter. It will likely be more informal, like a phone call, and will trigger a protracted courtship. The next step is usually a studio visit.

THERE'S A PLACE FOR EVERYONE

It's good to push yourself. If you're getting accepted to everything you apply for, you should try applying to more selective programs.

Likewise, if you're getting *rejected* from everything, you're probably aiming for the wrong places—either because they're too competitive or because they're geared toward a different kind of artist. Yes, persistence is important and it's almost a given that you'll need to reapply a few times before getting into a program that's right for you. But after a certain number of years (we'll let everyone else argue over how many, exactly) it becomes clear that the program just isn't a good match.

You can minimize your rejections by targeting your applications more carefully. Go back and reread chapter 6 on searching for the right residency or grant. Or chapter 7 on the different types of venues out there. These chapters should give you an idea of how you can learn where you fit into the art world.

—————"Rejection can be devastating for a day or weeks or months. It can make you backtrack and try to find faults in your artwork or process. I've gotten rejected for grants and exhibitions, been asked to be in something, and then, at the last minute, been pulled out. I've had sales fall through. But I always try to keep work going, because that's the one thing that excites me—as loose as that sounds and as airy and perhaps not practical as advice. The thing that I keep going is the thing that got me going in the first place—dialogue with other people and other artists.

"After a rejection, the last thing you want to do is get back in the studio, but it's the first thing you should do. Or just go out somewhere and get more inspiration. Look around. I keep a number of projects going (whether they're actually going someplace or not) and when there's something that misfires, there's always someplace to turn energy.

"Rejection can be fuel and it's something that you've got to realize you're not alone in. It's part of the pulse and the pattern and it should be seen as part of the whole picture. If you don't have rejection, there is something wrong with the picture." **Michael Joo, artist, Brooklyn, N.Y.**

—————"Ultimately, there is a place for you. That's the key thing. I had lots of dealers and curators whom I had hoped to work with come to my studio after graduate school and I just wasn't the right person for them. It's all for the best because the fit has to be right for both parties. You don't want to find yourself in a high-profile gallery that loses interest if the response to your work disappoints them." **Charles Long, artist, Mount Baldy, Calif.**

CHAPTER 9

—————Getting Your Work to the Show

PACKING

When you need to ship your work somewhere, packing it well is crucial. In this chapter we tell you how to do it right.

That said, there's more than one way to do it "right." What we recommend below are safe ways to pack the most common art objects. So take our detailed instructions for the recommendations that they are. Different shapes and materials call for different techniques; your budget may require cutting corners. We can't cover every possibility here, so take the principles we outline in this chapter and apply them intelligently to whatever it is you're packing.

Some museums with exceptional budgets have machines that can scan an art object and create foam pieces to fit perfectly around the work, preventing it from shifting once it's placed in a crate. This is called "cavity packing" (seriously) because the foam fills the space between the object and the sides of the crate. No matter what you're packing, no matter how small your budget, no matter where your destination, you want to follow the same principle as best you can: your work should sit in the center of the crate, it shouldn't shift around, and its weight should be as evenly distributed as possible.

A few more guidelines before we get to it:

—Clean your work area. Clear out more space than you think you'll need.

—Wear white gloves whenever you touch finished artwork; they protect the surface from the oil and dirt on your hands. For heavy or slippery work, use gloves with "grip" that won't mark the surface. We recommend nitrile or latex.

—When packing work, any materials that touch the surface of an artwork should be "archival" (meaning permanent, pH-neutral, durable, and used for preservation). You can you find archival materials at stationery, hardware, craft, and art supply stores.

—Your work should have the same orientation when it is packed that it has when it isn't.

—Don't use peanuts. Fill spaces with bubble wrap, foam, or other soft material.

—Never let tape touch a piece of art. After sunlight and gravity, tape is the most common cause of damage to art.

—To seal any material that you wrap around the work, use archival tape or the "blue tape" or "painter's tape" that removes cleanly from most surfaces. Once you've protected the work in at least one layer, you can use a stronger plastic tape to tape up the bubble wrap and the box.

—As for that stronger plastic tape, buy brown, printed, or colored tape that you can see. Many artists use clear plastic tape because it looks so good. But it looks good because it disappears, making it a nightmare to remove. And bits of tape that you don't remove can end up harming the work.

—Pay special attention to edges and corners. They're always sticking out and getting hurt. Reinforce and protect them accordingly.

————"Wrap work like you're wrapping a present. It should only take three pieces of tape. Sometimes I'll be with a client and they have to wait while it takes fifteen minutes to unwrap a piece!" **Heather Marx, Marx & Zavattero, San Francisco**

————"If you're an artist who makes delicate paintings where nothing can touch the surface, then learn how to build a travel frame! Don't expect a gallery to take your wrapped paintings that nothing can touch and store them properly and caretake for them. If you want them shown, you need to build a travel frame so they can be shown and shipped properly. That's part of your work." **Steve Zavattero, Marx & Zavattero, San Francisco**

Frame your flat work with UV-treated Plexiglas, not regular glass. Plexiglas is not as fragile and a heck of a lot lighter, so it's much easier to ship. It's also the best thing for the work. Sunlight is the greatest enemy of art and UV-Plexiglas is the easiest way to protect works on paper (including photographs) from harmful UV rays.

Even with the UV-Plexiglas, works should never be hung in direct sunlight. In fact, some serious collectors go as far as getting a UV-treatment on the windows in their home.

Tyvek vs. Glassine

A lot of artists (and galleries) prefer glassine because it's cheaper than Tyvek. While you *can* use glassine, you should understand its limitations: when exposed to humidity it can become rough; if it gets folded anywhere, the crease will be sharp and could damage your work; and glassine won't protect your work from vapor the way Tyvek does.

—You'll make your life easier by reusing packing materials (except glassine and tape). As you pack, label each layer of wrapping with the name of the piece so you'll know what goes with what when you repack.

—If you're shipping your work to someone who bought it, consider charging a "shipping *and handling* fee" to cover the extra expense of quality packing materials. Many galleries do this because collectors understand that it's worth paying a little more to have their work packed properly.

—When you're sending an unsold piece to a show, it doesn't hurt to ask the venue whether there is a budget for crating (and shipping). Never be afraid to ask the gallerist or curator for advice on how to get your work to the show in the safest, least expensive way possible.

Flat Work—Framed

Repairing a frame can cost nearly as much as buying a new one. So protect the frame as carefully as you would the work itself.

1. Wrap the framed piece in butcher paper and jot down "front," "back," and "up" with an arrow.
2. Place Styrofoam or cardboard corners around each of frame's corners. You can buy corners or make them yourself.

3. Wrap with bubble wrap, bubbles facing *out*. Use one-inch, big bubbles—not the little ones, unless the piece is small. If you skipped Step 1, bubbles facing in could mark up the Plexiglas and even stick to it.

4. Tape up the bubble wrap.
5. Wrap with another layer of bubble wrap, bubbles facing *in*. Tape up.
6. Place the wrapped work into a cardboard box and stuff the space between the wrapped work and the sides of the box with more bubble wrap or similar material.
7. At this point, the piece should be suspended in the center of the box with packing material surrounding it on all sides, packed tightly enough to prevent it from moving inside the box. If you make your own box, make it just large enough to slide the bubble-wrapped piece in without any filler.

MAKING A BOX!

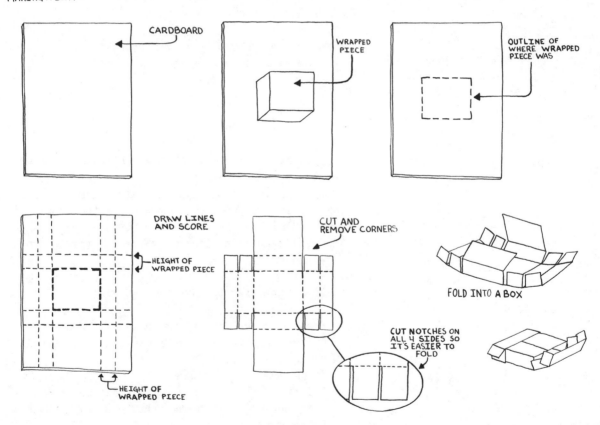

8. Pieces larger than around 16 x 20 inches need more stabilization. There are three ways to do this:

 A. Compete Steps 1 and 2 above. Then, on either side of the butcher paper–wrapped work, place sheets of Masonite, plywood, double-wall cardboard, or a rigid foam material (such as pink, blue, PolyPlank, or ether foam). Bubble-wrap and box.

 B. Complete Steps 1 through 5 above. Then place foam on each side of the bubble-wrapped work and box it up.

 C. Complete Steps 1 through 6 above. Then place the box into the center of a second, slightly larger box and pack up as if the first box were the artwork.

If none of these techniques gives you enough stability and there's still a chance that the work will twist, you'll have to make a crate. (See "Large Paintings" below.)

Flat Work—Unframed

There are two ways to ship flat work: rolled up in a tube or flat. Don't use a tube unless you're shipping a photograph or other "simple," smooth work on paper. (Painted and textured works can crack and flake when you roll them up.) You basically roll the work around a small tube and place that inside a larger one. Needless to say, the outer tube has to be very strong. One little dent will damage your piece.

To ship flat work in a tube, follow these steps:

1. Wrap the drawing in Tyvek, glassine, or archival paper.
2. Roll the wrapped work around a tube. Tape it down to prevent shifting.
3. Bubble-wrap the tube, bubbles out.
4. Slide the bubbled roll snugly into a second tube. You can use quarter-inch-thick cardboard or plastic tubes. We recommend PVC pipes or Sonotubes.
5. Seal each end of the outer tube.

How can I get specific advice on packing my work if there aren't any galleries where I live?
For advice on packing and shipping, look up any institution or store in your town that handles fragile goods. You might try a local museum (of art, natural history, or science) or an antique shop.

6. Write your address and the shipping address on the tube.
7. Wrap the entire tube in plastic to protect from moisture.
8. Write the addresses again on the plastic.

To ship unframed work flat, follow these steps:

1. Make a "sleeve" or envelope out of archival paper or soft-spun Tyvek.
2. Slide the work into the envelope and seal it with archival tape.
3. Attach the envelope to a piece of cardboard (or foamboard or rigid foamcore) the same way you'd attach photographs to a scrapbook. To do that, make "corners" by folding pieces of paper into triangles with open ends, like triangular pita bread. Tape the corners to the board, which we'll name "Martha." (Just go with us here.) Slide the envelope into the corners and tape the edges of the envelope to Martha, using archival tape.

Toss That Tape!

While you should keep your packing materials after unpacking your work so you can use them to repack after the show, toss *all* the tape. Random bits of tape tend to find their way onto artwork and are a real pain to remove. Better to use new tape each time.

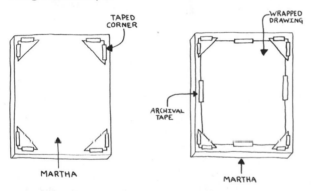

4. Cut a second board the same size as Martha. We'll name this one "Henry." Take four pieces of tape and wrap them over the middle of all four of Henry's edges. (The tape provides a better surface for sealing the boards together.)

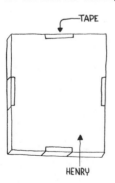

5. Sandwich the envelope between Martha and Henry.

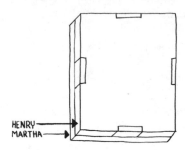

6. Take four more pieces of tape and fold over one end of each of them to create a tab. Use these tabbed pieces to tape Martha to Henry. Each tabbed piece of tape should line up with the tape on Henry's edges (tabbed end on Henry, untabbed end on Martha). This makes it very easy to untape and retape the sandwich.

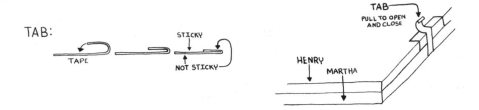

7. Secure the entire package between two pieces of dense foam, hardboard, or Masonite (making a second sandwich).
8. Bubble-wrap and box as described above in "Flat Work—Framed."

—————————"I'm not in this business to talk about pet peeves. I do what I do because I learn something different from every single person every time I have an interaction with them. I find that my world is illuminated. But if I had to choose a pet peeve, mine would be— learn how to wrap your own work!"

Eleanor Williams, art advisor, curator, former gallerist, Houston

Small Dry Paintings

Follow these instructions for dry paintings up to 30 x 40 inches. But if your painting is covered in impasto or has a delicate surface, such as enamel or encaustic, follow the instructions below for "Small Wet Paintings."

1. Cover the front of the painting with a sheet of soft-spun Tyvek or glassine. Tape the sheet to the back of the painting, to itself, or to the stretcher bars. It's really not a good idea to use plastic at this step, because over time it can bind to the surface of the work. This is bad.
2. If you're using Tyvek, skip to Step 3. If you're using glassine, wrap the painting a second time with plastic. (Glassine doesn't protect the work from vapor the way Tyvek does, which is why you need the outer layer of plastic.)
3. Completely cover the front of the painting with a piece of cardboard the same size as the painting.
4. Attach corners, bubble-wrap and box as described above in "Flat Work—Framed."

DON'T FORGET TO PACK SOME CAT FOOD WHEN YOU SHIP THIS.

Cutting Down on Your Art Shipper's Bill

Art shippers will pack everything for you, but they charge by the hour so the packing alone can be a small fortune. To save money, pack your work before they arrive (ask them how they want it packed).

You can also save money by "soft-packing" your work, which means protecting your work so someone can carefully pick it up and place it in a van without damaging it. It's the way you'd pack your work if you were moving it yourself: maybe a layer or two of bubble wrap or a box. In other words, less than what you'd do to ship with a common carrier.

You shouldn't soft-pack large or delicate paintings, though. Better to build a travel frame: a crate without a front, covered in Tyvek or plastic. It's basically a deluxe collar.

Make sure you tell your art shippers how you are packing the work, because they may use different trucks for crated and soft-packed items.

She did WHAT?

A few years ago, an artist we know needed to transport her painting home from a show herself. It was a large, heavy painting—6 x 6 feet—so she put it in the back of a pickup truck and hit the highway. No rope, no cover, no nothing.

Somewhere around sixty miles per hour, the painting lifted up like an airplane wing and flew out into the traffic behind her. She was lucky it didn't kill anyone.

And that painting, which proceeded to get run over by dozens of cars, happened to be the one that art critic Jerry Saltz said was the best she'd ever done.

Estimated Shipping Costs for a 36 x 48 x 4 inch package weighing 20 lbs (before insurance)			
FROM CHICAGO TO LOS ANGELES			
	GROUND	2ND DAY	NEXT DAY
UPS	$45	$150	$190
FEDEX	$26	$150	$190
ART SHIPPER	$600-$900		
ROUND-TRIP RENTAL CAR	$500 plus gas		
FROM MANHATTAN TO BROOKLYN			
UPS	$25	N/A	$75
FEDEX	$10	$50	$70
ART SHIPPER	$100-$300		
TAXI	$14 + tip		

————*"We are a gallery, not a museum, so we use common carriers sometimes. One time, we had a painting that had heavy impasto so I used an art shipper. I paid extra for them to collar the painting so nothing would touch the surface. The painting arrived, wrapped in plastic. I had to call a conservator!! The artist was present in the studio when it was wrapped. She, another dealer, and I had all agreed the painting needed to be collared and the guys bullied her. They told her it didn't have to be packed that way and they were in a hurry. She is a sweet, nice girl and she didn't stick up for herself.*

"I would tell artists not to let anyone bully you. Make sure your work is handled the way you need it to be handled because it is your work and no one is going to take care of it better than you. Even if the dealer tried to make sure everything is right, there is always an in-between person involved."
Eleanor Williams, art advisor, curator, former gallerist, Houston

————*"I've never insured anything I shipped. I just sent it, usually via UPS. I figure I made it, so I can make another one. It would be sad to have a piece lost or damaged, but I can make another one, and insurance money won't fix it. I lost a painting for a year once, but it eventually turned up unharmed, just when we thought it was gone forever."*
Bill Davenport, artist and critic, Houston

Small Wet Paintings

Build a "collar" for the painting out of rigid foam or cardboard. A collar is just what it sounds like: it wraps around the edge of the painting just as a collar wraps around your neck. A cross-section of a collar should look like an L, with the short end of the L flush against the back of the painting, and the long end flush against the sides of the painting, extending several inches beyond the painting's surface.

1. Staple or screw the short end of the L to the stretcher bars behind the painting. Be careful not to poke any holes in the canvas. If you have D-rings or other hanging hardware on the back of the painting, poke them through the cardboard collar and tape them down to reduce the number of screws you need to use.

2. Stretch Tyvek or plastic over the collar, covering the painting without actually touching its surface. You can use plastic here because it won't touch the piece. Tape in back.
3. For paintings up to 11 x 14 inches, bubble-wrap and box as described above in "Flat Work—Framed." For larger wet paintings that you're shipping with a common carrier, build a crate as described below in "Large Paintings."

Large Paintings

For dry paintings larger than 30 x 40 inches and wet paintings larger than 11 x 14 inches, you really should either hand-deliver them yourself or hire an art shipper. If you have to use a common carrier, build a crate—essentially a wood box. Don't

skimp here. Build the crate or pay for the art shipper. (Or do both to cut down on the art shipper bill.)

It's safest to build a custom-sized crate each time you ship, though sometimes you can get away with repurposing a sturdy wooden box you already have. Here's how to build a custom crate:

1. If the painting is wet or very textured, skip to Step 2. If not, wrap the painting in Tyvek or glassine and plastic, as described above in "Small Dry Paintings."
2. Make a "travel frame" for the painting, which is essentially a wood collar with wooden slats across the back. (See "Small Wet Paintings" for how build a collar.)

3. Cut enough plywood to make a box a few inches larger than the collared, wrapped painting on all sides. The plywood should be at least three-fourths of an inch thick. (If you're using regular wood and shipping internationally, it has to be heat-treated to comply with regulations.)
4. Construct the box. (But don't attach the front piece until Step 8.) Use "skids" for large boxes: strips of wood along the bottom that raise the box off the ground.
5. Drill support bars or spacers to the inside of the back of the box.

6. Attach the travel frame to the support bars (or spacers) by drilling from the outside of the crate through the support bars and into the slats. Make sure the screws are long enough to secure the travel frame, but not so long that they touch the painting.

CROSS SECTION OF CRATE

PAINTING — WOOD TRAVEL FRAME
— CRATE
SUPPORT BARS

DRIVE SCREWS THROUGH CRATE AND SUPPORT BARS AND INTO BUT NOT THROUGH THE WOOD TRAVEL FRAME.

7. Draw circles on the back of the crate around the heads of the screws that you used to secure the painting. This ensures that the people unpacking your work only unscrew what they need to to remove the painting (as opposed to taking apart the entire crate).
8. Number the circles in the order you want them unscrewed, if that matters.
9. Drill the front of the crate in place. Circle the heads of these screws as well.
10. Write FRONT, BACK, and TOP on the crate. Draw arrows to show which way is up.

Since crates last longer if you don't drill as many holes into them, artists who reuse their crates a lot—or who ship multiple pieces in one crate—prefer securing their work in other ways. They might line the entire crate with thick foam, leaving just enough space to fit the (bubble-wrapped) work. Or they'll wrap each piece, place them in the crate, and stuff the empty space the same way they'd pack a small painting into a box.

If you go this route, the usual packing principles apply. Your work should never touch the sides of the crate or shift in transit.

3-D Work

The right way to pack three-dimensional work depends on the material. Whatever you decide to do, plan it all out before you start to pack. You'll often need to separate the work into parts, wrap the parts separately, and then pack them into a few boxes. As with paintings, you need to build a crate for large pieces. Be especially careful with fragile edges and delicate extremities. Protect them with foam covers the way you would the corners of a frame.

You can hang a lightweight sculpture inside a box (or crate) with fishing wire and secure it, suspended in the center of the box, by tying more fishing wire to its sides and bottom.

If any of your sculpture's components were delivered in specialized packing material, save them to reuse when you ship your work.

Include instructions for unpacking and reassembling *and disassembling and repacking* the work. Note every single component: how it should look after unwrapping it, how it fits with the others to make the piece, and how to take them apart and pack them after the show. Make your instructions idiot-proof with photographs and diagrams. It's the only way to ensure that the people receiving your work handle it properly.

Do this even if you plan on unpacking the work yourself at the gallery, art fair, collector's home, or wherever it's going. Things come up, flights get canceled, cars break down . . . you might not be there when the work arrives and someone else may have to unpack it after all. Do it even if your collector says she'd never dream of reselling the work. Tastes change, memories fade. You can't prevent your piece from be resold, but you can protect it from being damaged.

Videos

Shipping DVDs is a piece of cake (actually, it's easier than shipping a piece of cake). Since a plain DVD doesn't look very special, you should at least put it in a case. There are plenty of inexpensive, safe mailers on the market designed specifically for DVDs.

Always send a backup copy to an exhibition in case something happens to the original disk.

—————*"Sculptors should definitely consider how their pieces will move. In some ways that is a buzz-kill for the artistic process, but you'll be really popular with gallerists and collectors if you consider these things."* **Jonathan Schwartz, CEO, Atelier 4, Long Island City, N.Y.**

SHIPPING

When you're represented by a gallery, the space hosting the
exhibition should pay for shipping. Otherwise, don't count on it.
Sometimes the space will cover one-way shipping; sometimes
it won't cover either way.

When you're stuck dealing with the shipping and the show is
local, deliver your work yourself. You won't need to build a crate
but make sure you pack the work carefully. And if your painting
will need a collar or travel frame while stored at the venue, build
one regardless of whether you need it for transport.

If you can't deliver the work yourself, the safest way to
ship it is with reputable art shippers. They can pack your work
for you, have specially equipped, temperature-controlled
storage and vehicles, and can take care of any insurance and
customs paperwork.

Just be sure to plan ahead when you go with an art shipper.
These guys tend to be smaller operations with less flexible
schedules than the common carriers you may be used to using.
And be clear about what you're shipping, how it's wrapped,
and whether it needs special care. Paper sculptures, for example,
need to travel in climate-controlled trucks because they're so
sensitive to heat and humidity.

While most art shippers take their jobs seriously, sometimes
they're sloppy. It's a good idea to hang around while they pack
your work to make sure they're doing it right.

Given how expensive art shippers are—they are really
expensive—the vast majority of artists and galleries go with
FedEx, UPS, or other big commercial shippers. Keep a few things
in mind when shipping with these guys:

—To be absolutely safe, you need to crate larger works.

—Make sure the package is safe to drop and can withstand a
one-inch gouge without damaging the work.

—Some of these companies offer very low insurance caps (like
five hundred dollars) or say they won't ship fine art. Check
with your insurance provider about what your policy covers.

—Common carriers can charge less because they make it up in volume. They will stack, rotate, and jostle your work.

—Cover your crate or box with FRAGILE stickers. It can't hurt.

—Write the waybill number, your address, and the delivery address clearly on the box or crate. Don't rely on the waybill alone.

—Never ship on a Thursday or Friday. When you do, there's a good chance your work will sit in storage over the weekend. That means more moving around, more handling, more stacking and unstacking—all by personnel who aren't trained to handle art. And the warehouses aren't climate-controlled. In other words, there is a much higher risk of damage.

International shipping is slower, riskier, and more expensive. Go with an art shipper if you can afford it; otherwise, use a common carrier and pack your work extremely well.

INSTALLING YOUR SHOW

For basic installing tips, see chapter 5 on open studios. Here are a few more tips for installing a show or art fair:

—*Ask ahead of time whether there are any general restrictions.* Can you paint on the walls? Drill into the floor? Does the art fair require you to use union labor or can you install everything yourself? How big are the doors and elevators? Your piece may fit inside the room, but that doesn't matter if you can't get it *into* the room. Depending on these kinds of restrictions, you might have to show different work.

—*Ask what the walls are made of.* Plywood—which is what most art fair booths are made from—can take regular screws. Drywall, plaster, and other thin walls require specialized hardware. Galleries and museums have no real standard when it comes to wall material. You don't want to wait until you're installing to discover that behind the clean white wall is a layer of brick.

————"Artists who work at LA><ART have a great deal of autonomy throughout the process. But the entire process from inception to production to installation is truly collaborative." *Lauri Firstenberg, director and curator, LA><ART, Los Angeles*

————"It is very important for an artist to keep in close contact with the curator. Even though a show is locked down and confirmed, it is difficult for the institution when the artist is a terrible correspondent. I hope that any artist I work with would be available and forthcoming with ideas, questions, and concerns. They should absolutely expect the same from me." *Laura Fried, curator, Contemporary Art Museum St. Louis, St. Louis*

————"Be a professional about the installation. Be a professional about every part of it. It's not grad school and a bunch of artists getting together and having a fun time. There is a lot of money at stake here. Even though you and your gallery might get along great, it's still a business venture." *Murat Orozobekov, director, Winkleman Gallery, New York*

————"Whether it's at a gallery or a museum, you have to call your own shots in terms of the artwork itself. I've learned that more from positive experiences than negative ones. Galleries and museums benefit from your saying what you know is right for the work. They have their areas of expertise and you have yours. My personality is often too eager to accomodate, but I've learned that it doesn't do anything for the work if I lose track of the boundaries." *Charles Long, artist, Mount Baldy, Calif.*

*————————"Sound is my most common problem
with showing video. Even headphones are more
complicated than they seem, as they often need to be
amplified. Audio presentation issues should be
discussed as early as possible. If you have specific
needs, you probably have to supply all the hardware
unless it is part of an initial agreement that the
gallery will provide all the equipment.*

*"For this stuff, I have to choose my battles. No
point in making the gallery angry. But when I come in
and the sound has been turned down on my
video, it's as if the lights were out on my photo."*
Rob Carter, artist, Brooklyn, N.Y.

—*Ask whether you'll get assistance from staff.* For artist-run
shows and nonprofit venues, or if your work is site-
specific, expect to install and deinstall everything yourself.
Galleries and museums will usually have staff to hang
and take down your work.

—*Ask how much time you'll be given to install your work.*
Don't assume you'll be able to stay late unless they say so.

—*Be realistic about how much time you need to install.* You know
how airlines always say a flight takes longer than it really
will, so that even if there's a delay they can pretend they
arrived on time? Same principle for estimating your installation
time—especially if people are going to be assisting you. They
have other artists to help, other tasks to finish, and are
under as much stress as you are. No one cares if a "three-hour
job" ends early. But a "one-hour job" that actually takes
three hours will make everyone mad (and, in an art fair, will
ripple out and disturb a lot of other people's schedules).

—*Ask what equipment they have and what you need to bring.* A
lot of artists bring their own drill, level, and measuring tape—
even if the venue has its own equipment—because it's
frustrating to have to wait your turn for the drill. Make sure
they have a ladder if you need one. If you're an unrepresented
video artist, you will likely have to provide your own hard-
ware. Don't forget to bring backup disks. And train the staff
how to maintain the work throughout the show: how to turn
it on and off; what the volume should be; how to keep it clean.
Leaving them with an instruction sheet is a nice touch.

—*Be cool to the staff.* They are there to help you—really. Don't
take them for granted, don't act like a prima donna, and don't
tell them to be there at 9 A.M. if you're going to waltz in at noon.

—*Understand how much control you have (or don't).* Some ven-
ues don't let their artists anywhere near the installation
process, period. If you don't like that, don't show with them.
For the rest of the venues that do collaborate with their artists
on installation decisions, you have more say when you're

installing a solo show than when you have one piece in a group show. (If this seems obvious and fair to you, wonderful. You'll be easy to work with and people will want to continue showing you.) Installation artists get more say in how their work is installed—even for a group show—because the installation itself is integral to the work. For the same reason, no matter what kind of art you make, if the work's meaning requires a particular placement or lighting, make sure you tell the curator.

—*Be professional*. Don't bring friends or family to the installation. The curator or gallerist is collaborating with *you*, not your posse.

—*Leave the place as you found it*. If you changed the architecture or painted the floor, the venue may expect you to help put the place back together when the show ends.

Group Show Etiquette

The kindergarten basics apply here: think about the other artists, think about the other work, and think about how you all fit together.

—Don't take up more space than you're allotted, because that will encroach on someone else's space. That said, don't let someone else take over your space. Ask the gallerist or curator for help if you're uncomfortable.

—If you're going to do anything that creates a lot of dust (like drilling) or emits toxic fumes (like gluing), find out ahead of time when you should install so as to minimize the nuisance.

—Mind the work on the other side of the wall.

—Use headphones for sound work, or keep the volume low, or work out intermittent plays, or ask everyone if they're okay with full blast—including the gallerists.

—Talk to the venue ahead of time about what to do with your packing materials during a show. Most of the time, the venue should be able to store them, but that may not be possible for large group shows.

CHAPTER 10
————Consignments

———————"Everything went smoothly with a show I curated except one of the artists and the gallery director had bad chemistry. There were no consignment forms and I was not in town so I couldn't help smooth things out. One piece sold but months later the artist was still not paid. The gallery and the artist were both calling me because I was the in-between person. There was nothing I could do really.

"I suggest, from this experience, that artists always use a consignment form and not worry about being too pushy. Consignment forms are a good business practice and the gallery may respect you more when you ask for a consignment form."
Leah Oates, artist, curator, writer, Brooklyn, N.Y.

———————"The problem with the art consignment statute is that it's not self-enforcing. One of the things it says is that the gallery can't hold the work for ransom. But galleries do it anyway, and they know it's expensive for the artist to try to do something about it. So you end up settling for something less than 100 cents on the dollar in order to get the work back." **Donn Zaretsky, art lawyer, John Silberman Associates, writer, Art Law Blog, New York**

You thought we were done with paperwork way back in chapter 3, didn't you? Not even close.

You should use a written consignment agreement whenever you let *anyone* sell your work for you. A one-day art fair, a nonprofit group show, a solo show at a reputable gallery—it doesn't matter. If the venue doesn't have its own consignment agreement, you need to make your own. It's easier than you might think and in this chapter we'll show you how.

WHAT IT MEANS TO CONSIGN WORK

Almost all contemporary galleries sell art by consignment: you let a gallery take your work and sell it for you and the gallery keeps a percentage of the sale. Because it doesn't buy the work from you, the gallery *possesses* it but never *owns* it. You still own the work while it's in a show or at a fair; as soon as a collector buys it, ownership passes directly from you to the collector. And you don't get paid until the collector pays the gallery.

This consignment arrangement applies to any kind of exhibition where the works are for sale, from a commercial gallery to a nonprofit venue to a café space, regardless of whether anyone expects the art to sell. So it is almost a given that when you show your work, you'll be showing it under consignment.

By this point in the book, you've gotten to know us a little and can probably anticipate what we're about to say: *sometimes things go wrong.* A gallery doesn't give back your unsold work when you need it for a new show; your piece returns from an art fair damaged; a nonprofit space loses its lease and the landlord confiscates everything inside, including your work.

You cannot afford to be naïve about these things. You're a professional and you need to look out for yourself. It's not that everyone's trying to take advantage of you—they're not. It's that you can easily minimize the fallout from the kinds of accidents and misunderstandings that happen all the time in the art world. A written consignment agreement will protect you from the unhappy consequences of consignment mishaps.

How? Thirty-two states, including New York and California, have laws specifically protecting artists who consign their work.

While they vary from state to state, most of them prohibit your artwork from being seized if the venue goes bankrupt; require that money from the sale of your work goes to you *first* (rather than, say, the electric bill); and, in some states, even dictate thirty-day payment deadlines. Some of them protect you whether you have anything in writing or not, but it is much harder to prove that you consigned something if you don't have it in writing. A consignment agreement is like a receipt that proves you consigned the work.

It's also very helpful to have a record of what you've given whom. And writing up a consignment agreement encourages you and the venue to think about the basic arrangement ahead of time, so you don't discover after the fact that you had very different expectations.

It's easy to make one—you won't need more than one or two pieces of paper. Consignment agreements have two basic parts: an inventory list and terms. The inventory list identifies the specific works you're consigning and states the basic price information. The terms are all the details of the arrangement, such as the length of time, the maximum discount, etc. (We'll walk you through all of them in a moment.) Any inventory list that includes more than just the description of the work is technically a consignment agreement, although it may not be a "complete" agreement, in that it leaves out a lot of details.

Before you spend time making your own consignment agreement, ask the venue whether it plans to give you one. Most venues will prefer to fill out their own form, rather than use yours. *Who* drafts the agreement isn't as important as what it says. Some places just give their artists inventory lists, so there's a record of which work the place has but no details about the arrangement. Some add a few basic terms. Some don't write anything down at all.

If the venue does have a form—whether a comprehensive consignment agreement or bare-bones inventory list— read through it and make sure it covers all the issues that are important to you. You may want to add a few details to the form—just discuss them with the venue first so you're on the same page before you start marking up the form. You can have the conversation over email, but you should still take whatever additional issues you've agreed on and add them to the

Call your local bar association to find out whether your state has an art consignment law. For a detailed comparison of all art consignment laws in the country, see the book *The Artist-Gallery Partnership* by Tad Crawford and Susan Mellon.

———————"There's still very little paperwork between galleries and artists. Very little if any, incredibly enough. It's still the Wild West. Although that is changing and artists are changing. If one of my artists asked for paperwork, I would do it. Absolutely. Happy to." **Tim Blum, Blum & Poe, Los Angeles**

———————"If the gallery refuses to sign something like an inventory list, you might really wonder whether you want to work with that gallery. I mean, would you just leave personal property with anybody without getting some sort of written statement? But in that case, you could always then send a letter to the gallery saying, 'On such and such a date, I left the following art with you.'" **Tad Crawford, arts lawyer, author, publisher, New York**

———————"Many of the terms of an oral contract will be unclear, or subject to dispute, without putting them in writing. People simply don't know what they've agreed to on issues they never discussed, or issues that they heard differently from what the other party thought he or she was saying. It creates a much higher likelihood of disagreement, and ultimately a bad relationship, than if you have a clear, written agreement." **Tad Crawford, arts lawyer, author, publisher, New York**

consignment agreement so that they're in one place. That's better than, for example, ending up with an inventory list and seven email messages that together "count" as a consignment agreement.

If the venue doesn't write anything down, offer your own consignment agreement. This is another situation to approach delicately, because people can overreact or misinterpret your intentions when you hand them an "agreement," especially people who aren't in the habit of writing things down. (For more on written agreements in general, see chapter 14.) One way to handle the situation is to just ask for an inventory list, since even galleries who don't usually give their artists inventory lists should be willing to make one for you. And if they're not, you can offer to make your own and give them a copy. At that point, you'll need to decide whether you're comfortable saying you want to add a few more details to the form so that it covers your consignment arrangement, or whether you'd rather just take your chances.

I LOVE YOUR NEW WORK... ...IT'S WORTH SO MUCH MONEY.

WRITING A CONSIGNMENT AGREEMENT

Now we'll show you how to write a simple consignment agreement. You'll notice that the language we suggest using is more colloquial than you're likely to find in a lot of the consignment agreements out there. That's because our goal is to set you up with the most practical, user-friendly agreement we can, avoiding formal language and legalese wherever possible. We'll say "gallery" throughout the agreement, but that can refer to any venue.

Note also that we're only talking about a consignment from you directly to a venue that will show or sell your work, not a consignment from your gallery to a second gallery or a loan to a museum.

Your consignment agreement should begin with the basics:

—your name and studio address
—the name and address of the venue to which you're consigning your work
—an inventory list: the name and description of each work you're consigning (title, year, medium, dimensions or duration, edition)
—the retail price of each work
—production and framing costs (on a separate line)

Remember that retail price is what the collector pays, so it includes any production and framing costs. You break those out on a separate line to be clear about any amounts you or the gallery (depending on the arrangement) will be reimbursed *before* applying any discounts or calculating the gallery's commission. Galleries differ on how they treat production and framing costs, so ask them what their policy is. (See chapter 13 for more on production and framing.)

The rest of the consignment agreement contains the terms. At a minimum, a consignment agreement should include these terms:

1. Consignment language
2. Time frame
3. Commission
4. Discounts

Why You Need a Consignment Agreement, Part One
People have bad memories. Even people with good memories have bad memories. It's part of our charm as human beings. Writing a short consignment agreement relieves you, and the person to whom you're consigning your work, from having to remember every detail of the arrangement. It prevents uncomfortable conversations like this:

"So, I'm going to need that work back for another show this weekend."

"But you said I could have it for two months!"

"No, I said two *weeks*."

"I remember *exactly* what you said."

"Um, *I'm* the one who said it, and I know I said two weeks." Etc.

With a consignment agreement, you can pull it out of your pocket and shake it dramatically in the other person's face—just make sure you go back and reread it because, well, maybe you *did* say two months.

5. Payment
6. Shipping
7. Safekeeping and insurance

We'll go through each of these in turn, and then raise some other common issues you may want to add.

Consignment Language

You'd think that putting "Consignment Agreement" at the top of the page would be clear enough, but you actually need to state that you're consigning your work (as opposed to selling it to the venue). If you ever need to prove that the venue doesn't own your work, this is the sentence you point to:

I consign to the gallery the work identified in the inventory list above.

If you are represented by a gallery and expect to consign it work regularly, you can write a general consignment agreement to cover all your future consignments so that, from then on, all you need is a new inventory sheet each time you deliver work. Just add this sentence to the end of the agreement.

This consignment agreement will apply to all works I consign to the gallery in the future, unless a new inventory list modifies some aspect of this agreement or the gallery and I write a new agreement.

The reason for the second part of the sentence is that many galleries do more for their artists the longer their artists are with them. Maybe you have to cover shipping for your first show, but by your third, the gallery will pick up the tab. As these things evolve, so should your consignment agreement. Print out a new one that says "the gallery pays for shipping" where it used to say "I pay for shipping" and give it to your gallery. (Or add it to your next inventory list.)

Note that we don't include this sentence about future consignments in our sample agreements because most consignments

A Matter of Style

A lot of galleries use terms like "the Artist" and "the Gallery" in their consignment agreements because there's less to fill out every time they write up a new one:

The Artist consigns to the Gallery the work identified in the inventory list above.

Since it's obvious that you're the one doing the consigning, we say "I" or "me" instead of "the Artist" because it's less formal and a little friendlier. We stick with "the gallery" because it'll save you a lot of time, but go ahead and substitute the actual name of the venue everywhere you see "the gallery" if you like how that sounds better.

Also, you may notice that we don't capitalize "gallery" the way a lot of consignment agreements do. Lawyers capitalize terms to distinguish them from their generic version: "the Gallery" is the place you're consigning work to, a "gallery" is any gallery in the world. But we only talk about one gallery in our consignment agreement, so there's no chance anyone will get confused about which gallery we're talking about.

————————"As an advocate for artists, I would be in favor of anything written rather than just a handshake. If only to train people: get your dealer used to the fact that, each time you're consigning some work, they have to sign something."

Donn Zaretsky, art lawyer, John Silberman Associates, writer, Art Law Blog, New York

—————"Last year, one of our artists consigned us three pieces for Miami and two pieces for the Los Angeles art fair. It took sixteen emails and six phone conversations to get these works consigned with the correct titles, dates, sizes, media, and prices. He said things like 'Can you check the size on this?' and 'This says 2007, but I actually made it in 2006.' It was amazing how complicated it could be. So now we make emailed consignment forms and ask our artists to fill in the inventory before they give us the work." **Greg Kucera, Greg Kucera Gallery, Seattle**

—————"Issues can certainly arise around keeping track of work and getting work back. Sometimes it is just awkward and sometimes it requires investigation or confrontation. It's important for an artist working with a gallery they don't know or a gallery that's a little fishy, to have a time limit on consignments. Time limits and spelling out how discounts work. Because there's always a discount and it shouldn't be a surprise." **Charles Long, artist, Mount Baldy, Calif.**

—————"I want consignment forms only because they help me to keep track of everything and because they help artists—especially younger artists—outline everything, including whether they agree to split a discount. That way I don't have to make that phone call every time I want to give a discount. It's already in writing and understood." **Eleanor Williams, art advisor, curator, former gallerist, Houston**

are one-offs and you don't want to come across as too presumptuous. You should add the sentence once you have an ongoing relationship with a gallery.

Time Frame

Specify how long the consignment will last. Either tack the dates onto the first sentence of the agreement or start a new sentence:

The consignment will last from [start date] through [end date].

Consignments can range from a few days to many months. They typically run from the week before an opening through the week after the show closes, though galleries often want to hold work longer than that to follow up with interested collectors. When you're consigning your work to a gallery that doesn't represent you (that is, beyond the show you're in), the gallery shouldn't need to keep your work for more than six months. A gallery that does represent you might want an indefinite con-signment, which is fine given that your relationship will continue well beyond the current show. (More on that in chapter 13).
It's also a good idea to state:

The gallery will return any unsold work to me within [15] days of the end of the consignment period.

You and the gallery can always decide to extend the consignment period. Just do so in writing, either by marking up your original consignment agreement or sending the gallery an email with the new date. It doesn't have to be formal:

Hi [gallerist],

It's not a problem at all if you want to hold on to [title of work] until [new date], instead of what we said in the consignment agreement. Let me know before [new date] if you end up needing more time than that.

Hope all is well.

The point is to avoid an ambiguous, open-ended arrangement where you don't know when you'll get your work returned. Otherwise you'll be stuck in the awkward position of trying to guess when it's appropriate to ask for it back. Too soon and you give the impression that you don't like the gallery; too late and your work just stays hidden. This also complicates planning for upcoming shows, since you don't know whether you'll be able to include the work. Much better to set expectations in advance.

Some consignment agreements state that, regardless of the time frame, either the gallery or you can end the consignment at any time, usually with some kind of written notice:

Either the gallery or I may cancel this consignment agreement by writing to the other, in which case the gallery will return any unsold work to me within [15] days.

Commission

State the commission the venue will receive for any sales and whether one of you will be reimbursed for production costs off the top. (For an explanation of production costs, see chapter 13.)

Nearly every contemporary gallery takes a 50 percent commission on sales. When a gallery works with an outside curator to put together a group show, the curator may also take a commission—usually around 10 percent—but that commission should come out of the gallery's half, not yours. So it's easier to state the percentage *you'll* get, regardless of any arrangement between the gallery and a curator (or art consultant or anyone else).

The gallery will offer the work for the prices listed above. For any sales, I will receive [50 percent] of the retail price, after subtracting production costs. [The gallery or I] will receive 100 percent of production costs for any work sold.

If the gallery does not agree to reimburse you for your production cost, then you can omit everything after "retail price" in the paragraph above. If the general split will be different for a specific work, just add that fact:

Why You Need a Consignment Agreement, Part Two
Literally as we were writing this chapter, a New York gallery closed down without paying the fees for storing its artists' work in an off-site facility. None of the artists could get their work back from the storage facility without proof that they had consigned the work to the gallery.

For any sales, I will receive [50 percent] of the retail price, except that for [title of work], I will receive [_percent] of the retail price.

Nonprofit venues usually take a smaller commission—from 10 to 40 percent—if they take one at all. When a nonprofit doesn't take a commission, your consignment agreement should say that you will receive 100 percent of the retail price. In that case, it is considered good form to make a donation when you end up selling work because of the show. You can donate 10 percent of the sale price or whatever dollar amount you think is fair (that is, give more to a nonprofit that spent a lot of money to make your show happen). It's a tax write-off and good for karma. If the venue won't actually offer the work for sale, you should use a loan form (see chapter 11).

Speaking of karma, when you donate a work to be auctioned at a benefit, you still use a consignment agreement (since the work is still yours until someone buys it, and if no one buys it you get it back). Just say in the agreement that the venue's commission is 100 percent of the sale price.

Discounts

State the maximum discount you will split with the venue:

I will split up to a [10 percent] discount, unless we agree to split a larger discount before a particular sale.

As you know from chapter 5, discounts are so common that many collectors expect them. The average discount for an ordinary sale is 10 percent. "Splitting" that means 5 percent comes off your half and 5 percent comes off the gallery's half (so you end up with 45 percent of the original price). Museums regularly get 20 percent discounts—sometimes even more—and the gallery will expect you to share that discount as well.

While we don't recommend agreeing to more than a 10 percent discount on a regular sale, the gallerist may want more leeway—say, up to 15 percent—for an especially important collector. Or you may feel that you're at the mercy of the gallery anyway, so you'll live with the discount whatever it is.

You should still put it in your consignment form to prevent unpleasant surprises.

Payment

Note when you'll be told of any sales and when you'll be paid:

The gallery will let me know of any sale within [one week] of making it. The gallery will pay me my share of any sale within [30] days of receiving payment from the buyer.

Some galleries are very good at telling artists right away when their work sells, but others are notoriously lax. There's just no reason you should have to wait a long time to know your work sold.

Even more important, of course, is when you get paid. Once again, galleries differ wildly on this point. Some pay the same week, some pay at the end of the month, a few are known to drag their feet for a year. We think every gallery *should* commit to paying within thirty days from when a collector pays them, but don't be surprised if you find yourself consigning work to a place with a two- or three-month turnaround. In any case, don't agree to more than ninety days. That's just not fair to you (and the galleries know it, whether they'll like us for saying so or not).

Shipping

Say who will cover the costs of packing, shipping, and insuring the work. Expect to pack the work in your studio before it goes to the venue. Usually the venue will pack the work before it's shipped back to you, though some places will expect you to pack it on both ends.

[The gallery is or I am] responsible for shipping the work to and from the gallery, including insuring the work for risk of loss or damage during shipment. I will pack the work before shipping it to the gallery and the gallery will pack the work before shipping it back to me (or to the buyer if the work sells).

————"In some cases, you are lucky to know if something has sold at all. In the past, I have personally had the experience and I know at least two or three other people who had similar problems. It is not uncommon for dealers to take your work and, two years later, when you ask for its return, tell you it sold and (hopefully) pay you. It's a way of not paying until the very last minute." **Bill Davenport, artist and critic, Houston**

————————"It is all individual. I don't think there is a norm and it has a lot to do with what you think your status is. I'll do this show, but I expect you to pay for shipping. In another case, maybe I won't. Or if you feel you're more the supplicant then maybe you will pay or you will split it. I haven't had to pay for shipping in quite some time. But at the beginning, I did." *Francesca Fuchs, artist, Houston*

————————"It would be madness to not have your gallery insured." *Shannon Stratton, artist and director of ThreeWalls, Chicago*

What you can get here depends on your clout and your relationship with the venue (more on that in chapter 13). Expect very little from a first-time group show—though it never hurts to ask. Some places will only pay for shipping when an artist raises the issue. A nonprofit might give you a small shipping stipend. Smaller galleries often ask artists to cover shipping *to* a show but not from it, in which case you could say:

I am responsible for shipping the work to the gallery. The gallery is responsible for shipping the work back to my studio, including insuring the work (to its retail price) for risk of loss or damage.

Safekeeping and Insurance

Your consignment agreement should include a line about the condition of the work and its safekeeping:

The work will be assumed to have arrived in good condition unless the gallery notifies me in writing, within 24 hours of delivery, that it arrived damaged. The gallery is responsible for safekeeping the work while it is in the gallery's possession.

If the venue pays for shipping both ways, it should insure your work from the moment it leaves your studio to the moment it comes back (sometimes called "on a nail-to-nail" or "shelf-to-shelf" basis). If you're paying for shipping the work one or both ways, the venue should insure the work the rest of the time. Don't compromise here: the venue *must* have insurance for its premises (even small nonprofits do).

The gallery will insure the work (to its retail price) for any loss or damage while the work is in the gallery's possession.

Jump to the end of the chapter to see what your consignment agreement will look like if you only include what we've discussed so far.

—————"I have consignment forms with my artists. You have to be straightforward with every agreement you do with an artist. You can't surprise them—it's not fair. Most artists, when you show them at the beginning of their careers, really don't know how the art market works. You need to carefully explain it to them and be up-front and clear. When everything is clear, it works well. When things are muddy, you're opening yourself to problems."

Shoshana Blank, Shoshana Wayne Gallery, Santa Monica, Calif.

EXTRAS

There are a few more issues you or your gallery might want to address in your consignment agreement. We'll include all of them in another sample consignment agreement but you can decide to use any combination of them (or none at all). It depends on how detailed you and your gallery want to get in the agreement.

8. Installation
9. Removal
10. Reproduction
11. Alteration
12. Collector information

Installation

You or the gallery may want to specify:

[The gallery is or I am] responsible for installing and deinstalling the work.

Removal

A gallerist might want to take your work to an art fair, hang it in their house to show collectors during a party, or consign it to another gallery, all in the hope of making a sale. If you're consigning your work to someone for the first time, you may want to include a line reminding them to ask you for permission:

The gallery may not remove the work from its premises during the consignment period without first getting my permission.

If you trust the gallerist's discretion or don't feel comfortable wording it that strongly, you can still ask the venue to *tell* you if it moves your work:

The gallery will let me know beforehand if it plans to remove the work from its premises during the consignment period.

Reproduction

Almost every venue will want to use an image of your work for *something*: the website, a press release, a show card. It's a good idea to have the venue keep you posted on how it uses your images and to make sure you get proper credit:

Although I retain all reproduction rights to my work, the gallery may take images of my work and use them to publicize it or the show, crediting me as the artist. Images reproduced in the press should include the line "Courtesy of [my name and the gallery]."

Alteration

Once you consign your work to a venue, it will not appreciate you coming in to "improve" the work in the middle of a show (unless the work is supposed to change, of course). Some galleries have had problems with artists doing this and therefore say something in their consignment agreements such as "The Artist may not alter the work during the consignment period." We don't include this sentence in our sample agreements, but if a gallery raises the issue, you can always add it (using "I" rather than "The Artist" to stay consistent).

Collector Information

We think you are entitled to know who buys your work. Not all galleries agree with us, though, so, as we explain more thoroughly in chapter 13, you have to tread carefully here. Assuming your gallery agrees to do so, you can add this phrase to the sentence on payment turnaround:

Within [30] days of receiving payment from the buyer, the gallery will pay me my share of any sale and give me the name and address of the buyer.

You don't have to tie payment turnaround to getting collector information, by the way. It's just a way to keep things simple. The

I WANT MONEY, RESPECT, FREE FOOD, SEX, GLORY AND EVERYTHING ELSE ENTITLED TO AN ARTIST OF MY CONSIDERABLE GENIUS.

gallery may want sixty days to pay you but be willing to give you collector information within a week of making a sale, in which case you'd break up the sentence into two.

LEGAL ISSUES

There are a number of legal terms that any lawyer would tell you to definitely include in a consignment agreement. At the same time, we understand that you have to balance the need to protect yourself with the need to show your work. Try to add too much legalese to an agreement and you might scare people away.

If you live in a state with art consignment laws, many of these legal protections exist even if you don't write them into your consignment agreement. Still, we have to tell you about them so you don't sue us.

13. Agency
14. Warranty
15. Title
16. Creditors
17. Trust
18. Gallery disclaimer
19. Automatic termination
20. Entire agreement
21. Modification
22. Assignment
23. Enforceability
24. Waiver
25. Interpretation
26. Legal fees
27. Choice of law

We'll go through these terms one at a time, but you can pack them all into one paragraph at the end of your agreement to make them look less offensive.

Agency

The venue you consign your work to becomes your agent for whatever you're consigning. This is important from a legal perspective because an agent automatically has a number of responsibilities to its principal (that's you).

When you consign your work on an exclusive basis, you're telling the gallery that no one else is allowed to sell the same work during the consignment period. Most galleries assume that this is the arrangement, as opposed to a "nonexclusive" one in which you could theoretically have another gallery try to sell the same work. (Legal issues aside, trying to consign the same work to more than one gallery is a very, very bad idea.)

I appoint the gallery as my exclusive agent for the work identified in the inventory list above.

Note that the "exclusivity" relates only to the work you consign. If the gallery doesn't fully represent you, then there's nothing wrong with consigning *other* work to a different gallery—as long as you're aboveboard with everyone and not trying to go behind anyone's back. See chapter 12 for more on courting galleries.

Warranty

A warranty is essentially a promise that something really is what you say it is, or really does what you say it will do. When you buy a new TV, for example, the manufacturer gives you a warranty that the thing works (at least for a while). A gallery selling your work on consignment wants to be sure that the work you consign really is yours, that you haven't sold the copyright to someone else or licensed it or whatever.

I warrant that I own the work and all proprietary rights to it and that I have the right to appoint the gallery as my agent to sell it.

Title

You already know about title from chapter 2, where you added it to your sales invoices. Here, you want to make it clear:

I retain title in each work I consign to the gallery until I am fully paid for any sale, at which time title will pass directly to whoever bought the work.

Creditors

You also want to make sure you won't be on the hook for any of the gallery's debts:

I shall not be subject to claims by any creditors of the gallery.

Now, there's this thing called the Uniform Commercial Code (UCC). If you're ever suffering from insomnia, the UCC will cure you in about five minutes. It's basically a bunch of rules for buying and selling things.

If the gallery goes bankrupt (or becomes "insolvent"), you want to be what the UCC calls a "secured party," because you have a better chance of getting your stuff back than if you're an "unsecured party":

If the gallery becomes insolvent, I shall have the rights of a secured party under the Uniform Commercial Code.

Technically, if you don't live in a state with an art consigment law, you or your gallery has to fill out a specific UCC form and file it for each consignment. Let's be honest: that's never going to happen. At least the sentence above is better than nothing.

Trust

One technical aspect of a consignment relationship is that the person to whom you consign your work can't use your share of sales for anything other than paying you. This is called holding

your money "in trust." Many states have art consignment laws that require sale proceeds to be held in trust, but it doesn't hurt to address the issue in your agreement. And if you're in a state that doesn't have an art consignment law, you definitely need it:

The gallery will hold in trust my share of the proceeds from any sales.

—————"I do not own the art, the artist owns it. It's $20,000. When it sells, I get paid $10,000 to sell it. It's not our money and we are holding it in trust for the artist. A lot of gallerists don't think about it, but I think it's a critical base for the rest of the relationship." **Kerry Inman, Inman Gallery, Houston**

Gallery Disclaimer

There's no guarantee that a gallery will sell your work. It will hope to sell your work, and if it's doing its job it will *try* to sell your work, but no gallery is going to promise that it *will* sell your work. That's pretty much built into the concept of consignment, but some galleries may want to be explicit about it:

I understand that the gallery does not promise any particular outcome from its sales efforts on my behalf.

Automatic Termination

Here's a downer! What happens if you die? The law doesn't necessarily cancel your consignment agreement, so you might want to include this sentence:

This agreement will automatically terminate if I die or the gallery becomes insolvent.

Entire Agreement

It's standard for written agreements to state that they "express the complete understanding of the parties" or something like that, so you don't end up arguing later over whether there were other promises made (orally or in writing) on top of what's in the agreement.

This agreement states our complete understanding and replaces any earlier understandings between us.

But *watch out* with this one. Don't include it unless it's really true! If you use a bare-bones consignment agreement because your gallery hates paperwork and doesn't want to see anything longer than one page, then whatever you've written probably *isn't* the "entire understanding."

Modification

It's standard to spell out how you can change an agreement if you want to, so you don't end up arguing later over whether the agreement was actually changed.

We may only modify this agreement in writing, signed by both of us.

Assignment

Normally, you can let anyone else take your place in an agreement. This is called "assigning" the agreement, and it means the new person takes over your obligations and becomes entitled to whatever benefits you were getting. It makes sense for certain agreements in other markets. It makes no sense at all for consignment agreements, given that relationships in the art world are so personal. You may like the gallery owner's son just fine, but that doesn't mean you want him selling your work for you when the gallery owner retires and assigns your consignment agreement to him.

To make sure you have a say in the matter, add this sentence:

The gallery may not assign its rights or obligations under this agreement without my written permission.

Enforceability

This is fun, right? Sometimes a judge will decide that a specific part of an agreement isn't enforceable for some reason or

another. Maybe it's too vague, or requires something illegal (you can't enforce an agreement to consign marijuana, for example, because selling marijuana is illegal). When that happens, the judge could throw out the entire agreement unless it says something like this:

If a court holds any part of this agreement illegal, void or unen-forceable, the rest of the agreement will remain enforceable.

Do you need this when you consign a $600 drawing? Probably not. Will it make you look like someone planning on suing if things go wrong? Maybe. So don't include this language unless you're including all the other legal terms we recommend.

Waiver

This is another get-ready-for-court clause. Say the venue doesn't live up to one of its obligations (it "breaches" the agreement): you find out through the grapevine two months later that the venue sold your work and didn't tell you within a week, as it was supposed to. If you don't sue the venue right away (which you're probably not going to do), then you might "waive" your right to sue the venue later. Now say the venue never pays you for the work. If you sue the venue to get paid, a judge might tell you that by waiving the right to sue over the first problem, you waived your right to sue over *anything*. To prevent this, you need to include:

The waiver of one right is not a waiver of any other right.

Interpretation

If any part of an agreement is ambiguous and you end up in court arguing over what it means, a judge will have to interpret the ambiguous language. Normally, the judge will accept the interpretation of the person who *didn't* draft the particular sentence that's ambiguous—unless you add this sentence:

This agreement shall not be interpreted for or against me (or for or against the gallery) because one of us (or our respective counsel) drafted a contested provision.

This is important because by starting with your own agreement, you are considered to be the one who drafted it. And you don't want a court favoring the gallery's interpretation of the agreement over yours just because you used your agreement.

Legal Fees

If you're like most artists, you can't afford a lawyer. And even if you could, hiring a lawyer can easily end up costing more than the amount of money some gallery is refusing to pay you. So it's often not worth it, from an economic perspective, to sue the gallery (never mind all the other reasons it's not a great idea, which we'll talk about in chapter 14). One way to at least leave the option open to you, regardless of your pocketbook, is to add that:

In any proceeding to enforce this agreement, the losing party will pay the winning party's reasonable attorneys' fees.

In other words, it doesn't matter whether you can afford a lawyer, because—assuming the gallery really does owe you the money—when you win, the gallery will not only have to pay you what it owes you, it will have to pay for your legal bills, too. And the prospect of this will encourage the gallery to try and settle quickly, since delay only drives up your legal costs, which the gallery is now on the hook for. (Don't go filing any frivolous claims, though, because if you lose, you'll have to pay the gallery's fees.)

Choice of Law

Say you live in Texas and have a gallery in California—does Texas law or California law govern your consignment agreement? If you're a normal person, the answer is "Who cares?" But lawyers *love* these kinds of problems, because they're very expensive to solve.

The last thing you want to do, if you end up in court, is spend time and money arguing over which state's law applies to your consignment agreement. So decide ahead of time:

[State] law shall govern this agreement, regardless of conflict-of-law principles.

To decide which state is "best" for you, talk to a lawyer. People *usually* choose the law of the state they're in: if you and a gallery are both in California, you will almost certainly end up choosing California law; you will probably not choose the laws of North Dakota. But sometimes people do choose to have another state's laws govern a contract (which may sound weird but is perfectly legal and, in other industries, happens all the time). As you can imagine, there are serious implications to choosing one state's law over another's, so get advice from a volunteer arts lawyer. (Especially if your gallery is not in the state where you live.)

AND NOW FOR THE MOST IMPORTANT PART

Both of you should sign and date the consignment agreement.

SAMPLES

Here are a few different samples. First, a basic inventory list
(without any terms). Then three consignment agreements,
corresponding to the three sections in this chapter: a bare-bones
version, a version with some "extras," and a full-blown version
with all of the legal terms, too. We obviously recommend using
the full-blown version, but if you're not comfortable with it, using
the simpler ones is still better than nothing. And if you really
won't follow our advice on consignment agreements, at the very
least use the basic inventory list.

Remember that you can (and should) edit these sample agree-
ments. We present them as starting points, not finished products.
You may want to add items, delete terms, or edit phrases to
make them more specific to your situation. The venue may want
to do the same. And the volunteer arts lawyer you ask to review
the final draft may also need to add language specific to the
state you're in.

Inventory List

Work by _____
(Artist name and address)

TITLE, YEAR MEDIUM, EDITION DIMENSIONS/DURATION	RETAIL PRICE
	FRAMING/PRODUCTION COST
1.	
2.	
3.	
4.	
5.	
6.	
7.	
8.	

_____ has received on consignment the works described above.
(Venue name and address)

The consignment will last from today until _____

_____ _____
Venue signature Date

(print name)

Consignment Agreement

From: To:

_____ ("I/me") _____ ("gallery")
Artist Venue

_____ _____
Address Address

Inventory List

TITLE, YEAR MEDIUM, EDITION DIMENSIONS/DURATION	RETAIL PRICE
	FRAMING/PRODUCTION COST
1.	
2.	
3.	
4.	
5.	
6.	
7.	
8.	

1. I consign to the gallery the work identified in the inventory list above, from _____ through_____.

2. The gallery will offer the work for the prices listed above. For any sales:

 a. I will receive _____% of the retail price, after subtracting production costs.

 b. I will split up to a _____% discount, after subtracting production costs, unless we agree to split a larger discount before a particular sale.

 c. _____ [The gallery or I] will receive 100% of production costs for work sold.

3. The gallery will let me know of any sale within one week of making it. The gallery will pay me my share of any sale within ____ days of receiving payment from the buyer.

4. _____ [The gallery is or I am] responsible for shipping the work to and from the gallery, including insuring the work for risk of loss or damage during shipment. I will pack the work before shipping it to the gallery and the gallery will pack the work before shipping it back to me (or to the buyer if the work sells).

5. The work will be assumed to have arrived in good condition unless the gallery notifies me in writing, within 24 hours of delivery, that it arrived damaged. The gallery is responsible for safekeeping the work while it is in the gallery's possession. The gallery will insure the work (to its retail price) for any loss or damage while the work is in the gallery's possession.

6. The gallery will return any unsold work to me within _____ days of the end of the consignment period.

7. Either the gallery or I may cancel this consignment agreement by writing to the other, in which case the gallery will return any unsold work to me within _____ days.

Dated: _____

Artist signature

Venue signature

(print name)

Consignment Agreement

From: To:

_____ ("I/me") _____ ("gallery")
Artist Venue

_____ _____
Address Address

Inventory List

TITLE, YEAR MEDIUM, EDITION DIMENSIONS/DURATION	RETAIL PRICE
	FRAMING/PRODUCTION COST
1.	
2.	
3.	
4.	
5.	
6.	
7.	
8.	

1. I consign to the gallery the work identified in the inventory list above, from _____ through _____.

2. The gallery will offer the work for the prices listed above. For any sales:

 a. I will receive _____% of the retail price, after subtracting production costs.

 b. I will split up to a _____% discount, after subtracting production costs, unless we agree to split a larger discount before a particular sale.

 c. _____ [The gallery or I] will receive 100% of production costs for work sold.

3. The gallery will let me know of any sale within one week of making it. Within _____ days of receiving payment from the buyer, the gallery will pay me my share of any sale and give me the name and address of the buyer.

4. _____ [The gallery is or I am] responsible for shipping the work to and from the gallery, including insuring the work for risk of loss or damage during shipment. I will pack the work before shipping it to the gallery and the gallery will pack the work before shipping it back to me (or to the buyer if the work sells).

5. The work will be assumed to have arrived in good condition unless the gallery notifies me in writing, within 24 hours of delivery, that it arrived damaged. The gallery is responsible for safekeeping the work while it is in the gallery's possession. The gallery will insure the work (to its retail price) for any loss or damage while the work is in the gallery's possession.

6. The gallery will return any unsold work to me within _____ days of the end of the consignment period.

7. _____ [The gallery is or I am] responsible for installing and deinstalling the work. The gallery may not remove the work from its premises during the consignment period without first getting my permission.

8. Although I retain all reproduction rights to my work, the gallery may take images of my work and use them to publicize it or the show, crediting me as the artist. Images reproduced in the press should include the line "Courtesy of [my name and the gallery]."

9. Either the gallery or I may cancel this consignment agreement by writing to the other, in which case the gallery will return any unsold work to me within _____ days.

Dated: _____

_____ _____

Artist signature Venue signature

 (print name)

Consignment Agreement

From: To:

_____ ("I/me") _____ ("gallery")
Artist Venue

_____ _____
Address Address

Inventory List

TITLE, YEAR MEDIUM, EDITION DIMENSIONS/DURATION	RETAIL PRICE
	FRAMING/PRODUCTION COST
1.	
2.	
3.	
4.	
5.	
6.	
7.	
8.	

1. I consign to the gallery the work identified in the inventory list above, from _____ through _____.

2. The gallery will offer the work for the prices listed above. For any sales:

 a. I will receive _____% of the retail price, after subtracting production costs.

 b. I will split up to a _____% discount, after subtracting production costs, unless we agree to split a larger discount before a particular sale.

 c. _____ [The gallery or I] will receive 100% of production costs for work sold.

3. The gallery will let me know of any sale within one week of making it. Within _____ days of receiving payment from the buyer, the gallery will pay me my share of any sale and give me the name and address of the buyer.

4. _____ [The gallery is or I am] responsible for shipping the work to and from the gallery, including insuring the work for risk of loss or damage during shipment. I will pack the work before shipping it to the gallery and the gallery will pack the work before shipping it back to me (or to the buyer if the work sells).

5. The work will be assumed to have arrived in good condition unless the gallery notifies me in writing, within 24 hours of delivery, that it arrived damaged. The gallery is responsible for safekeeping the work while it is in the gallery's possession. The gallery will insure the work (to its retail price) for any loss or damage while the work is in the gallery's possession.

6. _____ [The gallery is or I am] responsible for installing and deinstalling the work. The gallery may not remove the work from its premises during the consignment period without first getting my permission.

7. Although I retain all reproduction rights to my work, the gallery may take images of my work and use them to publicize it or the show, crediting me as the artist. Images reproduced in the press should include the line "Courtesy of [my name and the gallery]."

8. The gallery will return any unsold work to me within _____ days of the end of the consignment period.

9. Either the gallery or I may cancel this consignment agreement by writing to the other, in which case the gallery will return any unsold work to me within _____ days.

10. I appoint the gallery as my exclusive agent for the work identified in the inventory list above. I warrant that I own the work and all proprietary rights to it and that I have the right to appoint the gallery as my agent to sell it. I retain title in each work I consign to the gallery until I am fully paid for any sale, at which time title will pass directly to whoever bought the work. I shall not be subject to claims by any creditors of the gallery. If the gallery becomes insolvent, I shall have the rights of a secured party under the Uniform Commercial Code. The gallery will hold my share of the proceeds from sales in trust. I understand that the gallery does not promise any particular outcome from its sales efforts on my behalf. This agreement will automatically terminate if I die or the gallery becomes insolvent. This agreement states our complete understanding and replaces any earlier understandings between us. We may only modify this agreement in writing, signed by both of us. The gallery may not assign its rights or obligations under this agreement without my written permission. If a court holds any part of this agreement illegal, void or unenforceable, the rest of the agreement will remain enforceable. The waiver of one right is not a waiver of any other right. This agreement shall not be interpreted for or against me (or for or against the gallery) because one of us (or our respective counsel) drafted a contested provision. In any proceeding to enforce this agreement, the losing party will pay the winning party's reasonable attorneys' fees.
_____ [State] law governs this agreement, regardless of conflict-of-law principles.

Dated: _____

_____ _____
Artist signature Venue signature

 (print name)

CHAPTER 11

Loans and Commissions

There are a couple of other arrangements you might run into whether you are represented by a gallery or not: a loan, which is basically a consignment without the sales part, and a commission, which is when someone (or some organization or company) commits to buying specific work from you before you've made it.

LOANS

Museums and nonprofits almost always have their own loan agreements (or "loan contracts"), so you shouldn't need your own. Just make sure you read what you're given and find a volunteer lawyer to help you understand everything. And don't be afraid to edit the language if you disagree with something, or to add items that are important to you but not addressed in the agreement.

There's no industry standard, by the way, when it comes to loan agreements. You might get a long document full of legalese, you might get a short list of touchy-feely requirements ("Be nice to interns").

Since loans are very similar to consignments, pay attention to all the issues we talked about in the last chapter (except the ones related to payment, of course). And while you need to have a lawyer look through the agreement to make sure you're okay, there are three big issues to look out for.

First, don't give away your copyright or grant the venue an "irrevocable, perpetual, exclusive right to reproduce images of your work for any purpose." Agreeing to that means giving the venue permission to do literally anything it wants with images of your work. If you see a sentence along those lines, either take it out or limit the grant to one "for any *noncommercial* purpose." If the venue wants to use your images for commercial purposes (such as selling shirts in the gift shop) it should have to get your written permission on a case-by-case basis.

Second, try to get an "indemnity." That means the venue—and *not* you—will have to pay for any accidents or injuries that happen while the venue has your work. If someone trips over part of it, breaks a leg, and sues you for "injuring" them, the venue will pay the legal fees to defend the case, pay any settlement

amounts, etc. Look at paragraph 12 of our sample site-specific commission agreement (later in this chapter) to see what indemnification language looks like.

Third, pay attention to insurance value. Even though your work won't be for sale, the institution will need to insure it, which means it will need to value it. Some places try to cut corners by having you value the work at 50 percent of its retail price, on the theory that, if you were selling the work through a gallery, you'd only get half the sales price. Bad idea. List the *full* retail price. That's the price that reflects the market value of the piece, and, therefore, affects the value of your other work. That's the price you deserve if the work is damaged beyond repair.

PRIVATE COMMISSIONS

Being asked to do a commission can be very flattering. It means someone likes your work enough to want to buy something from you before they've even seen it. The thing to keep in mind, though, is that collectors often have very specific ideas about what they want when they commission something, which necessarily limits your creative freedom. If they were just going to let you make whatever you wanted, they wouldn't need to commission it; they could just wait and see what you make and then decide whether to buy it.

This aspect of working on a commission can be rewarding, in that the collector's priorities challenge you to experiment in new directions. But it can also be frustrating if, for example, the collector starts telling you to "add more blue" or "make me look younger and thinner."

That's why you need to set the ground rules ahead of time. Decide how much creative control the collector has—and what *kind* of creative control. Will you need to agree on the subject matter together? On the materials? Who will have final say at each step? What is the budget? Which costs will the collector cover? When will you get paid?

Once again, you *have* to talk about these issues before you get started. You don't avoid them by delaying the conversation, you just make them more complicated. We know too many artists who

———"We have loan agreements as contracts. We've made mistakes over the years and we knew we needed to make proper forms. With a nonprofit it's hard because there's a really high turnover and it's hard to know what happened before and how it should be going forward. We're still learning after thirty-five years how to make it work. We want to leave room for experimentation, but there are some set things and having a contract protects both parties.

"Artists come in not knowing how things work and our funding is constantly changing. Sometimes we can pay for shipping and sometimes we can't. Sometimes we can install work and sometimes we ask the artist to install it. It depends on multiple factors, so we try to make those things clear from the beginning." *Hillary Wiedemann, artist and former gallery manager of Artists Space, New York*

———"With the level of intensity and collaboration involved in a site-specific work, I found that contracts were helpful tools. They were helpful as ways of getting the issues out onto a piece of paper so they could be worked out beforehand. Neither party is likely to sue the other, and it is important to keep a contractual negotiation from souring a working relationship. Questions get answered in the course of those discussions if they are conducted properly and sensitively. Just in the course of having them, you build up trust and reinforce the artist's faith that the work is going to be respected and, on the curatorial side, that the artist will deliver the work and be happy with how it is displayed and installed." *Peter Eleey, curator, Walker Art Center, Minneapolis, former curator of Creative Time, New York City*

——————"With commissions, I rely on a paper trail, which is invoicing. My invoices are incredibly explicit. Everything is outlined—the description of services, the breakdown, balances, payments, and what the outcome is expected to be.

"It's a little more subtle for me. It's in writing and everyone has it. Once the money's exchanged, at least there's a piece of paper outlining what the understanding is." *Michael Joo, artist, Brooklyn, N.Y.*

——————"The problem with commissions is doing way too much. Too much for too little. Artists tend to give a little bit more and they don't realize they are giving so much away for not enough. They tend to undervalue their commissioned artwork." *Steve Henry, director, Paula Cooper Gallery, New York*

——————"Sometimes the things I have done for commissions are things I would not have thought of doing in exactly the same way, but they're actually extensions of the ideas in my work. There have been situations when I have done commissions for a little less because I already got something from it. There's intellectual currency." *Joseph Havel, artist and director of the Core Program, Houston*

——————"You have to think about your work and the work you are going to make, but you also have to think about the environment your work is going to go into. It's a grueling anti-art experience. You have to make the piece fit above the couch and match the draperies." *Eleanor Williams, art advisor, curator, former gallerist, Houston*

weren't paid for a commission, or ended up ruining a relationship with a collector, because they didn't clarify expectations at the start.

To help you think through those expectations, we've made two sample commission agreements that you can use when you're working directly with a collector: a basic commission, for work that can be hung or installed anywhere, and a site-specific commission, for work that can only be installed at a particular location. (When a gallery represents you, it should use its own agreement, although you can still compare that with ours to make sure it covers all the issues you want it to.)

We set up the sample agreements so that you're paid a fee up front to compensate you for the initial creative work and planning you'll have to do. The amount is for you and the collector to agree on; it should correlate with how much time and effort you have to put into the planning stage. If all you have to do is a simple drawing or two that won't take a lot of time, ask for a small fee. If it will take a lot of effort to put together the proposal, your fee should be significant.

When you finish that stage, you propose your final ideas to the collector for approval. If the collector doesn't approve your proposal, you can walk away or start over (for another up-front payment). If the collector *does* approve your proposal, then you know you're on the right track and the collector, by approving the proposal, is agreeing to pay you for the finished work. This arrangement does several things: it gives the collector some creative control, it ensures you're paid for the effort you've put in until that point, and it protects you from taking a direction the collector won't pay for in the end.

Of course, once the collector has approved your proposal, you have to stick with it. You can't just change major elements and expect the collector to go along—unless, that is, you stated in your proposal that those elements might change. So give yourself enough leeway in your proposal to make the kinds of adjustments you may need to make as you create the work.

Like our consignment agreements from chapter 10, our commission agreements are made to be edited. You can add details and change or delete any sentences that don't apply to your situation, and the collector may mark it up as well.

One thing you should *not* let the collector add, though, is a sentence saying you agree "not to make any work in the future that is *substantially similar* to the commissioned work." Collectors sometimes put this in a commission agreement because they want to ensure that the work they commission is unique and that you won't make a bunch of copies in the future. Their concern is understandable but the language is a problem. Isn't a lot of your work "substantially similar"? Certainly all the pieces in a body of work are "substantially similar"— that's what justifies them being in the same body of work! It's fine to agree not to make "identical" work, but get that "substantially similar" phrase outta there.

There are a few legal terms at the end of the agreement. Go back to chapter 10 if you need to jog your memory about what they mean. And bring the agreement to a local volunteer lawyer for the arts before you sign it, just to make sure it works for the state you live in.

Pricing Your Commission

Your commissions should cost anywhere from 20 to 100 percent *more* than comparable "uncommissioned" work. The premium is based on the fact that you're giving up some creative control and that the commission takes you away from your regular studio practice. The more creative control you have to give up, and the further away you have to move from your practice, the more your commission should cost.

Commission Agreement

between

_____ ("I/me") _____

Artist Address

and

_____ ("buyer") _____

Collector Address

1. Buyer has asked me to conceive of and create an original _____ ("work").

2. The price of the work is $ _____. The price does not include the costs described below.

3. Buyer will pay me a non-refundable fee of $ _____ on signing this agreement.

 a. Within _____ days of signing this agreement, I will propose the work to buyer.

 b. If buyer does not accept my proposal within 30 days, I will not have any more obligations to buyer.

 c. If buyer accepts my proposal, buyer will pay me 50% of the work's price (minus the non-refundable fee) within 30 days of accepting the proposal, and I will finish the work within _____ days of receiving this payment. Buyer will pay me the remaining 50% within _____ days after I finish the work.

4. Buyer will promptly provide me (at buyer's expense) any photos, documents and other information that I need to create the work.

5. Buyer will cover the costs of insurance, shipping and any storage of the work.

6. Buyer may not allow any modification to the work during my lifetime without my written permission. If anyone modifies the work during my lifetime without my written permission, the work will no longer be attributable to me.

7. I do not waive my rights under the Visual Artists Rights Act. Buyer may not allow any damage to the work. If the work is damaged during my lifetime, buyer must pay for restoration by a restorer whom I approve. If anyone else restores the work during my lifetime, it will no longer be attributable to me.

8. I retain the copyright to the work. I grant buyer a limited, nonexclusive right to reproduce images of the work for non-commercial purposes, as long as they are credited as "Courtesy of [me], [my city]."

9. I continue to own any drawings, models, molds and similar materials created for making and installing the work.

10. If I die before finishing the work, neither I nor my estate will have any more obligations to buyer and the unfinished work may not be attributed to me.

11. This agreement states our complete understanding and replaces any earlier understandings between us. We may only modify this agreement in writing, signed by both of us. Buyer agrees that I will be entitled to specific performance and injunctive and other equitable relief to prevent or remedy any breach of this agreement. If a court holds any part of this agreement illegal, void or unenforceable, the rest of the agreement will remain enforceable. The waiver of one right is not a waiver of any other right. This agreement shall not be interpreted for or against me (or for or against the buyer) because one of us (or our respective counsel) drafted a contested provision. In any proceeding to enforce this agreement, the losing party will pay the winning party's reasonable attorneys' fees.

_____ [State] law shall govern this agreement, regardless of conflict-of-law principles.

Dated: _____

_____ _____
Artist signature Collector signature

Commission Agreement
between

_____ ("I/me") _____
Artist Address

 and

_____ ("buyer") _____
Collector Address

1. Buyer has asked me to conceive of and create an original _____ ("work"), to be installed at this site:

_____.

2. The price of the work is $ _____. The price does not include the costs described below.

3. Buyer will pay me a non-refundable fee of $ _____ on signing this agreement.

 a. Within _____ days of my initial site visit, I will propose the work to buyer.

 b. If buyer does not accept my proposal within 30 days, I will not have any more obligations to buyer.

 c. If buyer accepts my proposal, buyer will pay me 50% of the work's price (minus the non-refundable fee) within 30 days of accepting the proposal, and I will install the work within _____ days of receiving this payment.

 d. Buyer will pay me the remaining 50% within _____ days after I finish installing the work.

4. Buyer will promptly provide me (at buyer's expense) drawings, photos, maps and other information about the site that I need to create and install the work.

5. Buyer will cover the costs of:

 a. Travel expenses to _____, hotel accommodations, car rental and a $_____ per diem fee for:
 i. My initial visit to the site, to last _____ days.
 ii. My installation visit to the site, to last _____ days.
 iii. _____ assistants, to accompany me during the installation visit.

 b. Materials and labor for preparing the site, including any engineering.

 c. Materials and labor for installing the work.

 d. Insurance, shipping and any storage needed for the work or its installation.

6. Buyer may only display the work in the manner and position I approve. Buyer may not allow any modification to the work during my lifetime without my written permission. A change in the work's position, or the manner in which it is displayed, is a modification to the work. If anyone modifies the work during my lifetime without my written permission, the work will no longer be attributable to me.

7. I do not waive my rights under the Visual Artists Rights Act. Buyer may not allow any damage to the work. If the work is damaged during my lifetime, buyer must pay for restoration by a restorer whom I approve. If anyone else restores the work during my lifetime, it will no longer be attributable to me.

8. I retain the copyright to the work. I grant buyer a limited, nonexclusive right to reproduce images of the work for non-commercial purposes, as long as they are credited as "Courtesy of [me], [my city]."

9. I continue to own any drawings, models, molds and similar materials created for making and installing the work.

10. If I die before finishing the proposal for the work, neither I nor my estate will have any more obligations to buyer. If I die after buyer accepts the proposal but before I install the work, _____ will complete the installation. If the installation is not finished for any reason, the uninstalled work may not be attributed to me.

11. As long as buyer possesses or controls the work, buyer will release, indemnify, defend and hold harmless me (and my successors and assigns) against all claims, demands, losses and expenses connected in any way to the work (including, for example, injuries and property damage caused during shipping or installation of the work; legal costs; attorneys' fees; and settlements). The only type of claim this paragraph does not apply to is a claim that the work infringes a copyright.

12. This agreement states our complete understanding and replaces any earlier understandings between us. We may only modify this agreement in writing, signed by both of us. Buyer agrees that I will be entitled to specific performance and injunctive and other equitable relief to prevent or remedy any breach of this agreement. If a court holds any part of this agreement illegal, void or unenforceable, the rest of the agreement will remain enforceable. The waiver of one right is not a waiver of any other right. This agreement shall not be interpreted for or against me (or for or against the buyer) because one of us (or our respective counsel) drafted a contested provision. In any proceeding to enforce this agreement, the losing party will pay the winning party's reasonable attorneys' fees.

 _____ [State] law shall govern this agreement, regardless of conflict-of-law principles.

Dated: _____

_____ _____
Artist signature Collector signature

PUBLIC COMMISSIONS

Because public commissions often involve government bodies and taxpayer money (or nonprofit donations), the process is much more complicated than a private commission. It can take months to hammer out all the details and years to complete the project. And it usually involves many people, not all of whom share the same priorities.

The major issues you have to think through ahead of time are the same as with private commissions: budget, creative control, deadlines, and payment. You don't need your own agreement for a public commission because organizations and agencies that commission public projects always use theirs. You do, however, need to read the agreement you're given and make sure you understand everything it says. It will very likely be written in technical legal jargon, so get help deciphering it from a volunteer lawyer for the arts. Again, if a gallery represents you, it will help (if you ask!).

YOU CAN DO WHATEVER YOU WANT... AS LONG AS IT'S 24×30 ON CANVAS WITH LOTS OF BLUE, AND EVERYONE IN MY FAMILY LIKES IT.

As with loan agreements, feel free to edit the language in a public commission agreement. Think of it as a draft rather than a nonnegotiable demand. (The truth is that most of it won't be negotiable, but some details will be and, if you're lucky, they'll turn out to be the very details you want to adjust.)

There are a few general things to look out for in these agreements.

First, do not waive your VARA rights. VARA is the Visual Artists Rights Act, and it grants you, as an artist, several important rights: to have your work attributed to you, to *not* have other people's work attributed to you, to prevent your work from being changed or destroyed in a way that would hurt your reputation, and, if your work is changed, not to have it attributed to you anymore.

VARA's prohibition against "changing" work can be a problem for public commissions because removing the work from its initial site arguably changes it. (The exact language is "distortion, mutilation, or other modification of the work.") So you may need to give the commissioning body permission to remove the work—or waive your right to prevent "modification" necessary to remove the work—but you should not waive *all* your VARA rights. Make them specify exactly what it is they want permission to do, rather than say they can do whatever they want.

Second, cross out any "substantially similar" language, as we talked about in the last section.

Third, as with loan agreements, do not give away your copyright. Cross out the language or limit any grant of your copyright to one "for any *noncommercial* purpose."

Fourth, as with loan agreements, get an "indemnity."

Of course, we can't tell you how to deal with every issue because every agreement will be different. So, one more time, just for fun: bring the agreement to a lawyer. Don't try to wing it yourself.

CHAPTER 12

———The Gallery Courtship

——————"The art world is all about people and relationships. Once you are showing with a gallery, it is all about a good relationship. Try to remember what it was like before you were married and what you had to do to get in good with her. You had to impress her, but you had to be a real person. You couldn't present yourself as one thing and then be another thing later on. You couldn't be a cool, nice guy and then a classless slob once you were married. So, make a good impression and be a real person." *David Gibson, curator and critic, New York*

——————"Never, ever put yourself in a position where you can't change your work. That would be the most important thing—to contextualize yourself in a place where they are interested in your evolution and your growth regardless of how profitable your first body of work might be. If you don't grow and your work is not changing, it's going to die." *Andrea Rosen, Andrea Rosen Gallery, New York*

——————"Artists get the art world they deserve. I want a relationship that I can live with for a long time—one where I would be happy to get the call when a gallerist rings me up. It's a very intimate relationship, like a marriage. It's one of the bigger relationships that I have, so the way my personality meshes with the gallery is really important to me. I also want a gallery that does all the horrible things I don't want to do. If they do their job, I won't have to do all the mundane tasks that come with running a small business." *Fred Tomaselli, artist, Brooklyn, N.Y.*

Gallerists put a lot—financially and emotionally—into their artists. Sure, some are reputed to take advantage of artists or to only care about sales. But most do what they do because they love art and want to work with living artists. So it's only natural that they want to be careful, and take their time, when considering taking on new ones.

This is not a bad thing, in and of itself, because you should want to take your time, too. Signing on with a gallery is putting your career in its hands. Your reputation and your success, both short-term and long, will be linked to your gallery's. And while you can always walk away from a bad situation, that's a painful experience you're better off avoiding altogether.

This is why getting gallery representation is a lot like a romantic relationship: first you meet through friends; then you hang out in a group, maybe go on a few dates; if you like each other, you keep going out and eventually one of you pops the question. Sometimes the other person is flaky or hard to read; sometimes you feel like you're being toyed with; sometimes you know where you stand; sometimes you don't. But there's usually a long stretch of time between your first introduction and your wedding day.

FRIENDS WITH BENEFITS: THE BACKROOM

This is an easy way to test you as a new artist. The gallery keeps a few pieces in the backroom (literally, a room in the back of the gallery, also known as the "office") and shows them to collectors when they come through the space. There's little risk for the gallery because it isn't associating with you in public or investing a lot of money in a show. And it can use your work to make collectors feel extra special, since they're getting "exclusive" access to work not available in the front space.

When you hand over work to go in a gallery's backroom, you should get a consignment agreement from the gallery or write one up yourself (see chapter 10). This is exactly the kind of situation that you don't want to leave open-ended. At a minimum, fill out an inventory list.

Limit the consignment period to six months or less (the most common increments are three months and six months). You can always extend the time.

If your work sells and you get along with the gallery, everybody's happy and—in theory, at least—the gallery will want more. Maybe it'll even start going out with you in public.

DATING IN PUBLIC: THE GROUP SHOW

A group show is the most common "first" in a gallery relationship. Like a first date, the group show is a bit of an audition. You're putting your best self forward and hoping the gallery and its audience like what they see. It's not a one-way street, either: the gallery is on its best behavior, too. (Unless, well, it's just not that into you.)

This is still relatively low risk for the gallery, since it isn't banking on you alone. And unlike putting work in the backroom, curating you into a group show allows the gallery to gauge the reaction of the press and the general public to your work.

Group shows come together in a couple of different ways. A gallery might curate the show itself, selecting work from within its program and from people it knows either through its artists, open studios, art fairs, or submissions. Or a gallery will collaborate

It's Just An Analogy, People!

Every gallerist we interviewed made some kind of analogy to courtship and marriage when describing what it's like to bring a new artist into their program. We think the comparison goes a long way to explaining how gallery relationships *feel,* but in the end it doesn't explain everything.

A gallery is still a business. It has bills to pay, art to sell, and other artists to support. These obligations can force trade-offs that a truly loyal friend wouldn't make, but that a business simply has to. That doesn't mean you shouldn't be friends with your gallerist; it means you have to keep that friendship distinct from your professional relationship. The two overlap a great deal—you want to work with someone you trust, someone you respect, someone you *like*—but they are not the same thing.

What happened? I thought we were in love.

————————"If they don't get in touch with you again, they're probably not interested. It's like dating. If you don't get a call back, they don't like you."
Heather Marx, Marx & Zavattero, San Francisco

————————"If you contact me three times and I don't respond, I'm not interested. Three times is the cut-off. I wouldn't ask a guy out more than three times."
Anonymous

with an independent curator who will bring in artists the gallery doesn't know.

Some galleries make room in their schedules for group shows every year, usually in the summer. Others have them when they are looking to expand their roster. Either way, being successful in a group show—meaning sales, press, or even a lot of interest—will often lead to more shows.

As always, remember to get a consignment agreement.

Dating More than One Gallery

It's common for unrepresented artists to participate in overlapping group shows at different galleries in the same city. As long as you're aboveboard with everyone, you won't inadvertently damage your relationships or hurt your reputation. Galleries actually like to see that other people are interested in you and that you've got a lot going on.

If you're already in a group show and a second opportunity presents itself, ask both galleries whether it's a problem. It shouldn't be, unless you're trying to show the exact same work in both places. As we write this chapter, for example, an artist we know is in two group shows in Chelsea at the same time: one gallery has his drawings and the other an installation. (He's also showing an installation at a Brooklyn nonprofit, which was fine with both galleries because the venue isn't commercial.) If a gallery tells you not to show at a second venue, ask why and decide for yourself whether it's a valid reason.

While no one can stop you from showing wherever you want when you're unrepresented, keeping people informed is a sign of courtesy and respect. The galleries you work with will appreciate it and will be that much more likely to want to work with you again.

Whatever you do, never show your work with two different galleries in the same art fair or show the same piece in consecutive fairs. It undermines the fact that your work is unique, instead giving the impression that you have saturated the market with your work. It's also better to be publicly associated with one gallery so that people know whom to contact about your work. The galleries you work with should have enough sense to avoid this scenario, but they can't help you if you keep them in the dark.

Make sure your prices are consistent in all the venues showing your work. This is important for several reasons: you don't want collectors bargaining over your work, you don't want dealers competing over prices, and, because it's customary for prices to be consistent, it looks like something is wrong when they aren't.

What's Your Price for Flight

If you really, really want to go to an art fair but the gallery won't pick up the tab, you might be able to get the gallery to pay for airfare if you help install and deinstall the booth.

—————"Sometimes we use that shorthand language for talking about the inclusion of an artist in a group exhibition—'is it going to be a one-night stand or will you continue to date?' The analogies are silly, but they're also really apt because we all understand the relationship thing and we can understand how difficult it is to navigate. It gets even more difficult when there is money and a career on the line."

Catharine Clark, Catharine Clark Gallery, San Francisco

—————"It's a real rookie move to have pieces at more than one gallery in one art fair. They don't have the strength of one dealer, steering them through it. And they may think 'I can do this myself. I'm going to work directly with everybody and I know how to work the world; I'm a master of business as well as paint.' And they'll fail publicly." **Tim Blum, Blum & Poe, Los Angeles**

—————"There is a term in the auction world when a work goes on the market and doesn't sell and then goes back on again too soon. It's called 'burning a work.' I think that holds true for art fairs, too. If you visit PULSE in Miami and then again in New York and you see some of the same works, then both PULSE and the dealer lose a certain amount of credibility. There was an exhibitor who hung the same work in New York and Miami once. It was a small work, but it had a big impact and we had to ask for it to be removed" **Helen Allen, executive director, PULSE Contemporary Art Fair**

—————"Usually we like to take a few pieces, put them in the backroom and maybe take them to a fair to show our collectors. You can tell how your audience and your artists react to them. It's like bringing a new wife in. What do you think about the sister wife?" **Lisa Schroeder, Schroeder Romero Gallery, New York**

—————"In times past it was probably more difficult for artists to go to art fairs. Today, the center of the art market appears to be the international art fair. Consequently, artists have become more accustomed to seeing their work in such a grossly commercial setting. Many actually love it and regard fairs as enabling them to be part of the international art scene. It's another indication of the commodification of art. Only the more idealistic artists these days still have difficulty attending them." **Rosamund Felsen, Rosamund Felsen Gallery, Santa Monica, Calif.**

WEEKEND GETAWAY: THE ART FAIR

Another way a gallery can test your work is to take it to an art fair. This allows the gallery to expose your work to more collectors than would see it in the backroom, without committing to an actual show.

Art fairs are expensive and galleries can't bring everything to their booths, so feel good if a gallery believes in you enough to ship your work to some other city and take time away from its own artists' work to try and sell yours. Also, curators and other gallerists will be scouring the fair looking for new artists. Having your work there is a real opportunity to end up in someone else's group show.

On the other hand, just as galleries differ, so do art fairs. Not every fair will make sense for you, so don't say yes without doing your homework and thinking about whether that particular one is a good fit. And keep in mind that when work sells at an art fair, it goes straight to a collector. No show, no press. Unless you have the clout to demand that a collector lend the work back for a show, it may never be seen in public again.

In chapter 7, we talked about whether you should go to art fairs in general. Whatever problems you may have with going to an art fair will only be compounded when you see *your work* at the fair, so think about that before you decide to go. It's not such a big deal when you're the only one in a curated, solo booth because that's as close to a gallery show as it gets. But it can be traumatizing to see your work out of its context, competing for space with entirely unrelated work—not to mention watching glassy-eyed collectors spending all of three seconds taking it in before moving on to the next booth.

You'll need to pay your way there unless you're the featured artist at your gallery's booth and the gallery needs you to install your work. When you go, whether on the gallery's dime or yours, don't sit in the booth all day. Pop in every once in a while, but otherwise let the gallerists do their job.

—————"You always remind yourself, no matter how close you get, it's still about business. Your heart will be broken or you will break a heart."

George Adams, George Adams Gallery, New York

————"A lot of times I'll just try out a few pieces. There's this one young artist in town and I think his painting technique is incredible and his subject matter is really interesting. But I told him I want to bring in three pieces and try them out with my collector base over a period of time. I hope it's going to develop into something larger."
James Harris, James Harris Gallery, Seattle

————"Someone once told me—how you go into a gallery is how you go out. For instance, if you go into a gallery and you're asked to deliver the work, you'll be delivering the work when you are seventy. Since it's still, by and large, a handshake, you need to be aware of any unspoken precedents you are establishing. Another problem is having your friend as your dealer. Boundaries can get blurred, and if you accommodate for the sake of the relationship you might find yourself still doing that later. And that's just not a place you want to end up."
Charles Long, artist, Mount Baldy, Calif.

————"I like working with people before giving them a solo show. Doing group shows or an art fair is helpful in starting a relationship. I want them to be as excited working with us as we are working with them. Both gallery and artist are parallel. We are working together for the same goals. Once we've done a few things together and the vibe is good, I'll say, 'Hey, come on board! We want to work with you.'" **Lorraine Molina, owner and director, Bank, Los Angeles**

GETTING ENGAGED: THE SOLO SHOW

Many gallerists say that by the time they give an artist a solo show, they've already committed to full representation. Others will let an artist have a solo show and see how it goes before deciding to add them to their roster—but they obviously do so hoping that it'll work out.

Because a solo show is a big deal, and because there is so much overlap with full representation (which, to oversimplify, is a series of solo shows), we'll talk about both in the next chapter.

Can you hear the wedding bells?

—————"People could perhaps pay more attention to the historical model in which participation in a group show precedes the endeavor of a solo show. I think it's vital that an artist be allowed first to have a relationship with a gallery on a smaller, simpler level, and for the gallery itself to see if the artist is someone they want to work with. Not everyone might find it necessary, but it can be tremendously important. Call it a one-night stand before deciding to commit. It's how things in life happen." **Jasper Sharp, curator, art historian, VOLTA art fair selection committee, Vienna, Austria**

—————"I will never represent an artist I don't know well. I consider the relationship to be a very serious and weighty one. For me, it's more than just liking the work—we need to be able to work together. I like a lot of artists' work and I've been in the business long enough to know what I like, but I don't know if the work is right for the program or if the relationship is right." **Amy Smith-Stewart, Smith-Stewart, former curator at PS1, New York**

—————"I try to be really open and honest with them, so I want them to say, 'so-and-so is really interested in giving me a show and I know I have pieces with you. What do I do? Do you want to give me a show or not?'" **James Harris, James Harris Gallery, Seattle**

CHAPTER 13
————————Gallery Representation

———————"I expect artists to work hard. I expect them to focus, be very serious, and not be last-minute. They can't rely on me for everything. There are sixteen of them and only one of me. I have a lot of artists who are very good at self-promoting and then sending people to me. I rely on that. They should not be selling out of the studio. It's a deal breaker for me. I don't sell the work and not pay them. I expect loyalty because I am trying to promote them on every level from sales to museum shows to press coverage and selling out of the studio undermines the trust." **Monique Meloche, moniquemeloche gallery, Chicago**

———————"Once we represent an artist, we are going to spend all of our days working to further their careers. If someone calls the artist about a potential opportunity, he or she should direct the call to us. We're not just sitting here, waiting for people to walk in. We are writing and contacting other galleries, collectors, and press. That effort needs to be respected." **Heather Taylor, Taylor de Cordoba, Los Angeles**

———————"One thing to remember—always promote your gallery because they are always promoting you. If you're doing an interview with a publication, pound home the idea that you show at the gallery. Never fail to mention your recent show, your upcoming show, or where they can see more work. Send them to the gallery. It does everyone a disservice when artists don't promote the relationship." **Heather Marx and Steve Zavattero, Marx & Zavattero, San Francisco**

Okay, the courtship's over, no one broke off the engagement, and now it's time to get married. The gallery wants to represent you and you want to be represented by the gallery. So how do you make this relationship work?

As with any marriage, to really be successful you both need to be open and honest with each other; to trust each other; to collaborate and cooperate on major decisions; and to always keep the long-term perspective in mind. Don't let frustrations fester. Deal with them, discuss them, resolve them.

And while frustrations and misunderstandings are inevitable, you can minimize them from the beginning by knowing what to expect from each other. Talk about the arrangement *before* you agree to it. Ask questions. Understand what the gallery thinks you're embarking on together—it may not be exactly what you have in mind, and it's better to be surprised now than two years down the road, when the stakes are higher.

Oh—and don't forget that if representation is like marriage, you're getting hitched to a polygamist. No matter how much your gallery loves you, you'll never be the only one.

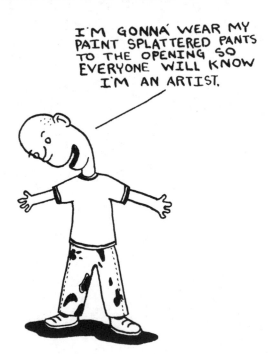

WHAT YOUR GALLERY WILL EXPECT FROM YOU

From your gallery's perspective, your job description is straight-forward: keep making your work. Your gallery expects you to make your work all the time, not just when you're preparing for a show; to constantly challenge yourself; to be dedicated and ambitious.

You're also expected to act like a professional: to communicate, to meet deadlines, to respect your end of the deal. That means a lot of basic things like replying to email and returning phone calls; telling the gallery if you're going on vacation; updating the gallery when you have a new body of work; treating the gallery staff with respect. It means coming to your openings on time. And it means being discreet with confidential gallery information.

Your gallery expects you to keep it updated on your direction and to share your ideas and intentions as you make your work. It's only through an ongoing dialogue about the substance of your work that your gallery can do you justice when it presents your work to its collectors and the press.

Here's a big one: you may no longer sell directly out of your studio without your gallery's permission. That's no joke. You could lose your gallery and seriously damage your reputation. The gallery invests time, energy, and money into your career, which is why it gets a commission from selling your work. When you go behind a gallery's back and sell your work directly from your studio, you cut the gallery out of its commission, which is only one or two steps away from stealing the money outright. Occasionally, a gallery will let an artist sell certain kinds of work directly, but the default expectation is that everything goes through the gallery unless you specifically come to some other agreement. And while you will almost certainly be allowed to give your friends and family heavy discounts, if not outright gifts, you still need to check with your gallery beforehand.

Along the same lines, when collectors visit your studio and ask to buy something, you need to refer them to your gallery. You shouldn't even quote them a price because the price you and the gallery decided on probably didn't include tax and shipping. Or the gallery may have promised the work to someone else that morning.

—————"If you come to me and you are professional, prepared, and can present your work articulately and clearly, when asked, I'm going to talk about you as a great artist to work with. If you are always late, unprepared, and you can't explain what you are doing or where you are going, I'm not going to be as apt to include you." *Kim Ward, director, Washington Project for the Arts, Washington, D.C.*

—————"The artist community is really tight and everyone talks about who's doing what. I've heard about times when an artist has spoken too much about their relationship with a gallery and it got back to the gallery. The gallery canceled the deal. We don't talk about one gallery artist to another gallery artist because there is competition there and we use discretion. We ask our artists to do the same." *Mary Leigh Cherry, Cherry and Martin, Los Angeles*

—————"Once you start selling out of your studio, it gets out and you get blacklisted. It is a very tiny, gossipy world. Communication is instant so you have to watch your reputation. If you are in a real financial bind, call your gallery! Maybe they can come up with something." *Andrea Pollan, owner, Curator's Office, Washington, D.C.*

————————"I expect them to take it seriously and participate in the gallery. I risk as much as I can in terms of time and money. There is a commitment and a risk put up front with the hope of long-term success. I expect the artist to also be in it for the long term." **Shane Campbell, Shane Campbell Gallery, Chicago**

————————"I had been a picture framer for artists and galleries for many years. One of our clients was the wonderful Paula Cooper when James Cohan was her director. He was a really nice person and he would talk to me and all the woodworkers and treat us like human beings. A lot of the other dealers treated me really poorly back then, and eventually, some of them came around asking to represent me. They didn't remember me from when I was a framer and all of a sudden they were being really nice. But I knew they were phonies. James Cohan eventually approached me and I remembered how graciously he had treated me when I was his framer. I asked around and people said he was honest, solid, and museums liked him. Since I wanted a hardworking, competent, likable gallerist that wouldn't rip me off, I decided to go with him and I have no regrets." **Fred Tomaselli, artist, Brooklyn, N.Y.**

————————"The artists I represent should expect that I will be there to help them, encourage them to remain curious and not be afraid to take risks in their work, and be there for advice." **George Adams, George Adams Gallery, New York**

When you're allowed to sell something out of your studio without giving your gallery a commission, you should sell the work at the same price your gallery would sell it at (giving the same discount your gallery would). To do anything else would be a disservice to yourself, your gallery, and your career.

You also need to tell your gallery about any direct relationships you have with galleries in other regions. Galleries differ on how they handle those arrangements, so find out what your gallery's policy is. It's usually a function of power and resources. Galleries with more muscle insist that everything goes through them, regardless of who discovered you, because they have the administrative personnel to handle the extra workload. Smaller galleries, on the other hand, are more likely to let you work directly with galleries in other regions if you want to. There are benefits to having your gallery handle your relationships with galleries in other regions, rather than working directly with them; we'll talk about that in the next section.

Once you have a gallery, you always need to mention it when you're interviewed for press. That includes noting recent and upcoming shows and attaching a courtesy line to your images when you email them to a journalist ("Courtesy of the artist and [gallery name, gallery city]"). Otherwise, people who like the image won't know where to look to find out more about it.

Finally, your gallery will expect you to support the rest of the artists in the program by coming to see their shows, either at the opening or later in the month. While no one's going to ask you to be a "team player," your gallery does quietly expect you to help out other artists when, for example, you have equipment you can lend or some other favor you can do.

When you're first brought into a gallery program, you should give the gallery updated copies of your:

—CV and artist statement
—press and press releases
—price and sales history
—collector list
—any sales leads
—contact info for curators, consultants, or press who have expressed interest in your work
—images of recent work

Add your gallery's contact info to your website. Link to the gallery's website from yours and ask the gallery to do the same. Keep your website up to date—and make sure your gallery adds your images, résumé, and other information to its website.

WHAT YOU CAN EXPECT FROM YOUR GALLERY

Ideally, your gallery will help organize your professional life, taking over most of the administrative tasks so you have more time to make work. It will act as your agent and manager, raising your recognition among collectors, curators, other galleries, and the press. It will sell your work and give you emotional support. You should feel that your gallery is behind you for the long haul, not just when sales are good.

There are many more details to this arrangement, of course, which you need to discuss with your gallery before your first show. Many artists don't bother. They're just happy to finally get a gallery and hope that they'll be treated well. This is astounding, if you take a step back and think about what a consequential decision it is to put your career into someone else's hands.

You should, at a minimum, ask enough questions to know whether your expectations are realistic, since most places aren't going to hand you a stack of paperwork outlining their responsibilities. A gallery that is seriously interested in you will not walk away just because you ask about the relationship it envisions having with you. (And a gallery that does get skittish is probably one to be wary of in the first place.)

You can't assume that everything will "work itself out" as you go along or that a gallery will always put your best interests first. There are lots of little things that come up when a gallery is working hard to get your work out there and you should think about them ahead of time. Only you know whether you're going to care about a particular wrinkle—for instance, you're asked to install your own work—and if something is going to bother you later, then you should try to deal with it now.

You'll recognize many of these issues from our discussion of consignments in chapter 10. The difference, obviously, is that here you're thinking about a much more comprehensive relationship that will last well beyond the next show.

──────"Someone once said to me that there are two types of galleries: galleries who are primarily focused on sales and the others who do weddings, bar mitzvahs, and funerals. I feel like we fall into the latter category. We are interested in supporting the artists at every level. It means different things for different artists, depending on where they are in their careers." **Catharine Clark, Catharine Clark Gallery, San Francisco**

──────"When I break down my costs, I shock artists. With most artists, the gallery doesn't even break even until the second or third solo show. I am artist-centric and supportive, so if it's clear to both parties that the artist is making the gallery a lot of money, I say renegotiate the 50/50 split. Until that point, the gallery is investing in you and it's not a bad deal." **Edward Winkleman, Winkleman Gallery, New York**

──────"Percentage can change based on value judgments. How much you need them, versus how much they need you. But, in my experience, the artist never gets less than 50 percent." **Sabrina Buell, director, Matthew Marks Gallery, New York**

──────"My husband, who is an artist, likes to say that artists who complain about how much money galleries take usually don't have galleries. If you have gallery representation, and it's a pro-fessional and mutually respectable relationship, you aren't asking those questions. Each of you is trying to help the other survive and thrive." **Catharine Clark, Catharine Clark Gallery, San Francisco**

What if I brought the collector in? Shouldn't I get more than 50 percent?

The short answer is no. Should the gallery get more than 50 percent when it sells to "its" collectors?

Production Costs

Not all galleries will reimburse you for production costs. And the ones that do reimburse vary on what counts as reimbursable. It might be specialized services, such as printing, casting, or mounting. It might be especially expensive materials. Ask your gallery what its practice is so you don't end up counting on something that isn't coming to you. (Even galleries that don't normally pay for production make exceptions, sometimes, to help artists make work that they couldn't otherwise. So it's still worth asking.)

And keep in mind that there's a downside to having the gallery front production costs: you will have less control over the vendors you use.

If a collector is taking a long time to pay for work, you can always ask your gallery for an advance. You're not entitled to one (and many galleries can't afford it) but sometimes a gallery will give you one if you need it. And if a collector is on a payment plan, see if your gallery will split each installment with you, rather than wait until all of the installments come in before paying you your share.

The Fifty-Fifty Split

With few exceptions, your gallery will take 50 percent of all sales. Some galleries take a smaller percentage for commissioned work, on the theory that there's less work for the gallery to do, since the work is sold before it's made (and, frankly, more hassle for you, as you know from chapter 11).

Framing and Production Costs

Most galleries pay for framing once you're represented and sales are happening. If it fronts the cost, it will recoup that money first and then take its 50 percent commission. This is easy to track because the gallery will bill a collector separately for framing. A $2,000 drawing that cost $300 to frame, for example, would retail for $2,300: the bill would show $2,000 plus $300 (before tax and shipping); you'd get $1,000 and the gallery would get $1,300. That should work in the other direction as well. If you paid for the $300 frame, you'd get $1,300 and the gallery $1,000.

Depending on your medium and how much clout you have, your gallery might front some of your production costs. The math works the same way—the gallery will recoup its costs and then you split the rest—except that, unlike framing, production costs aren't usually broken out on the bill the collector receives. Take a $2,200 photograph that cost $200 to print and $300 to frame. The bill would show $2,200 plus $300 (before tax and shipping), of which $300 would go to the gallery for the framing, $200 would go to the gallery for the printing, and the remaining $2,000 would be divided evenly between you and the gallery.

The opposite is also true. If you fronted the framing or production cost *and* told your gallery about it in advance, you should be reimbursed before the split is made. Most galleries will agree to this arrangement as long as you are clear with them long before the sale happens.

Discounts

As we explained in chapter 10, many galleries routinely agree to a 10 percent discount to close a sale and will expect you to split

that evenly. Instead of getting 50 percent of the retail price, in other words, you get 45 percent. (The collector pays 90 percent of the original price; splitting that in two gives you and the gallery 45 percent each.)

Discounts are calculated after subtracting production costs. Say, for example, a photograph cost the gallery $100 to print and it retails for $800. A 10 percent discount would lower the price by $70 (not $80). The collector would pay $730, the gallery would get $415, and you would get $315.

You shouldn't have to split more than a 10 percent discount for an ordinary sale (meaning 5 percent would come out of your half and 5 percent out of the gallery's). If your gallery wants to give a collector a 15 percent discount because she is a friend of the gallery or is buying several works at once, you should still only have to split the first 10 percent of that discount (5 percent out of your half, 10 percent out of the gallery's). Museum sales, on the other hand, are anything but "ordinary." They usually come with at least a 20 percent discount, and you'll be so happy you won't mind having to split the whole thing with your gallery.

That you *shouldn't* split more than 10 percent on ordinary sales doesn't mean that you *won't*. You may find yourself working with a gallery that insists on splitting all discounts, no matter how large. Better to know that ahead of time so you can decide whether you want to make an issue of it. Maybe it's not a big deal to you at all. Maybe you "adjust" a larger discount into your original price. (So you know, a gallery that wants you to split discounts bigger than 20 percent is taking advantage of you.)

Payment

As we went over in chapter 10 on consignments, your gallery should commit to paying you within a certain number of days after it's paid. Thirty days or end of the month is totally reasonable, since it's more efficient for a gallery to deal with its monthly bills all at once, which means putting off cutting your check until the next "bill day." A smaller gallery may need more time, like 45 or 60 days, because it has less staff to handle the paperwork. But more than 90 days is—to use a legal term—

————"Different situations require different strategies. When there is high production cost, we figure out how that got paid and it gets deducted off the top of sales. In some situations, the artists actually prefer to take care of their own production costs. Those are usually the more established ones who want more control." **Steve Henry, director, Paula Cooper Gallery, New York**

————"Do not go into a gallery situation expecting production costs or framing." **Cornell DeWitt, private dealer and consultant, former gallery owner and director, New York**

————"My position on production has changed and evolved as my artists have gotten older. Early on, I thought it was imperative for artists to pay or partially pay the production on their work because I thought it was important for them to think about viability. They had to be responsible for what they were making. It is a deep responsibility. If early on they can't afford something, whether it is when it costs $1,000 or $300,000, and they are not willing to invest in the work on that level, then their work is probably not viable on that level." **Andrea Rosen, Andrea Rosen Gallery, New York**

————"Once you have a show and there's a sale, it's usually too late to start saying 'We didn't talk about discounts.' The dealer is going to assume it's the usual arrangement in the art world where the artist and dealer split the discount up to 10 percent." **Stephanie Jeanroy, director, Michael Benevento, Los Angeles**

————"Artists have the right to have information regarding who acquires their artworks. This information should be provided at the time of the sale. Somewhere down the line an artist will have a museum exhibition. The organizing curator will need to know the location of artworks to be included." **Rosamund Felsen, Rosamund Felsen Gallery, Santa Monica, Calif.**

What's the best month for my show?

There isn't one. Really. Everyone wants September or May, which makes for a bit of a self-fulfilling prophecy. Since everybody wants those months, and the artists with more clout get what they want, the artists with the most clout get those months, and then everyone thinks those are the best months.

The truth is that there are advantages and disadvantages to every month and you can't predict which one is going to be the best for your work. A month when an art fair is in town means there will be more collectors around, but they'll spend most of their time at the fair. The summer months are a little slower, but that makes it easier to get press.

It's your gallery's job to consider these factors when it plans out the next year's schedule—as well as, for example, which shows should come before and after yours (from a curatorial perspective) and whether museums or other galleries will have shows of similar work that year. Because the decision has as much to do with the rest of the artists in the program as it has to do with you, it's ultimately the gallery's call.

So in terms of picking your battles, this is not a very worthwhile one. You're better off going with the flow and asking a lot of questions, if you're interested, about what went into the decision to schedule your show for a particular month. That way, by the time you have enough clout to influence the gallery's schedule, you'll have a much better feel for which factors matter, for your particular work, and which ones don't.

"crazy." Your gallery has no good reason to keep your money for months and months, earning interest on your sweat and tears while you sleep in your studio to keep the rent down.

As with everything else, though, when you're considering a gallery notorious for paying its artists late, you have to weigh the costs and benefits. We know plenty of artists who decided to show with a gallery, despite its reputation on this score, because they believed the boon to their careers would be worth the inevitable headaches over payment.

At the end of chapter 14, we'll talk about what you can do if you're not paid when you should be. (*Spoiler alert:* very little.)

Solo Shows

Solo shows are extremely important for your career. They allow you to develop a complete body of work, which is the best way for your ideas and intentions to mature. They raise your profile and increase your chances of getting press. And they typically generate more sales than you'll make at any other time of the year.

So don't be shy about asking how often the gallery intends to show your work. On average, galleries give their artists one solo show (lasting at least a month) every one and a half to three years. Much longer than that is a red flag, unless your work takes an especially long time to complete.

Also find out what kind of announcements and other materials the gallery ordinarily prepares for its shows. The idea is to find out what the other artists get, not to demand special treatment. Cards? Catalogs? Ads? Does the gallery use the same format for every show? Does the gallery send real cards or is everything digital?

At a minimum, your gallery should send out some kind of press release, ideally six to eight weeks before your opening to give editors and writers enough lead time to write about the show. A press release for a solo show is essentially a project statement, which means your gallery will need your input and, depending on the gallery, may want you to help write and edit the statement. While you won't have final say on how it's written, you should be happy with it. Speak up if you're not. Ask to look at

a draft early on and raise any points you don't like. Once you're at your opening, it's too late to change anything.

Most galleries mail postcards or email announcements (or both) to their collectors. They usually use the same style and format show to show because the gallery has a certain look and wants its collectors to recognize its cards when they get them. Although you can ask for a different size or format if it relates to your show's concept and it's really important to you, don't be surprised if the gallery says no.

Same deal with catalogs, brochures, and ads. You'll get what everyone else gets, which, in this case, is usually nothing. Because these items are all very expensive—a full-page ad in a major art magazine, for example, is more than five thousand dollars—they don't make sense until you're more established. But if you can pony up the cash yourself, the gallery will probably be willing to help you put the materials together and edit the content.

WE'LL REPRESENT YOU BUT ONLY IF YOU GIVE US 48% OF THE SALE PRICE ON TOP OF OUR REGULAR 50% COMMISSION.

—————"When I got gallery representation, it was exciting and my work did change. Instead of trying to make huge, overarching statements in every work, I concentrated on the notion that each piece I made was a small part of a larger story. I could tell a very small part, one piece at a time, and let that build up over time. And with each successive exhibition, I was adding to the collective memory of my audience, particularly the community of New York City where I felt a sense of belonging." **Charles Long, artist, Mount Baldy, Calif.**

—————"Sometimes press releases are written by dealers who can't get artists to speak, so they speculate. I know a lot of artists don't have the ability to speak, but if you don't speak up, you can't complain about how your work is described." **David McGee, artist, Houston**

—————"There is this fiction out there that galleries only show work that they can sell. I think it's the oddest assumption because if we knew what could sell, first, we'd be very wealthy and second, it would be like looking into a crystal ball. Part of the excitement of working with an artist is that there is so much that is unexpected and you are responding to this feeling that this work is worthy and important. It then becomes your job to convey that enthusiasm to your public. Sometimes people agree and they step up and sometimes not." **Catharine Clark, Catharine Clark Gallery, San Francisco**

Countdown to the Solo Show: Your Tasks

1 year
—get show dates

6 months to a year
—tell the gallery what your concept is and whether you need special equipment
—give the gallery images of finished work or details of works in progress

2 months
—give the gallery the title of your show, a statement and images for press release, listings, and collectors

4–6 weeks
—select an image for the postcard and email announcements
—make sure the gallery has the equipment you need

1–2 weeks
—be ready to ship (no wet paint!)
—give the gallery an updated résumé and statement
—send out postcards and invite people to the show
—send email announcement

3–6 days
—install

Day of
—be on time
—be professional

Day after
—send a thank-you note or email to the gallery

Countdown to the Solo Show: The Gallery's Tasks

1–2 years
—plan show dates, start contacting artists and collectors

6 months
—contact monthly magazines and reserve ad space

2 months
—write the press release and send it to listings, editors, and writers
—design and submit any ads
—secure necessary equipment

4–6 weeks
—design and produce postcards
—send out press reminders and listings
—post the show on its website
—hire art handlers for installation

3 weeks
—schedule shipping, contact collectors and curators

2 weeks
—send out postcards

1–2 weeks
—ship work to the gallery
—design and send email announcements
—plan the opening and after party
—update the artist's bio, statement, and résumé

3–5 days
—deinstall the last show; install the new one
—update its website with new show
—invite collectors, curators, and press to preview
—complete the installation, checklist, price list, artist book, press kits

Day of
—coordinate the opening and after party
—develop press/collector/artist relationships

1–2 days after (or before)
—document the work and take installation shots
—update its website with all new images
—thank the artist

Show Costs

Your gallery should cover the costs of installation, deinstallation, and insurance for any show you're in. Some galleries pay for shipping and some don't. (Most galleries will eventually cover shipping for their artists, it's just a question of when.)

If you live far away, most galleries will cover the travel costs when you need to be at the show—to install the work, for example, or perform a piece. Some galleries may pay for accommodations or help you find a place to stay while you're in town. Just make sure the gallery knows well in advance that you need to be there. If you don't "need" to be there—that is, they can install the show without you—then you'll probably have to pay your way there (unless of course you're at a place with a bigger budget).

Opening and After Party

The gallery should also organize, pay for, and host an opening. Once again, don't expect special treatment. If no one else gets hors d'oeuvres and champagne, neither will you. Many galleries will do a dinner or after party. What they pay for and whom you're allowed to invite varies from place to place, so work it out ahead of time.

Don't be discouraged, by the way, if no one buys anything at the opening. Most sales happen before or after an opening, not during. Nor should you be discouraged if people at the open-ing aren't looking at your work. The opening is more about showing support for you and publicizing the show. Most people come to see you and to socialize more than they do to really take in the work.

Serious collectors and press, on the other hand, tend to pop in early and take off before the crowds arrive. Another reason to be there on time.

Three Reasons You Don't Want to Get Drunk at Your Opening

1. You could pass out under a security desk, wake up the next day locked in the building, and have to call the staff to come let you out.
2. You could barf onto your plate in the middle of the dinner with your collectors.
3. You could forget that you gave your credit card to the bartender at your after party and wind up with everyone else's drinks on your tab.

And yes, all of these stories are true.

Although your gallery will appreciate you promoting your show while it's up, and probably expects to see you more often that month, you should still be sensitive to the gallery's needs. For example, given that Saturdays are the busiest days for a gallery, don't hang around talking to the staff for hours on a Saturday. Let them do their job and do right by your show.

Images

Your gallery should pay to digitally photograph your work for its website and inventory and take installation shots during shows. Ask for copies.

Don't wait until the last minute to look through the images your gallery takes. If you have a problem with them, you'll need to raise it while there's still time to take new ones. If you're particular about your images or think you could take better-quality ones yourself, go right ahead. Once the show's down, it's too late.

Records

Your gallery should give you copies of the records it keeps about you and your work, either once a year or on request:

—the gallery's inventory list of your work
—images of your work, including installation shots
—price lists from your shows
—press releases
—promotional materials
—sales information
—collector contact information

The last item shouldn't be controversial—you're entitled to know who buys your work—but unfortunately it is. While many galleries are willing to give you that information, many aren't. They have various excuses for not disclosing the names of their collectors: to keep their artists from bothering their collectors; to prevent their artists from selling behind their backs; to discourage their artists from leaving them someday and taking their collectors with them. None of these excuses, however, justify withholding that information from you. It's just not right. (In fact, in California it's against the law.)

Although your gallery is theoretically taking care of all your paperwork, we recommend keeping your own records up-to-date.

What if my gallery doesn't share collector information with its artists?

If your gallery doesn't share that information with its artists, try to raise the issue in a constructive way. Find out why—maybe it's just because no one's asked before—and see if you can reach a compromise. If the gallery is worried about you contacting collectors, you could promise not to do that without going through the gallery. If it's concerned about guarding the collectors' privacy, you could promise not to disclose the information to anyone else or put them on your mailing list. Whatever the gallery's reason, there should be a solution short of keeping the information from you altogether.

Galleries usually have standard written consignment agreements for consigning work to other galleries. If you used a consignment agreement when you initially consigned your work to your gallery, as we recommend in chapter 10, then there would be two written consignment agreements: one between you and your gallery, and one between your gallery and the second gallery. You don't need to sign the second one, because it's just between the two galleries.

——————"The best artists communicate with their galleries and keep the lines of communication open so there are no misunderstandings. If they work with more than one gallery, they are open and honest with everyone. They look at the galleries as being on the same level they are: no better or worse. They are equals with their galleries."

Steve Zavattero, Marx & Zavattero, San Francisco

Art Fairs

Your gallery should cover all fair costs, including shipping and insurance. As with a regular show, if you need to be at the fair, the gallery should cover your travel and lodging. (You can stay in town after the fair ends but the extra days will be on your own dime.)

Consigning Work to Other Galleries

Your gallery represents you exclusively in its city, which means you can't show with other galleries in the same city unless your gallery consigns the work to them. And if you want your gallery to act as your primary gallery, then it will handle consignments to galleries in other regions as well. That means you consign your work to your gallery, and then it turns around and consigns it to a second gallery (with your permission, of course).

When your gallery consigns your work to another gallery for a group show, it will split its commission with that gallery; you still receive 50 percent of any sales. For example, if your piece sells for $2,000, you get $1,000 and the galleries split the rest. A standard 10 percent consignment would earn your gallery $200 and the other gallery $800; you'd still get $1,000. (More powerful galleries demand anywhere from 20 percent to almost 50 percent from other venues.) Normally, the second gallery will agree to cover any discounts out of its commission, but you may need to split up to whatever percentage you agreed to when you consigned your work to your primary gallery.

The upside of letting your gallery handle everything is that your gallery will handle everything. It will deal with logistics; it will make sure the other gallery has insurance; it will make sure you get paid; it will make sure your unsold work is returned. The downside is that you have less control over the relationship with the second gallery.

When you have a solo show at a gallery in another region, it's customary for your first gallery to take a percentage the same way it would with work consigned to a group show. If the solo show goes well, your gallery may let you work directly with that gallery from then on, without taking a percentage of sales from future shows. Some artists prefer the control they

have in a direct relationship; others would rather let their first gallery do all the administrative work for them and continue to take a commission on those shows.

Your gallery should have a consignment agreement that it uses with other galleries (even if it doesn't use a consignment agreement with its own artists).

Museum Shows

If you're included in a museum show, your gallery will handle the relationship with the museum, dealing with all the issues we discussed in chapter 11. It might also need to kick in some money for the catalog, shipping, and other expenses. You'll still work closely with the museum's curator, especially if it's a solo show, but you can focus on the substance of the show and let your gallery tackle the logistics and paperwork.

Speaking of which, make sure the museum has a written loan agreement that you go over with your gallery together. Don't let your gallery loan your work on a handshake.

WHAT YOU CAN'T ALWAYS EXPECT FROM YOUR GALLERY (BUT HERE'S HOPING)

Right of First Refusal

Say a collector runs into financial problems, becomes desperate for cash, and decides to sell off part of her collection. If she's desperate enough she may sell her pieces for much less than they're worth—that is, much less than she'd get if she weren't in a rush to sell. This isn't good for you. Worse than just draining the value of the pieces sold, this kind of bargain-basement clearance can cut into the value of your other work and even hurt your reputation.

Or say a collector thinks she can get more money from putting your work up at auction than she would get reselling it privately through your gallery. If she's right, your prices could

—————"We would never demand someone bring a work back to us, but we make it clear that we appreciate being informed and to have the opportunity to take something back. Most collectors do actually bring things back to us or at least let us know if they are going to sell something. Not all, but most." **Steve Henry, director, Paula Cooper Gallery, New York**

—————"We let the collector know that there are unspoken expectations in the industry. When I started, when collectors resold work, they tended not to do it through the galleries. Not because it was more profitable at the auction houses but because they felt guilty. If they were not supposed to be selling, but collecting and saving something forever and ever, perhaps they thought it would be embarrassing when the artists found out they were going to sell their work, so the natural inclination was not to sell through the gallery.

"Everyone has the right to do whatever they like for whatever reasons, but there is an unspoken expectation of collectors that what would be appropriate for the artists is that the work be brought back to the gallery." **Andrea Rosen, Andrea Rosen Gallery, New York**

increase much more quickly than you or your gallery wants given where you are in your career and who your collectors are. If she's wrong, your prices could plummet based on poor auction performance—a setback that can take years to recover from. And either way, you have no control over who buys your work at auction, meaning you might never be able to get it back for a solo show or retrospective.

To prevent these outcomes, some galleries ask their collectors for a "right of first refusal." This requires a collector who wants to resell your work to let your gallery try to resell it first or buy it back, giving the gallery more control over your prices and where your work goes.

You can't make your gallery demand more of its collectors than it already does for its other artists, but you might as well raise the question so you know what to expect.

Resale Royalties

The first time someone buys a work of art, it's a sale; every time the same work is sold again it's called a "resale." In California, there is a "resale royalty" law that entitles you to 5 percent of the resale price for your work (with a few caveats). The idea is that you, as the artist, should benefit directly from the value of your work increasing over time. If you're going to qualify for resale royalties, because, for example, a lot of your collectors live in California, make sure your gallery stays on top of this for you.

No other states prescribe resale royalties. (The European Union has a resale royalty law, but California is the only place in the United States to follow suit.) The issue is a controversial one. Many people in the art world don't think you deserve more than what you get from the first sale of your work. After all, the thinking goes, the collector is the one taking a risk on your art, so the collector "deserves" to see all the upside if the bet "pays off." And prominent collectors help raise the value of your work just by buying it and adding it to their collections.

We happen to think that the arguments on the other side are stronger. It is your increasingly successful career that causes your early work to rise in value. While big collectors can obviously

California's Resale Royalty Law

Under California law, someone who resells your work must pay you 5% of the resale price, as long as:

—The resale takes place in California or the reseller is a California resident.
—The work is "a painting, drawing, sculpture or original work of art in glass" but "does not consist of stained glass permanently attached to real property."
—The work resells at a profit and for at least $1,000.
—You are a U.S. citizen at the time of sale or have been a California resident for at least two years.
—The resale happens during your life or within twenty years of your death.

The law doesn't apply for ten years after the first sale *if* you first sell the work directly to a gallerist *and* no collector buys it during those ten years. In other words, if the work is only resold to other gallerists, you don't get a resale royalty for the first ten years of resales; you only start to get resale royalties for resales *after* the first ten years.

raise your profile, that higher profile would be meaningless—
and from a collector's perspective, worthless—if you stopped
making work or your career took a nosedive. In other words,
what you do and what you make as your career progresses
directly affect the value of your old work. That is why we believe
you deserve a resale royalty.

Some galleries voluntarily give their artists a resale royalty
whenever collectors resell their work through the gallery,
regardless of the California law. And a recent trend among the
newest generation of collectors (who tend to be more open-
minded about this issue) is to create resale royalties outside of
California by promising, in an invoice, to pay the artist a certain
percentage of any resale. But these are all exceptions; the
vast majority of galleries outside of California (and, to be candid,
quite a few galleries *in* California) do not bother trying to
establish or enforce a resale royalty.

————————*"From a moral, ethical point of view,
a resale royalty seems fair to me. I think it's morally
fair to allow artists to be part of the action."*
**Joachim Pissarro, curator, professor, art
historian, former Museum of Modern Art curator,
New York**

————————*"Depending on the situation, it's a nice
thing to do. Many other art forms get royalties."*
Mary Leigh Cherry, Cherry and Martin, Los Angeles

————————*"I give the artist a percentage of
my resale profit. I think I'm in an incredibly small
minority of people who do it."* **Andrea Rosen,
Andrea Rosen Gallery, New York**

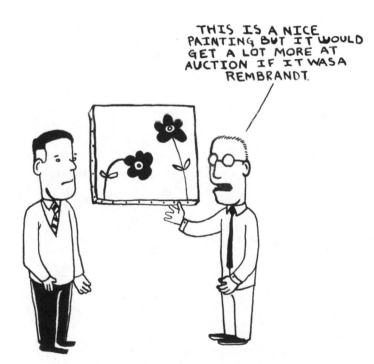

SOME GOOD THINGS MUST COME TO AN END

Not every marriage is a success. Sometimes you discover that you're better off going separate ways. If that happens to you, end the relationship in the same professional way that you began it. Talk to your gallery. Explain what's going on. Chances are it won't come as a complete surprise. You may even be able to work things out. But even if you can't, it's better to acknowledge what's happening and bring closure to the relationship than to just walk away and disappear.

Why You'd Better Be Sure Before You Leave Your Gallery

——————*"One artist decided I wasn't selling enough of his work. Another dealer told him she liked his work, so he left my gallery and went to her. He completely misread it. She was a friend of mine and told him she couldn't take him. She called me and said she was terribly sorry that he had done that, and that she would never show him.*

"Then he had the nerve to come to me and ask if I'd take him back. I said no. Sorrrrry." **Anonymous**

————————"I believe pretty strongly that change is beneficial to all concerned. When I started I thought 'I'll represent these people until I die!' But it doesn't happen. It's unrealistic to think that happens." **Greg Kucera, Greg Kucera Gallery, Seattle**

————————"If an artist comes to you and they ex-plain why they are leaving and where they are going, and they are up-front and honest as soon as they know, then there is nothing to complain about. Of course you might be disappointed, but the artist handled it respectfully and professionally." **Heather Taylor, Taylor de Cordoba, Los Angeles**

————————"Because I survive on the business, it has to be financially successful for both of us. I may love an artist's work, but if I just don't have the collecting base for that work, then I think the artist needs to find the right dealer to match up. It's better for them and better for the dealer, too." **James Harris, James Harris Gallery, Seattle**

————————"Breakups happen in very different ways—just like when you get an artist. I've had breakups when it was face-to-face and the artist understood. It wasn't easy, but we left in a good place. We were able to be friends and colleagues. Now that I know more gallerists, I know that people work with artists in different ways. Just because we might not be as successful with an artist as we would want to be doesn't mean that someone else can't take their career on. It doesn't mean they are not good artists. Our relationship might not be the right relationship." **Mary Leigh Cherry, Cherry and Martin, Los Angeles**

————————"Every gallery has its own direction. If artists feel a particular gallery isn't the right place for them and believe they would be better off someplace else, they should go." **Rosamund Felsen, Rosamund Felsen Gallery, Santa Monica, Calif.**

————————"If someone wants to leave, they are just going to tell me they are not happy or they are happy but they want to explore other options. I'm fine as long as they do it the right way. What irritates me, after years of support and hard work, is to get an email or a certified letter.

"I gave a well-known artist her first show in this gallery. She came to my office many years later and told me she was moving to another gallery. It was respectful, courageous, and well mannered. I had such an appreciation for her courage." **Shoshana Blank, Shoshana Wayne Gallery, Santa Monica, Calif.**

CHAPTER 14
—————Representation Agreements

————"'Contract' sounds sort of divisive and oppositional, whereas 'agreement' sounds more harmonious, but they're of course the same." **Tad Crawford, arts lawyer, author and publisher, New York**

————"I like calling them gallery-artist agreements. Contract seems to be a big word with emerging artists. I didn't mind using it until I saw how scared they got. Their eyes would get wide and they'd get really quiet." **Lorraine Molina, owner and director, Bank, Los Angeles**

————"When you have a dispute with a gallery, it's normally resolved in some sort of conversation. But the contract sets the context for that conversation. So even if you're not going to sue, I think it's worth some investment up front to set the parameters for that later discussion that has to happen if things go bad." **Donn Zaretsky, art lawyer, John Silberman Associates, writer, Art Law Blog, New York**

As you remember from chapter 10, a basic consignment agreement explains the details of a one-time consignment: It describes the understanding between you and the gallery about specific work you're consigning for a specific period of time. Now that you've read chapters 12 and 13, you know that there are add-itional issues that come up when you consider a long-term relationship with a gallery. (Exclusivity, solo shows, and direct sales, to name a few.)

Since a basic consignment agreement doesn't cover these issues, we think that when a gallery decides to represent you, you and the gallery should use a comprehensive "representation agreement," instead of a basic consignment agreement. A representation agreement covers your consignment arrangement, meaning that you won't need a separate consignment agreement once you have a representation agreement in place. You'll just fill out a new inventory list every time you deliver work to your gallery; the consignment terms will already be spelled out in the representation agreement.

Unfortunately, most galleries do not use representation agreements with their artists, so tread carefully here. Galleries don't have problems with consignment agreements, but the vast majority of them are quite hostile to the notion of using a representation agreement. While a few galleries do use representation agreements, and a few others told us they'd be happy to use them if their artists asked them to, some gallerists said they would *never* work with an artist who handed them a representation agreement.

This resistance to representation agreements is a little puzzling, given how normal they're considered to be in every other creative industry. Novelists, playwrights, musicians, actors, and just about every other creative type you can think of use written representation agreements with their agents and managers. There's no good reason your gallery, which acts as your agent (*and* manager *and* dealer), shouldn't also use a written representation agreement with you.

There are plenty of bad reasons, though, and we heard a lot of them in the course of researching this book. It turns out there is some fundamental confusion in the art world about representation agreements: what they are, what they're for, what they mean, what they're called, why so few people use them. To clear

——————"The number-one reason galleries and artists go their separate ways is that they haven't thought things through and discussed it. Then something comes up and they had very different thoughts about how something should be handled."

Edward Winkleman, Winkleman Gallery, New York

things up, we'll go through the most common explanations people gave us and show you how each one is grounded in a misperception or incorrect assumption.

1. *"If an artist wrote me a letter that said 'this is what I understand our basic relationship to be,' that is perfectly fine. If an artist made me a contract, I probably would not work with them."*

A letter that describes the "understanding" between an artist and a gallery—that is, the obligations each has to the other—*is* a contract. The fact that it's in the form of a letter, rather than in the form of a traditional legal document, doesn't matter at all. (Lawyers would call it a "letter agreement," but it has the same legal force as a traditional contract.)

The words *contract* and *agreement* mean the same thing. An oral agreement *is* an oral contract; a written agreement *is* a written contract. Thus, a letter agreement *is* a contract, and it doesn't make sense to say you are okay with a letter agreement but not a contract. From a legal point of view, they're the same thing, even though they look different.

A lot of artists and gallerists think *contract* is a dirty word. So call it an "agreement" instead. Call it a "letter" or a "form." Call it "Charlie" if you want to. What matters is what the thing says, not what it's called.

2. *"I don't want to write anything down because I don't want to be bound by a contract."*

You can be bound by a contract even if you don't write anything down—it's just an oral contract instead of a written one. That's because a contract is essentially a promise (more technically, it's an *exchange* of promises) and you don't need to go to law school to know that you're supposed to keep your promises even if you don't write them down.

When you get gallery representation, the gallery promises to represent you, to sell your work for you, etc.; you in turn promise to give the gallery a 50 percent commission, not to let another gallery represent you in the same city, etc. When you don't write down these promises, you have an "oral contract." An oral

Just the exercise of writing down your arrangement will encourage a healthy conversation about your hopes and expectations for the relationship.

contract is still a contract, and you and your gallery are still bound by it. Think about it: if you find out your gallery sold a piece of yours but never paid you, you're not going to say to yourself, "Oh well, that's okay because the gallery never promised *in writing* to pay me."

The problem with oral contracts is that they're vague. Instead of having an explicit conversation about a particular task, you might simply assume your gallery will be willing to perform it, only to discover later that your gallery never thought it was part of the deal. Or you might misinterpret something your gallery tells you, or remember a promise your gallery made that your gallery says it never even discussed with you. So given that you're entering into a contract, it's better to write it out.

3. *"I'd use contracts but they don't want to."*

Gallerists say artists don't want to use contracts. Artists say galleries don't want to. The truth is that there are artists and galleries who do, and artists and galleries who don't. Don't assume that the gallery you're working with is categorically against writing down a representation agreement. If you want one, ask the gallery whether it's open to that.

4. *"Artist-gallery relationships are built on trust. Introducing a contract breaks that trust."*

You don't stop trusting someone just because you write down the nature of your professional relationship. In fact, writing an agreement prompts discussions that can actually *build* trust, because you each get a better feel for how the other person thinks through issues and reacts to differing expectations.

5. *"That would be like asking my fiancée for a pre-nup. It's a sign you don't really believe the relationship will last."*

Remember when we said in chapter 12 that the marriage analogy only goes so far? This is a perfect illustration of why. You may love your gallery, but you are *not* getting married. You are not living together, you're not raising a family together, you're not moving to Florida together when the gallery gets old. You're doing business together.

————"I think it's really important to look at where you are going and deal with people in a way that's not ever soft, but suits the relationship. That is, as long as it is true to your goals and, more important, to your nature.

"I don't have anything specific in writing with my gallery, but we could. There's room for it. We've kept a dialogue open and because there are lines of communication open, I don't feel uncomfortable proposing that. I think that's another thing to look for in a relationship with a gallery—either professionalism or dialogue or whatever you want to call it. It balances the more murky, unclear aspects of the relationship." **Michael Joo, artist, Brooklyn, N.Y.**

————"The galleries are businesses. And the artists are, by and large, people who are pursuing something they love to do. And that's quite a difference when it comes to working together in a commercial realm.

"I really can't think of any situations where you'd be better off not writing something down, because writing something down merely makes explicit the parties' understanding. The whole purpose of the contract is to have a meeting of the minds. Writing something down helps to make sure that meeting takes place. And the failure to write something down makes it likely that the meeting doesn't take place. So it's really to protect everybody." **Tad Crawford, arts lawyer, author and publisher, New York**

————"The art world is closest to organized crime in terms of lack of moral structure." **Anonymous**

*————————"At the end of my gallery contract it says, 'Either party can dissolve this contract with thirty days notice.' If you don't want to work with me, it's best we not work together. If I don't want to work with you, it's best we not work together. I would always want it to be easy to get out of. I don't just have a contract so I can wave it at an artist and say 'You said right here!' and then make their life difficult. And it's not going to save me from having someone defect from the gallery—It's just going to make it easier for us to have a framework by which we live, minimizing the possibility for misunderstandings." **Greg Kucera, Greg Kucera Gallery, Seattle***

*————————"For Bank, agreements are customized for the artists because each artist does unique work. For example, with new media artists, issues of equipment, installation, and maintenance are addressed. These points are not always relevant for an artist who's working on paper, for example, especially when a sale occurs. Agreements are amended by both the artist and gallery before they're signed." **Lorraine Molina, owner and director, Bank, Los Angeles***

You can still be friends. You can still care about each other. And you had better trust each other. But that doesn't mean "until death do us part," nor should it.

6. *"I wouldn't want to be bound to a contract for years and years. I want to be able to walk away if things don't work out."*

You *shouldn't* agree to be bound for years and years—and a contract doesn't mean you have to. There's no minimum time requirement. A contract can last for as little time as you like. Or it can last until one side decides to end it.

We recommend writing that either you or your gallery can end the relationship at any time, for any reason. It's good for you and the gallery to have a "notice period" of thirty or sixty days, so that, for example, your gallery can't pull the plug on you the day before a solo show (or vice versa).

7. *"Every artist is so different and every relationship is so different. A contract can't cover it all."*

The point of a representation agreement isn't to predict every possible mishap. It's to make sure that you and your gallery agree on the major issues and to minimize surprises. You can still cover a lot in one or two pages, with the understanding that when things come up that the agreement doesn't specifically address, you'll work them out—just as you would if you didn't have any written agreement at all.

8. *"Contracts are impossible to understand."*

This one is sort of true. Most contracts are filled with technical jargon, arcane phrases, and convoluted constructions. ("Whereas," "hereunder," and "in witness whereof" are just the beginning.) But it doesn't have to be that way. You're allowed to write a contract in plain English, and don't let any lawyer tell you otherwise.

9. *"I can't afford a lawyer to draft a contract."*

You don't need to pay a lawyer to draft a representation agreement from scratch because there are already a number of

samples out there that you can use (including ours at the end of this chapter). You just need to show your final draft to a volunteer arts lawyer to make sure it covers your specific situation and works for whatever state you live in.

10. *"I would never sue my gallery, and my gallery would never sue me. So what's the point of a contract?"*

The point of writing down a representation agreement isn't to arm yourself for a lawsuit. It's to make sure you and your gallery are on the same page (literally). It's to help you identify your expectations, to prevent you from making unwarranted assumptions, and to minimize misunderstandings.

It's also to help you deal with any disagreements that crop up along the way, since people's memories are generally bad. We tend to remember things in ways that are favorable to us, and we tend to think of our memories as ironclad. When it comes to some detail of a discussion from three years ago, you and your gallery may genuinely remember it differently. If you wrote down your agreement, you can refer back to it for guidance.

There's also a moral component to having a written agreement. Sometimes it's enough to show people that they promised something in writing to motivate them to keep their promise.

11. *"Emerging artists don't make enough money to justify writing up a contract."*

It's true that the more money there is at stake, the more likely people are to want a written agreement. But that doesn't mean you shouldn't want one just because there isn't a lot of money at stake, for a couple reasons.

First, it *is* a lot of money—to you. Your gallery will probably want to represent you for *all* your work. So no matter how much you're selling—whether it's $5,000 a year or $500,000—the arrangement you're talking about covers *all* of it. One hundred percent is still "a lot."

Second, as we've already said, the point of a written representation agreement is to confirm expectations and avoid misunderstandings. Those goals definitely justify writing up an agreement.

————*"My perspective is that contracts are there to keep you from having a disagreement. They are not there to settle an argument. Some artists will never have them, but I am always surprised when I hear about young galleries with young artists not using contracts."* **Cornell DeWitt, private dealer and consultant, former gallery owner and director, New York**

————*"It is important to make clear who is responsible for what costs involved with representation. Whenever there is a dollar amount involved, there are miscommunications. Go dutch to dinner with a friend who is cheap and you'll see: the bill comes and they assert that they owe fifteen dollars and ninety-five cents, with tip, while you owe sixteen dollars and forty-two cents. Let's face it, most of us would just throw a twenty not to have the pain of counting pennies. There are always misunderstandings about money."* **Leigh Conner, Conner Contemporary Art, Washington, D.C.**

————*"The written contract lays out the least we can expect from each other. It doesn't put limits on the best we can do for each other. I think it's valuable to have it there as the lowest common denominator between us. At the very worst, this is the relationship we're going to have."* **Greg Kucera, Greg Kucera Gallery, Seattle**

————*"I think a lot of artists do not think about it. I think so much of the artist/gallery relationship comes out of a social push that it's hard to remember it's a business."* **Tamara Gayer, artist, New York**

SAMPLE REPRESENTATION AGREEMENT

Now that you understand why representation agreements are good, not evil, you're ready to see a sample. Note that it doesn't include a resale royalty or a right of first refusal, neither of which you should plan on getting until you're a superstar (unless your resale takes place in California, in which case, as you know from chapter 13, you're legally entitled to a 5 percent resale royalty even if you don't say so in your representation agreement).

Just as with our sample consignment and commission agreements, you can (and should) add, cross out, and edit the language in our sample representation agreement so that it applies to your situation. There may be other issues you want to address in the agreement. Or there may be some promises you or your gallery aren't willing to make. The sample we're giving you isn't all or nothing, it's a starting point. It's meant to be tailored.

Given that the vast majority of galleries do not use written representation agreements with their artists, we understand that you may never actually use this. But we hope artists and galleries begin to get comfortable with representation agreements and that this sample will someday prove useful.

"Dear Gallery"

You can always write a representation agreement as a letter (or an email) to your gallery. That makes it look a little friendlier and a little less formal. But you should still ask the gallery to sign the letter (or reply "agreed" by email); otherwise the gallery might turn around later and claim it never agreed to what you wrote.

OF COURSE THIS CONTRACT WILL BE VOID IF YOU MAKE ANY WORK THAT IS TOO CHALLENGING FOR OUR COLLECTORS.

Gallery Representation Agreement
between

_____ ("I/me") _____

Artist Address

and

_____ ("gallery") _____

Venue Address

1. I appoint the gallery as my exclusive agent in _____ [city/region] for the sale of my original artwork ("work").

2. Either the gallery or I may cancel this agreement by writing to the other, in which case the agreement will end within _____ days, the gallery will return any unsold work to me within _____ days and we will settle any outstanding debts within _____ days. This agreement will last for _____ years and automatically renew unless one of us cancels it.

3. The gallery will use its best efforts to sell and promote my work and to manage my career. The gallery will be responsible for all costs related to the sale and promotion of my work.

4. I will list the gallery as my representative on my website and in any public displays of my work. I will update the gallery in writing whenever there are changes to my resume, biography or similar materials. I will let the gallery know of any exhibition opportunities before committing to them.

5. The gallery will sell my work on consignment. Whenever I deliver work, the gallery will sign a receipt similar to the attached inventory list and give me a copy. The gallery will keep records of every work I consign and give me a list of my work in the gallery's inventory once a year (or on request). The gallery will cover the costs of photographing every work of mine that it offers for sale and will provide me digital copies of the images.

6. Whenever I give work to the gallery, it will be considered a consignment (not a sale) unless specifically noted in writing. The length of each consignment will be noted on the receipt when I consign the work. We may agree at any time to change the consignment period for particular work.

7. The gallery will offer consigned work for the prices noted in the inventory list describing that work. Unless we agree in writing to a different arrangement before the sale of a particular work, for any sales, including work the gallery consigns to another venue:

 a. I will receive _____% of the retail price, after subtracting production costs.

 b. I will split up to a _____% discount.

 c. Whoever pays for production costs will be reimbursed 100% for any work sold.

8. The gallery will let me know of any sale, donation, consignment or loan of my work (that the gallery makes) within one week. The gallery will keep records of every sale, donation, consignment or loan of my work (that the gallery makes) and give me a summary once a year (or on request). The summary will include, for each sale, donation, consignment or loan: the date, title of work, price, name and address of the buyer (or recipient or borrower) and any amounts due to me and to the gallery.

9. The gallery will not deliver work to a buyer until the buyer fully pays the gallery. Within _____ days of receiving payment from the buyer, the gallery will pay me my share of any sale and give me the name and address of the buyer. The gallery will not make any sales on approval or credit without my permission. The gallery will return any unsold work to me when the consignment period for that work ends.

10. I will pack my work before shipping it to the gallery and the gallery will pack it before shipping it back to me (or to the buyer if the work sells). _____ [The gallery is or I am] responsible for shipping the work to the gallery, including insuring the work for risk of loss or damage during shipment. _____ [The gallery is or I am] responsible for shipping the work from the gallery, including insuring the work for risk of loss or damage during shipment. The gallery is responsible for shipping the work to and from any art fairs, including insuring the work for risk of loss or damage during shipment.

11. The gallery is responsible for safekeeping the work while it is in the gallery's possession. The gallery will insure the work (to its retail price) for any loss or damage while the work is in the gallery's possession. The gallery may not remove consigned work from its premises without first getting my permission. If any work is lost or damaged beyond repair while in the gallery's possession—or after removal from its premises without my permission—the gallery will pay me the same amount of money I would have received had the work sold at its retail price. If any damaged work is not beyond repair, the gallery must pay for restoration by a restorer whom we agree on.

12. The gallery will give me one solo show, lasting at least one month, every _____ years. For each show, the gallery will:

 a. Provide a press release and show card (or announcement).

 b. Install and deinstall the work. (I will provide installation instructions.)

 c. Consult with me on curating and installation decisions.

 d. Host an opening reception.

 e. Cover the costs of taking installation images of my work during the show.

 f. Provide these additional sales and promotional materials:

13. The gallery will do whatever is necessary to protect my copyright in consigned work. Although I retain all reproduction rights to my work, the gallery may take images of consigned work and use them to publicize it or any show I am in, crediting me as the artist. Images reproduced in the press should include the line "Courtesy of [my name and the gallery]."

14. This agreement only applies to work I finish while the agreement is in place. I warrant that I own the work (and all proprietary rights to it) that I consign to the gallery and that I have the right to appoint the gallery as my agent to sell it. I retain title in each work I consign to the gallery until I am fully paid for any sale, at which time title will pass directly to the buyer. I shall not be subject to claims by any creditors of the gallery. If the gallery becomes insolvent, I shall have the rights of a secured party under the Uniform Commercial Code. The gallery agrees not to encumber consigned work, or incur any obligation based on it that I could become liable for. The gallery will hold my share of the proceeds from sales in trust. I understand that the gallery does not promise any particular outcome from its sales efforts on my behalf. This agreement will automatically terminate if I die or the gallery becomes insolvent. This agreement states our complete understanding and replaces any earlier understandings between us. We may only modify this agreement in writing, signed by both of us. The gallery may not assign its rights or obligations under this agreement without my written permission. If a court holds any part of this agreement illegal, void or unenforceable, the rest of the agreement will remain enforceable. The waiver of one right is not a waiver of any other right. This agreement shall not be interpreted for or against me (or for or against the gallery) because one of us (or our respective counsel) drafted a contested provision. In any proceeding to enforce this agreement, the losing party will pay the winning party's reasonable attorneys' fees.

_____ [State] law governs this agreement, regardless of conflict-of-law principles.

Dated: _____

_____ _____
Artist signature Venue signature

 (print name)

Inventory List

Work by _____
(Artist name and address)

TITLE, YEAR MEDIUM, EDITION DIMENSIONS/DURATION	RETAIL PRICE FRAMING/PRODUCTION COST
1.	
2.	
3.	
4.	
5.	
6.	
7.	
8.	

_____ has received on consignment the works described above.
(Venue name and address)

The consignment will last from today until _____

_____ _____
Venue signature Date

(print name)

RECOURSE

So what can you do you if a gallery screws you over? Not very much, unfortunately, unless you have some real clout or you're owed a serious amount of money.

Legally, of course, there are things you can do, which we'll talk about in a minute. But you could end up paying a high price for taking those steps, because other galleries may decide not to work with you when they hear that you threatened (or sued) a gallery. And they *will* hear about it.

Ideally, you and the gallery will work things out with a few conversations. When urging the gallery to do the right thing doesn't work, offer to compromise. Do whatever you can to resolve the issue informally and privately.

If you can't come to a resolution with the gallery, you have to decide whether to let it go or push back. That's a decision only you can make, since it turns on your style, your leverage, and what's at stake. If you don't want to leave it alone, the next thing to do is see a volunteer lawyer for the arts and find out what your options are. That's not a commitment to go to court; it's just to learn where you stand so you can make an educated decision about the most effective next step.

I'M NOT GOING TO KEEP A WRITTEN RECORD OF OUR AGREEMENT BECAUSE THAT WOULD MAKE IT NEARLY IMPOSSIBLE FOR ME TO SCREW YOU LATER.

—————"The question of recourse becomes a practical one. It's very expensive to litigate. You have to weigh the potential recovery against the cost of litigation and what may happen to your reputation in the art world if you're heard to be someone who rocks the boat and is hard to work with.

"The point of a contract is that most people will follow things that they agree to, and you won't have to litigate. And when you're dealing with crooks, they're going to be crooks whether you have a written contract or not." **Tad Crawford, arts lawyer, author and publisher, New York**

—————"We typically put in a provision that says 'In any lawsuit to enforce the agreement the loser pays the winner's legal fees.' You're in a stronger position with that sort of provision, because the dealer can't just say, 'Well then go sue me. It'll cost you more to litigate than you could possibly win.' With this kind of fee-shifting provision, you can say, 'No, it'll cost you more if I litigate.' But it ups the ante in both directions because the artist has to realize that if he breaches the contract and gets sued, he could be on the hook for the gallery's fees." **Donn Zaretsky, art lawyer, John Silberman Associates, writer, Art Law Blog, New York**

Every situation is different and will call for a different approach. You might write a letter to the gallery—with the attorney's help—again urging the gallery to do the right thing. (Sometimes putting the request in writing gives it a little more force.) Or you might decide to have the attorney write a letter on your behalf. That's akin to throwing a punch, though, so don't do it if you ever want to show in that gallery again.

If your letter-writing campaign doesn't get you anywhere, you could consider mediation. That's essentially a meeting between you and the gallery, with a neutral mediator to help guide the conversation to a resolution you're both satisfied with. There's a free mediation program in New York, for example, specifically for disputes related to the arts. But mediation is voluntary, meaning you can't force the gallery to participate and the mediator can't force either side to accept the resolution.

Then there's arbitration, essentially a cross between mediation and court. It's voluntary to begin, but once you commit, you have to abide by the arbitrator's decision the same way you do a judge's order. Arbitration can be very expensive—it can be more expensive than going to court—and we generally don't recommend pursuing a gallery-related grievance through that route. (Again, though, you should follow your attorney's advice based on your particular situation.)

Your ultimate option is going to court. It should go without saying that you need a lawyer to do it right. If your income is so high that you don't qualify for a volunteer lawyer, you might find one willing to take your case "on contingency." That means you only have to pay the lawyer if you win (in which case, you'll have to give up to a third of what you win to the lawyer). But given how quickly legal bills add up, it's just not likely that your case will be worth enough for a lawyer to take it on contingency.

If you used our contract, on the other hand, you should be able to get a very good lawyer—and you wouldn't even need to hire the lawyer on contingency. That's because our contract says that if you and your gallery end up in a legal dispute, whoever loses has to pay the winner's legal bills. This solves the problem of your case not being "worth enough," since the gallery will have to pay your lawyer's bills—assuming, of course, that you have a

solid case. But it's still not a perfect solution, because your lawyer will most likely ask you to pay your legal fees up front, to be reimbursed later when you win or settle. (And, as we said in chapter 10, don't file a frivolous lawsuit or you'll end up on the hook for your gallery's legal bills and your own.)

AND YOU'RE OFF

We began this book with a promise to give you the best information and advice for every stage of your art career. We also began with a piea: Don't listen to everything we say! That may be unusual for authors to tell their readers, but we're going to end the way we began.

The art world is a vast and sprawling place, and you, the artist, are its vital center. We envy your talent and admire your decision to pursue an art career, and we encourage you to do this on your own terms. There are many ways to be an artist, many routes to representation and many definitions of success. We hope that what we've told you will make your life easier, save you time, and let you focus on what's most important: your art.

We congratulate you on getting this far—and wish you good luck!

ACKNOWLEDGMENTS

Words cannot express our gratitude to Rebecca Dana and Rishi Bhandari for their love, support and daily encouragement. And for making everything 12–15 percent better.

We are forever indebted to Richard Liebner and Paul Fedorko for leading us to our phenomenal agent (and fast friend) Melissa Flashman. We are equally grateful to Wylie O'Sullivan, our tireless editor at Simon & Schuster. Many thanks also to Ari Melber, Barbara Melber and Ann Tarantino (and, again, Rebecca and Rishi) for their meticulous edits of early drafts.

We are grateful to:
Kammy Roulner for her perspective, Michael Greenblatt and Jessica Wexler for their vision. Our families for their advice and support, especially Dan Melber, Linda, Kevin, Marissa and Erin Darcy, and Natasha, Anil, Rohit, Riya, and Reyna Bhandari.

Rob Carter, Monica Herman, Steven Sergiovanni, Courtney Strimple and Paige West for their input and understanding during the writing of this book; to all Mixed Greens artists, past and present, who taught Heather invaluable lessons as they grew and flourished; to NURTUREart for its heart; to Do-Ho Suh and Bonnie Collura for making Heather want to work with artists always; to Erin Sircy for listening and understanding on walks through Chelsea.

Peter Parcher and Steve Foresta for mentoring Jonathan and teaching him how to focus on the right details without losing sight of the big picture.

Finally, thank you to everyone who generously made time for an interview:

George Adams
Helen Allen
Chris Ballantyne
Shoshana Blank
Christa Blatchford
Tim Blum
Sabrina Buell
Ian Campbell
Shane Campbell
Rob Carter
Mary Leigh Cherry
Catharine Clark
Leigh Conner
Tad Crawford
Michael Darling
Bill Davenport
Blane De St. Croix
Cornell DeWitt
Stephanie Diamond
Peter Eleey
Anne Ellegood
Alessandra Exposito
Rosamund Felsen
Lauri Firstenberg
Howard Fonda
Laura Fried
Francesca Fuchs
Alison Gass
Tamara Gayer
David Gibson
Massimiliano Gioni

Micaela Giovannotti
Michelle Grabner
Jim Harris
Joy Harvey
Joe Havel
Steve Henry
Ben Heywood
Cecily Horton
Kerry Inman
Kevin Jankowski
Stephanie Jeanroy
Michael Joo
Kelly Klaasmeyer
Greg Kucera
Jason Lahr
Knight Landesman
Melissa Levin
Sarah Lewis
Charles Long
Heather Marx
David McGee
Monique Meloche
Lorraine Molina
Shamim Momin
Eve Mosher
Jonathan T. D. Neil
Leah Oates
Stas Orlovski
Murat Orozobekov
Emilio Perez
Joachim Pissarro

Andrea Pollan
Melissa Potter
John Rasmussen
Trevor Reese
Sarah Reynolds
Sara Jo Romero
Andrea Rosen
David Salmela
Lisa Schroeder
Jonathan Schwartz
Howie Seligman
Jasper Sharp
Franklin Sirmans
Amy Smith-Stewart
Jessica Smolinski
Joseph Smolinski
Shannon Stratton
Heather Taylor
Fred Tomaselli
Kim Ward
Benjamin Weil
Hillary Wiedemann
Tony Wight
Eleanor Williams
Clint Willour
Ed Winkleman
Michael Yoder
Donn Zaretsky
Steve Zavattero

Heather Darcy Bhandari is a director of Mixed Greens Gallery in New York City. She has curated over forty exhibitions at Mixed Greens while managing and advising a roster of nearly two dozen artists. She also curates independent shows and sits on the board of NURTUREart, a non-profit in Brooklyn giving opportunities to unrepresented artists. Heather has lectured at career development programs at the School of the Art Institute of Chicago, Rhode Island School of Design, Georgia State University, and Hunter College. Heather majored in visual arts and anthropology at Brown University and received an MFA in painting from Pennsylvania State University. Before joining Mixed Greens, she worked at contemporary galleries Sonnabend and Lehmann Maupin in New York City.

Jonathan Melber was a lawyer at a prominent arts-and-entertainment law firm where he represented artists, galleries, and collectors, as well as a host of creative individuals and companies. He has also worked for several years on a probono basis for Volunteer Lawyers for the Arts. Jonathan graduated from Brown University with a degree in philosophy and received his JD from New York University School of Law, where he was an editor of the Law Review.

Photos by Coke Wisdom O'Neal